Vue 7

From the Ground Up

Ami Chopine

Vladimir Chopine

Routledge
Taylor & Francis Group

LONDON AND NEW YORK

First published 2009 by Focal Press

2 Park Square, Milton Park, Abingdon, Oxon OX14 4RN
711 Third Avenue, New York, NY 10017, USA

Routledge is an imprint of the Taylor & Francis Group, an informa business

First issued in hardback 2017

Library of Congress Cataloging-in-Publication Data
Chopine, Ami.
 Vue 7 : from the ground up / Ami Chopine, Vladimir Chopine.
 p. cm.
 Includes index.
 ISBN 978-0-240-81226-7 (pbk. : alk. paper) 1. Computer graphics. 2. Computer animation. 3. Three-dimensional display systems. 4. Vue (Electronic resource)
I. Chopine, Vladimir. II. Title.
 T385.C52165 2009
 006.6'93–dc22
 2009005180

ISBN-13: 978-0-240-81226-7 (pbk)
ISBN-13: 978-1-138-45625-9 (hbk)

Dedicated to Judy Ostermiller, who has always believed in her students.

Contents

Contents

Contents

Preface

Vue is quickly being recognized by professional and lay persons alike as the best software on the market for producing natural, animated environments. You've probably seen the lush and realistic backgrounds of such blockbuster films as *Pirates of the Caribbean*, *Indiana Jones and the Kingdom of the Crystal Skull*, and *Spiderwick*. All of these were created using Vue.

Vue has an easy-to-use interface that makes the concept-to-image process intuitive and enjoyable. You can have an idea, sit down, and within short hours have an image you'd like to hang up on your wall. If you're a professional with a three-dimensional (3D) application you already love, Vue can work right alongside it providing its power with atmospheres, terrains, material creation, and more. This book will guide you through everything you need to know to create stunning artwork and animation.

When working with Vue or any 3D program for that matter, the best way to get realistic results is to study reality. Check out photographs of land formations, clouds, plants—anything you intend to bring into the scene. Even if you're creating cartoon animations, knowing how nature really looks can help craft caricatures that look fantastic. A good example of this is in the movie *Kung Fu Panda*, where many of the backgrounds were created using Vue.

This book starts out with a basic explanation of the interface and the environment you'll be creating in. After that, it begins, literally, from the ground up with terrains and moves you through basic to advanced operations with each aspect of creation. Even if you intend to integrate Vue with an application like Maya, knowing how Vue works in stand-alone mode will give you the expertise to use it to its fullest strength as a plug-in and raise your artwork to new heights. At the end of each chapter is a tutorial applying some of the information so that you can quickly become proficient.

The tutorials are designed to be stand-alone sessions; that is, you will be able to do them even if you didn't read the chapter before. There will be several files you'll need for some of the tutorials, and you can find them at the book's companion web site, *www.vue7fromthegroundup.com*. In addition to these assets, you'll find several more video tutorials further exploring Vue, useful quick references, a reader gallery, a community, and other goodies.

There were several artists involved in creating the opening images for the chapters. More information about them and a small gallery of more of their work can also be found at the web site.

You can read this book cover to cover, read just a few parts to fill in some gaps, do just the tutorials, or use it as a reference. Any way you use it, we hope you'll find *Vue 7 from the Ground Up* to be a must-have book to help you bring your dreams to fruition on the screen. This book is only a guide to using a great tool. The art is in you. Enjoy.

Acknowledgments

Usually in the Acknowledgments, one of the most important persons thanked is the author's spouse (or partner). Well, since we (the coauthors) are married that would be like thanking ourselves. Even so, it has been great fun sitting right next to each other working on this project. We'd like to thank Chris Simpson for giving us the opportunity to share our knowledge of Vue with others.

Early on in the writing, Peggy Walters got involved as our technical editor. Not only did she point out technical gaffs, she helped clean up the text. Her cheerfulness and quick responses made it a joy working with her. This book is much better because of her hard work.

We'd also like to thank the community at Cornucopia3D. There were several times when questions were asked and answered that helped clarify Vue's inner workings to us. A few people in particular posted online tutorials that helped fill the gaps. Those were Steve James (Silverblade), Mark Caldwell, and Paul Fitzgibbon.

And of course, there is the great team at e-on Software who created Vue and kindly worked with us on several details.

Last, but not least, we'd like to thank our great children who had to deal with parents who sometimes seemed connected to the computer by umbilical. They were by far the most inconvenienced, but remained (mostly) patient and always helpful through it all.

The Artists

Dominic Davison, from the United Kingdom, has been a freelance digital artist for around 5 years. He primarily creates natural landscapes in Vue, focusing on classic landscape paintings of the 16th, 17th, and 18th centuries.
URL: www.digital-dom.deviantart.com
Email: king_dom1@hotmail.com
Woodland Waterway, Chapter 5
Autumnal Walk, Chapter 7

Luigi Marini (nickname raffyraffy) lives near Rome, Italy, with his wife and three sons. His main studies were in nuclear physics, but his great love is cartoon and cinema arts. He's been a digital artist for 13 years.
URL: www.3ddigitalenvironments.it
Email: rraffy@hotmail.com
Mountain Village, Chapter 6
Happy Little Farm, Chapter 9

Gary Miller, a tutorial instructor at Geekatplay, learned 3D art from online tutorials and now loves to use his knowledge to help others have fun and create models and scenes with ease.
URL: www.mysite.verizon.net/resuqas9/
Email: secretagentgmiller@verizon.net
Morningside, Chapter 15
Arctic Precipice, Chapter 19

Artur Rosa has been creating digital artwork for 2 years, using Vue with passion to crystallize the images in his mind. He lives near the sea in Portugal with his wife and son.
URL: www.renderosity.com/mod/gallery/browse.php?username=rutra
Email: artur.rosa@gmail.com
Sic Transit Gloria Mundi, Chapter 8
Somewhere in the Centaurus Constellation, Chapter 13

Chipp Walters is an award-winning industrial designer, 3D digital artist, and software programmer. Specializing in Vue modeling, he is the creator of several Vue plug-ins and the author of tutorials on modeling.
URL: www.blog.chipp.com/
Email: chipp@chipp.com
Cloud Carrier, Chapter 12
Who's Going First?, Chapter 18

The Interface

If you're new to Vue, you'll find that the interface is very intuitive. Although this chapter doesn't go into much detail about each Vue tool you should come away with a solid grasp of the layout and a basic understanding of what the tools are and their potential.

If you're familiar with Vue, you may wish to skim this chapter, if only to familiarize yourself with the terms used in the rest of the book. Otherwise, feel free to move forward to other chapters.

At First Sight

The most obvious thing you'll notice when you open up Vue is that there are four windows showing a scene from different angles. This is a common layout for three-dimensional (3D) applications. You'll be able to view your scene from the top, side, front, and what the camera sees. As you become familiar with the environment, you'll find it makes it very easy for you to see and manage the arrangement of everything that is in your scene.

By default Vue uses OpenGL, an industry-standard graphics library to quickly draw representations of your scene in the four different view windows.

Typically, this runs using your hardware drivers. However, sometimes the version of OpenGL in your computer and the one used in Vue aren't compatible. In this case, you can switch to OpenGL that is driven by the software rather than your hardware, or even leave OpenGL behind by choosing a wireframe view. You can access these options through File > Options > Display Options; you'll find them in the upper left corner. In this book, OpenGL will be used and the four window views will be referred to as OpenGL views.

Only the camera view will show your scene with perspective. All the other OpenGL views are orthogonal, which means that distance will have no effect on what you see. Not only will there be no blurring in the distance, size will be shown objectively and without regard to how far away the object is. For an example, let's use a small sphere and a large sphere. You've arranged the small sphere directly in front of the large sphere, so that in the camera view you can only see the small sphere. This is pretty intuitive, because it is how the real world works. However, you notice in the front view that you see the larger sphere behind the small one. This orthogonal view is imaginary, but it gives you the great advantage of being able to see each sphere's absolute size and exact placement.

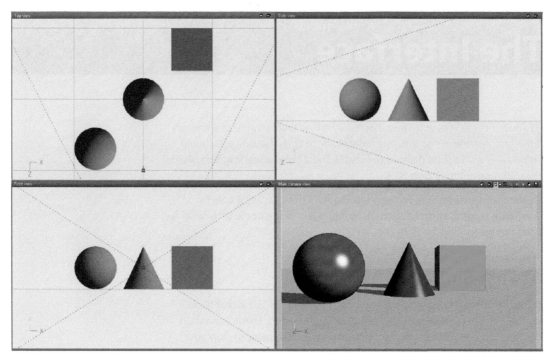

In this figure, you see in the top view that these figures are placed so the sphere comes before the cone, which comes before the cube, and that they are also displaced along the X axis. However, the objects appear to be in perfect alignment in the front and side views because of their orthogonal view. It is in the camera view where you see the effects of perspective, showing not only smaller shapes in the distance but also an appearance of being off center in the camera's field.

The Coordinate System

In the Vue environment, the world has a center from which the position and orientation of everything are measured. The three axes that make up the coordinate system—height, length, and depth—originate from this point at right angles to each other. This center of the world is also called the point of origin. The coordinate system that originates from this center is the world coordinate system. Objects also have their own center and coordinate system. The relationship between the object and world systems affects how you must manipulate your objects as well as how materials will apply to them. For more detail about this, refer to Chapters 6 and 8.

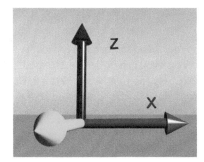
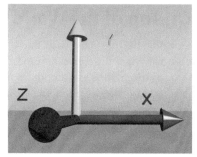

By default in Vue, Z corresponds to the axis pointing up, meaning the one that represents height; X represents length; and Y represents depth. However, many 3D applications use Z as their depth and refer to the effects of perspective as Z depth. You can make this change in Vue by going to File > Options; select the Units and Coordinates tab (if you're using Vue 6, select the General Preferences tab instead) and there you can toggle between "Y axis up" or "Z axis up." Select "Y axis up"; this will make X the length and Z the depth.

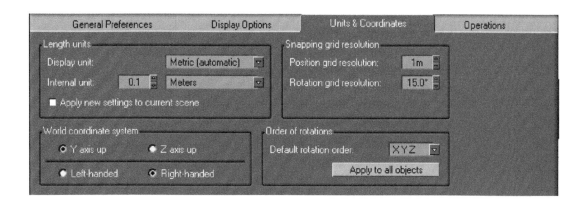

Units of Measurements

While you're in the Units and Coordinates tab, you'll also find that the world is measured using the metric system by default. Specifically, it's measured in meters. You could change this to the imperial system, but that can get a bit clumsy. Units are measured using the clear and logical decimal system. The problem is that the medieval system of inches, feet, and yards doesn't lend itself well to a nice breakdown into parts of ten. And furthermore, if you don't specifically set the unit of measurement as feet rather than imperial (automatic) in the Display Unit dropdown menu, Vue will tend to measure anything larger than 3 feet in yards. Unless you're working with fabric, this unit of measurement is not likely to be intuitive either.

On Top of the World

Crowning the four views you'll find the top menu and toolbar. The top menu, especially, rules the application. Most every task you can do can be accessed through the options and dropdown menus there. The toolbar just below it is devoted to viewing, editing, and overall scene tasks such as animation and atmospheres.

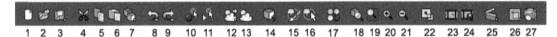

In the following list, the second task listed can be done by right-clicking or holding the mouse button.

1. **New**—Starts up a new scene.
2. **Open**—Loads a scene that has been saved.
3. **Save**—Saves a scene.
 Save As—Allows you to save a new version under a different file name.
4. **Cut**—Deletes the selected object in the scene while saving a copy.
5. **Copy**—Saves a copy of the selected object.
6. **Paste**—Adds the object most recently saved as a copy either through cut or copy.
7. **Duplicate**—Adds a copy of the selected object into the scene.
 Scatter/Replicate—Gives you options to copy the object several times with variable numeric attributes.
8. **Undo**—Undoes the most recent action.
 Undo List—Gives a list of recent actions to select from and undo in reverse order.
9. **Redo**—Redoes the action just undone.
 Redo List—If no other action than undone was taken, gives a list of recently undone actions.
10. **Record Macro**—When this button is pressed, Vue will record the actions you take until you press the button again.

11. **Play a Macro or a Tutorial**—Brings up a menu of previously created macros, and then performs the recorded actions of the selected macro.

12. **Load Atmosphere**—Opens a browser to select an atmosphere for your scene.
 Save Atmosphere—Allows you to save an atmosphere you've created for later use.

13. **Atmosphere Editor**—Opens a window that contains all the tools for creating or changing an atmosphere.

14. **Edit Object**—Opens whichever editor is appropriate for the selected object.

15. **Paint EcoSystem**—Opens the EcoSystem Painter, letting you apply instances of randomized rocks, plants, or other objects.

16. **Select EcoSystem Instances**—Enables you to select one or several of the instances to manipulate, convert to objects, or put under control of the EcoSystem.

17. **Show Material Summary**—This will bring up a browser that will show all the materials being used in the scene.

18. **Frame All / Selected Objects**—Clicking on this will bring selected object(s) into close range in the orthogonal views. If nothing is selected, the scene will be centered.

19. **Frame Selected Area**—Clicking on this will enable you to select an area to be centered in the views.

20. **Zoom Into View**—Moves your view closer in to the scene.

21. **Zoom Out of View**—Moves your view farther from the scene.

22. **Toggle Current View**—Makes the active view fill the whole interface or brings it back to being one of the four views.

23. **Show Color Picture**—Brings up your last render.

24. **Save Color Picture**—Saves the last render.

25. **Show Timeline**—Causes the timeline to appear. Unless set otherwise, the Animation Wizard will pop up first.
 Animation Wizard—Causes the Animation Wizard to appear.

26. **Select Render Area**—Enables you to select a small area to render, usually for a test.

27. **Render**—Starts a render.
 Render Options—Opens up the render options dialog.

The Left Side

The far left of your interface holds the Object toolbar, which contains either buttons that will add an object to the scene or buttons that manipulate objects.

1. **Infinite Planes**—Right-clicking will bring you three options: a water plane, a ground plane, or a cloud plane. Left-clicking loads the plane shown.

2. **Primitive Objects**—Right-clicking opens up eight primitive objects: a sphere, cylinder, cube, pyramid, cone, torus, plane, and alpha plane. Left-clicking loads the object shown.

3. **Text**—Brings up the Text Editor where you can type in and manipulate text to load into your scene.
4. **Standard Heightfield Terrain**—Loads a terrain into your scene.
 Heightfield Terrain in Editor—Right-clicking will open the Terrain Editor.
5. **Procedural Terrain**—Loads a procedural terrain.
 Load Procedural Terrain Preset—Right-clicking will open a browser to select different procedural terrain presets.
6. **Plant**—Loads a default or the most recently used plant.
 Load Plant Species—To select a plant, right-click this button.
7. **Rock**—Creates a rock in your scene.
8. **MetaCloud**—Adds a cloud as an object into your scene, allowing you to manipulate it.
 MetaCloud from Preset—Right-clicking will open a browser to choose from several cloud presets.
9. **Planet**—Adds a planet to the sky.
10. **Load Object**—Opens a browser to select from several objects to load from.
 Save Object—If you've selected an object, right-clicking this will save your object.
11. **Group Objects**—When two or more objects are selected, this button will connect them so they act as one object when being manipulated.
12. **Boolean Difference**—Subtracts the volume of one object from another.
13. **Create Metablob Object**—Merges the two or more selected objects and softens all hard edges.
14. **Ungroup Objects**—Ungroups any objects that have been combined through group objects, Boolean difference, or Metablob.
15. **Lights**—Creates a light in your scene. A right-click offers several different light options: point light, quadratic point light, spotlight, quadratic spotlight, directional, and light panel.
16. **Ventilators**—Gives you either a directional or an omni ventilator.
17. **Alignment Tool**—When two or more objects are selected, this tool gives you the ability to line them up by the desired axes.
18. **Select By**—Enables you to select objects by their similarities: wireframe color, material, or object type.
19. **Drop Objects**—Allows you to drop an object right onto an object below it.
 Smart Drop Objects—Causes the object to align the vertical axis with that of the object it has been dropped on.

The Right Side

Besides the four views, the Scene Information toolbar on the right dominates the interface with three important sections. The top part, called the Object Properties Panel, is how you'll have direct access to any object you're working with. Below that is the Camera Control Center with its render preview. The World Browser, at the bottom, is a convenient list of all the objects in your scene.

Object Properties Panel

The Object Properties Panel has three tabs—Aspect, Numerics, and Animation—to give you access to all the different characteristics of any object in your scene. The first tab, with the little marker icon, is the Aspect tab. This panel is the one that differs with each kind of object selected, and you'll be using it a lot. The camera aspect, for instance, shows you properties like the focal length, blue, focus, and exposure when the camera is selected while the Aspect tab for objects will preview the materials and control the scale. Lights have properties like color, softness, lens flares, and color gels to deal with in this panel. The Numerics tab is the same for all objects and shows you the position and size of your object. The Animation tab is also the same for all objects, and gives you several options to manipulate how objects move in relation to each other as well as in isolation.

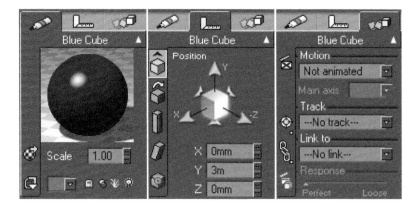

Camera Control Center

The thing that really makes the Camera Control Center pop out is the preview window, where you can see a quick render of what the selected camera sees. Just under that, you'll find the controls to rotate, pan, adjust the focal length, and move your camera back and forth. You'll also be able to manage multiple cameras in this panel.

World Browser

As you create your world in Vue, use the World Browser to keep track of everything. The first tab is the Objects tab and shows you all the objects, with the ability to organize them into layers. You'll be able to access them easily here, no matter where they are in the scene. When adding objects to the scene, they'll appear in the World Browser. Vue will automatically number

7

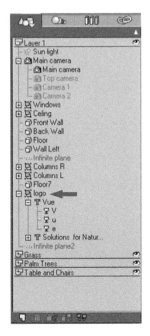

Note all the objects folded into one group. The red arrow points to where the list from a group has been unfolded.

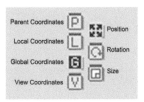

each object that is the same or a variable of the same (as with rocks and plants). However, it is good workflow practice to name each object so you can easily recognize what it is in the scene.

Layers can be thought of as files to help you keep track of your objects. Some versions of Vue 7 only give you limited layers, but if you have unlimited layers, you can create your own using the New layer icon at the bottom of this tab. Adding objects to the layer is accomplished by grabbing them from within the Objects tab and then dragging and dropping them in the layer. Each layer will have a small + or − icon next to it. If it is a plus sign, this means that clicking on it will unfold the list, letting you see all objects that are part of that layer. A negative icon will then appear. You can click on that if you don't want to see the list to make it easier to navigate through all your objects. This + and − icon combination works with grouped objects, which you'll learn about later, and other instances where there may be lists you can fold or unfold.

At the bottom of the Objects tab, as in the other tabs, are several useful options. Hidden here is one of the cool new gadgets in Vue 7: the Object Graphs tab. You'll find more detail about object graphs in Chapter 9. In the next tab you can see and work with all the materials used in the scene. The third tab is called the Library tab and shows you the objects that are in your scene multiple times, giving you the ability to change them simultaneously. The Links tab at the end shows you any relationships you've set up between objects or texture maps.

Gizmo Manipulation Tools

This industry-standard set of tools offers you a way to work with an object within the OpenGL views. These can be tricky for the new 3D artist at first, but become one of the most used tools when manipulating your objects. When you select an object, the gizmo manipulator appears in the active view. There are three gizmo tools, one each to change among position, size, and rotation. You'll be able to switch among these using the buttons that hang to the upper right of the gizmo tool.

Each of the three gizmo tools has a primary function. For instance, the position gizmo, which is the default, is used to move your object. However, you can always accomplish the other tasks—rotation and resizing—as well. Because of this, you may not find the need to change tools because you can already do everything the other gizmos do with this one. Depending on where you hover your mouse pointer, you'll see a different pointer showing you which task you can do.

There is a specialized selection area for each gizmo that will highlight to yellow with the mouse. For example, the rotation gizmo has circular bands around the object at each axis that, when highlighted yellow, can be rotated.

If you move outside the selection sphere, but still within the bounds of the object selection, you can move the object. At the corners and middle of the edges of the cube encompassing the object are large dots where you can scale it. If you aren't using the rotation gizmo, just outside the corners are bent lines with arrows at the end. With your mouse over these, you can rotate the object. The position gizmo is usually easiest to work with since it allows the easiest access to the rotation and scale tasks that you need. However, each tool gives you the most precision with the task it was designed for.

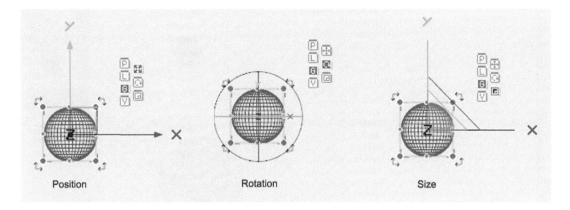

| Position | Rotation | Size |

Also in the upper right corner are the icons for four coordinate systems that these three gizmos might operate in: the Global, Local, Parent, and View. A gizmo working in the Global Coordinate system, selected by default, will change your object in relation to the point of origin in the World Coordinate system, as explained before. The other common option is to alter your object in relation to its own Local coordinates. This refers to the object's own coordinate system with its point of origin at its own center. The Parent Coordinate system works around the point of origin of the first object selected in a group of objects. The View Coordinate system is most useful for working within the main camera view and will use the axes shown in that view. All of these have different advantages and disadvantages that are covered in Chapter 6.

Popup Menu

When you right-click on any object in one of the four OpenGL views or in the World Browser list, a menu will pop up with several options for you. This changes slightly depending on what type of object is selected, but the things that you'll probably be doing the most are available from this menu—for example, editing functions such as cut, copy, and paste; functions to alter materials; and especially the edit object option, which will bring up an editor appropriate to the object you're working with.

Tutorial 1: A Simple Snowman

Step 1

With this tutorial, you'll be making a simple snowman just to get familiar with the Vue interface and OpenGL views. Begin by starting Vue. For a new scene, from the top menu, select the File > New option. The atmosphere browser will pop up; choose "Default." Now, for the base of the snowman, go to the left toolbar to the Primitive Objects icon. If you don't see a sphere, click and hold to open up the selections. Still pressing the button, move your mouse to the sphere and then let go. A sphere will appear in your scene. It may be too close to the camera. In the top view, using the position gizmo, select the Z axis (remember that the Y axis has been changed to the up axis) and push the sphere away from the camera until it is centered in the main camera view.

Step 2

Create another sphere. You should now only have to click on the Primitive
Objects icon for this. The new sphere will probably appear where the first
one did. Still working in the top view, use the inner triangle of the size gizmo
to make this sphere smaller. Pulling out and pushing in will decrease or
increase the overall scale in the top view depending on the placement of the
mouse. You can also use the outer corner with the position gizmo. This works
by becoming smaller when you push in and larger when you pull out, but
resizing like this will not keep the object's center in the same place.

Step 3

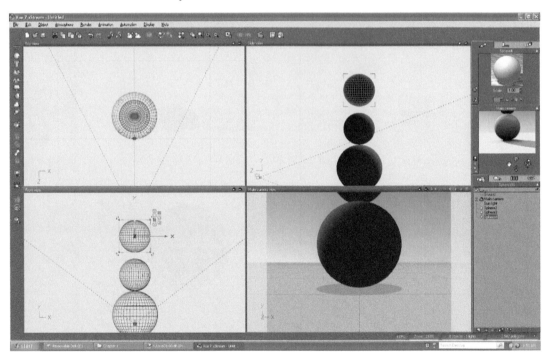

Switch to the side view. Use the position gizmo to move the smaller sphere up and over the larger one. Back in the top view, you can center it. It may make your work easier to zoom in with the mouse scroll or by pressing the Ctrl key and your right mouse button. With it centered, now you can place the middle sphere on the first by pressing the Smart Drop icon. Now, instead of creating a new sphere, you'll copy the middle sphere because it is already centered. This time, in the front view, while holding down the Alt key, move the sphere up using the Y axis of the position gizmo. Now you can make it smaller and then smart drop it onto the middle sphere.

Step 4

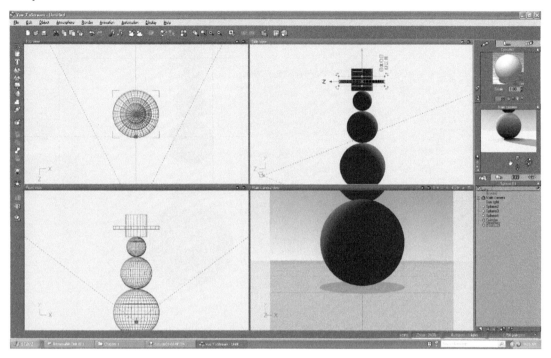

Select and maintain the Primitive Objects icon to choose a cylinder. This will probably appear centered over your snowman, but much too large. Move it up, resize it, and then smart drop it. Now create another cylinder. Choose the size gizmo again, and this time, only resize it along the up axis. This will keep its diameter the same size, but shorten it. Make the rim as thin as you'd like and then use the front or side views to move it up, but not above the main body of the hat. Now you can smart drop it. This will align the rim with the bottom of the hat.

Step 5

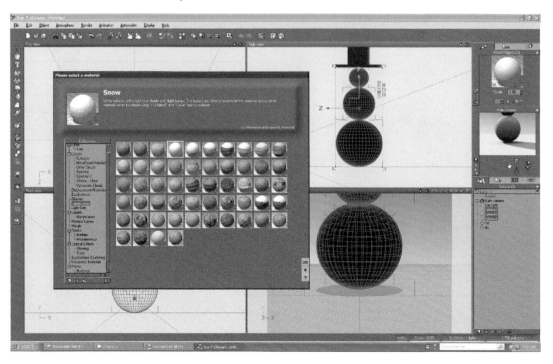

In the Objects tab of the World Browser, select the three spheres together by pressing the Ctrl key while you select them. In the Aspect tab of the Object Properties Panel, right-click on the preview pane (the window showing a sphere). From the dropdown menu, select "Load a Material." In the Landscapes section of the collections browser, select "Snow"; press "OK." Now select both the hat and rim the same way, and load "Black Porcelain" from the Basic collection onto it. With those still selected, you can snuggle the hat onto the head by moving both down. If you want, you can also settle the snowballs into each other for a more realistic snowman. Move your camera to center the snowman into view. In the top toolbar, click on the Render button to render your snowman.

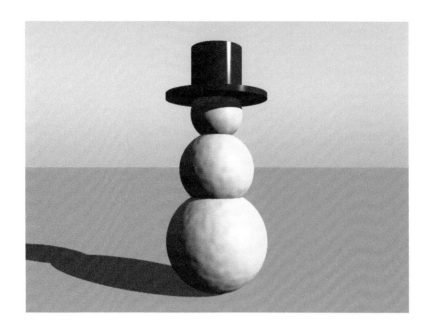

The World

While you're working in Vue, it's helpful for you to keep in mind that you are looking at an imaginary world created using math. Luckily, you won't have to be worrying too much about the math. That's what Vue was created for. However, there are a few things that you should have a good grasp of.

The Laws of Digital Nature

This imaginary world or environment that you are working in extends out infinitely. That is, you could theoretically place an object 20,000 kilometers away from the camera, or even farther. While that may not be practical, this infinite space allows you the ability to work on terrains at the same scale as those in reality. The larger the scale is, the more detail and realism become possible. This comes at a cost, however.

Every three-dimensional (3D) scene you create must be converted to a two-dimensional (2D) format if anyone is to enjoy them. This is accomplished by the process of rendering. Rendering is when the computer calculates the color and brightness of each pixel in a 2D picture based on where the virtual ray(s) of light hitting the pixel would have come from. Rays describing the

properties of the pixel are traced backward from the pixel "eye" to the light source. This light was emitted from the sun or any other light source you put in the scene and travels in a direct line to a surface. The color, reflectivity, or other settings of that surface change the settings in the ray, and then the light bounces and perhaps reflects off several other surfaces and through a virtual atmosphere, or is lost to something blocking its way. Following the path of that light is called ray tracing. A single pixel may require hundreds of rays to define it. The larger and more detailed your scene is, the more surfaces it has for light to bounce off of. This equals more calculations for the computer, and so will increase the amount of time it takes to render.

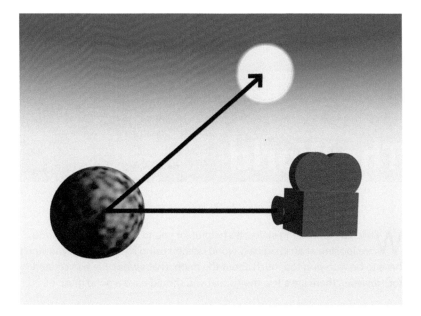

For every pixel, at least one ray is traced from the camera to a light source, bouncing off any objects it encounters. Each interaction with this ray returns information that will determine the color of the pixel.

Vue uses this method because it yields the most photorealistic results within a reasonable amount of time. Of course, reasonable is a relative concept. Be ready to allot some serious computing time to your projects, especially if you're looking for professional results.

The Four Parts of Every Scene

When you first open up Vue, you'll be looking at a start-up scene that has four things in the world. Three of them you will find in your World Browser: the ground, the camera, and sunlight. The fourth item already existing is the atmosphere.

Ground Plane

The ground plane is an infinite plane that is initially horizontal and occupies the center of the world. That is, the arbitrary middle of the ground plane is set there. You can see this in the Numerics tab of your Object Properties Panel. Switching to the size panel in the Numerics tab, you'll find it claims to be 10 × 10 × 10 cm. This is misleading. Changing its size in this tab will do nothing to your scene, and you'll find you'll be completely unable to change the size of the ground plane in the OpenGL views. It is truly an infinite plane. The apparent boundary of the plane's wireframe, if you zoom out far enough in the upper left top view, is merely where Vue has stopped measuring it.

Being only 2D, it can't have a volume. However, the underside of the plane is treated as the inside of an object when applying materials or interacting with other objects. If you do apply a material to the ground plane, be wary of applying anything with detail. Since it does extend to the reaches of where Vue will render a scene, it could slow down your render times. For this reason and more, it's better to make sure you have enough terrain or other objects to fill up your camera view when creating your scene.

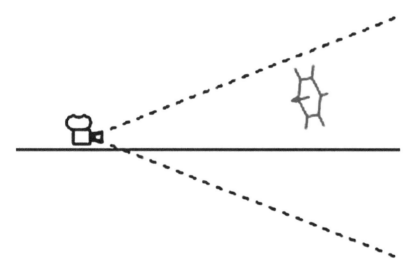

This capture of the side view shows the camera, ground plane, and sunlight.

Camera

The camera is arguably the most important object in your scene, and you're never going to see it in the finished image. What you do see in the three orthogonal views is a symbolic representation showing you the point where Vue will start the ray-tracing calculations from. The dotted lines you see (red if the camera is selected, black otherwise) are the virtual camera's field of vision. The virtual

camera in Vue mimics all of the attributes such as focal length or exposure that you would find with a real camera. These are generated through mathematical computations that you control through Vue's easy-to-use interface. This setup demonstrates one of the real advantages of Vue: You don't need to lug around lots of camera equipment to hard-to-reach locations to get fantastic scenery!

Sunlight

In Vue, sunlight is really a combination of two types of lighting. The one you see in your OpenGL views is a directional light with some special attributes. By default, no matter where you position this sun, the light will always be directed at the camera. You can see this when you move the position of the sun in one of your orthogonal views. The arrow will always point to the camera. You can also control the directional light that is from the sun through the Atmosphere Editor or by selecting and right-clicking on the Sunlight object in the World Browser and selecting "Edit Object" from the dropdown menu.

Ambient lighting is the other type of light that illuminates your scene. It isn't an object you can see or manipulate like the sun, but is a characteristic of the atmosphere.

Atmosphere

In addition to the sunlight and ambient lighting, a Vue atmosphere contains clouds, fog and haze, wind, and the sky. Different atmosphere settings can dramatically affect the look of the image you're creating, but you can only see it in a rendered image. To get an idea of how it will look when rendered, you can use the camera preview pane, which shows a low-quality render, or you can render a larger preview.

When you open a new scene, Vue starts with a preloaded default atmosphere that has a lot of haze and ambient lighting, making it useful for setting up a scene. Vue comes with a large number of preset atmospheres that you can load, but you can also create your own or tweak an existing atmosphere in the Atmosphere Editor. However, adding a different atmosphere to your scene should be one of the last things you do, since it can obscure the objects you're working with and slows down preview renders by quite a bit at times.

Basic Render Settings

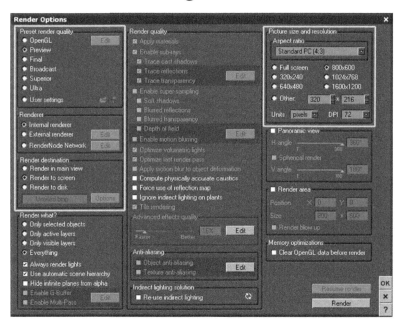

As you're working on your scene, you'll find yourself needing to see more detail than the OpenGL views or the camera preview can show you. You can do this by rendering a preview-quality image.

To access the render settings, right-click on the Camera icon located on the far right of the top toolbar. A Render Options menu will appear. There are some basic settings that you will need to know. Preset Render Quality is in the top left. Choosing one of these presets will make automatic selections of the render-quality options in the middle of the menu. For working with your image, you'll probably want to work with the preview-quality or final-quality renders. Which one you choose may depend on your computer speed. Broadcast quality will probably give you a render good enough for television, but for film and printing you'll need a higher-quality render.

Under the Preset Render Quality group is the section for choosing how and where you'll render your image. For previewing you'll just use the internal renderer, which renders using the Vue application. In Render Destination you can choose to render your image in the main camera view, but this has the disadvantage of limiting the size of the image. Selecting the Render to Screen option will cause a new window to appear where your image will render.

The size of your image is controlled in the Picture Size and Resolution section. The Aspect Ratio controls the width-to-height ratio of your image and should be appropriately set from the very beginning. Clicking on the dropdown menu will bring up quite an extensive and self-explanatory list. Once you have your aspect ratio, you'll be able to choose several different sizes. Of course, size will affect render times. A good working size is about 640 × 480 (if you're using the Standard PC ratio). Selecting Free (User Defined) will allow you to change the ratio in the other options.

Polygon Counts

As you add more and more objects to your scene, you'll increase the number of polygons that Vue has to deal with. You can see your object and polygon counts in the lower right corner of the Vue interface. Clicking on the arrow next to the polygon count reveals that you can also see how many free resources you have. This refers to how much memory Vue has to work with and is where the performance of your computer matters. The more RAM you have and the faster your processor(s), the more polygons you'll be able to handle. A polygon count that is too high could cause the Vue application to get hung up on the calculations and become very slow or even stop responding in the middle of your work. During work, this is generally a problem of viewing the work through OpenGL. You can set a maximum number of polygons that will be shown in the OpenGL views. After this maximum number, new objects may appear as boxes within your scene. While this is a rough fix, remember also that polygon count will affect render times. If the computer had a hard time handling polygon count in simple OpenGL viewing, render times could be pretty long, even several days.

Saving Your Work

And now, a final word as you embark on your creative ventures in Vue: *Always, always save your work on a regular basis*. This is really true of any kind of work you do on a computer. Every time you think, "Wow, that's cool!" save your work. Every time you've finally gotten a detail right, save your work. If you're about to add an element you're not sure of, save your work. Every time you stand up to stretch, get a drink, or go cross-eyed, save your work!

Vue, especially in the latest 7 release, is stable under most configurations. If you do find the application crashing a lot, you may want to review any compatibility issues with both software and hardware. Generally, it is better to have saved and never crashed than to have not saved and crashed just once. That one time is most likely to happen when you're farther along and have more to lose.

Tutorial 2: Singularity

In this tutorial, you'll create an interesting mirrored starscape with only the four elements that are part of the Vue start-up scene. You'll be applying a material to the ground plane and loading an atmosphere from the tutorials pack to achieve the effect. The unusual arrangement will give you an inkling of the fantastic possibilities of Vue's atmospheres and materials.

Step 1

Start a new scene in Vue. Now you'll see a scene with the basic elements. In the World Browser on the lower right, select "Ground." For the purpose of this tutorial, we want a very reflective surface. Go to the Aspect tab of the Object Properties Panel in the upper right corner. There are a couple of ways to load a material. In the lower left of the Aspect tab, you can click on the Load Material icon. Or, you can right-click on the preview pane, which should be showing a sphere with the default material applied, and then select "Load a Material."

Step 2

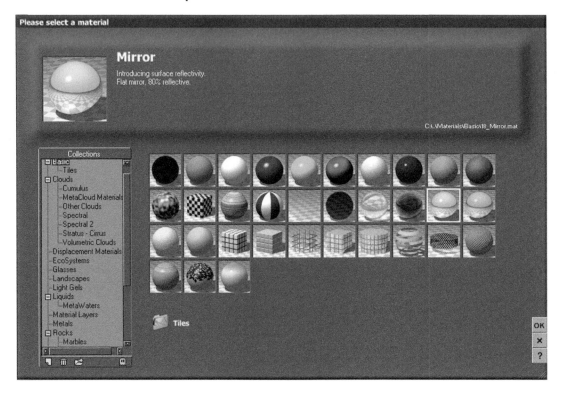

A material browser will appear. Under Collections, select "Basic." From this set of materials, choose "Mirror." There are several other materials that have reflective surfaces, but this one offers the truest color and no distortions in its reflection. Press "OK."

Step 3

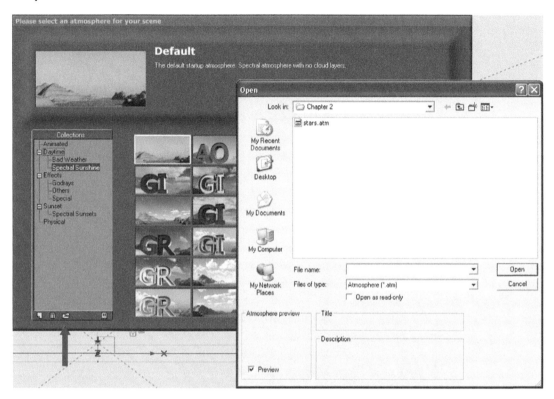

Now you'll add a starry sky. The atmosphere you want is in the tutorials pack that you can download from the book's web site, at *www.vuefromthegroundup .com*. Make sure you have that in your drive before you continue. Once you're ready, select the Atmosphere > Load Atmosphere option in the top menu. An atmosphere browser will appear. To choose an atmosphere that isn't in the Vue files, select the file with the arrow at the bottom of the Collections menu in this browser. Find the path to the tutorials pack, and then select the "stars. atm" file, which will be found in the "Tutorial 2" directory.

Step 4

Right-click on the Camera icon in the far right of the top toolbar to pull up the Render Options menu. For this image, choose the Final render preset. Make your render destination Render to Screen. Now move to the Picture Size and Resolution section in the upper right corner. The default Standard PC is just fine. If you intend to print this picture, change the units to inches and make your DPI (dots per inch) 300 or larger. This is only to help in calculating the pixels, as this information will not be embedded in the picture file. Otherwise, 800 × 600 pixels will work. Click on the Render button in the lower right corner. To print, save the rendered image either with the Save Disk icon in the render window or the Save Color Picture icon in the top toolbar, and proceed with the file from there.

Terrains

To build your landscape, the first thing you need to do is create ground by adding a terrain. Think of the ground in your scene as the foundation of your creation. If it doesn't work well, the rest of your scene will suffer. You might be able to pull off an acceptable piece of art by covering up flaws using textures or objects, but ultimately you'll be dealing with an image that is contrived. Even if you're creating low-detailed animation, such as for cartoons, the basic shapes should remain a good representation.

It's important that you have a basic grasp of geology to create lands that are authentic. The kinds of reference photos that the Vue artist needs are not just vistas of rolling plains or majestic mountains, but are elevation maps and the results of aerial photography and satellite imagery. Two excellent resources for referencing these are the United States Geological Survey (USGS) seamless map server and Google Earth. The USGS server is also where you'll be able to retrieve data to recreate geological features found on Earth. Spend a lot of time browsing through these resources so that you can get an innate grasp of what land looks like. You'll not only become educated, you'll be inspired by the wonders of the planet.

This chapter will cover the many tools Vue has for you and the real-world geology you need to know to use them. You'll be able to build lands realistic

enough that your audience will feel as if a photograph has been taken of a real place, even if it is on an alien world.

Terrain Types

There are two types of terrain objects to work with in Vue: heightfield and procedural. Heightfield terrains, called standard terrains in Vue 6 and previous versions, are generated by an elevation map, while procedural terrains are created using a fractal procedure.

To create a heightfield terrain, click on the Mountain icon, the fourth one down on your left toolbar. The terrain will appear in your views as a red wireframe, since it will automatically be selected on creation. The elevation map of a heightfield terrain has a set resolution. This means that no matter how close your camera is to the terrain, there is only a certain amount of detail that you can achieve. Also, larger renders with heightfield terrains may have artifacts of lower resolution such as angled edges. You can alter the resolution in the Terrain Editor (explained later) to adapt to a closer view or a larger scale.

The advantage of heightfield terrains is that they take up less memory and are faster to render than procedural terrains. Putting heightfield terrains in your backgrounds that are relatively distant from the camera is a great way to reduce render times. Also, if you are creating a static shot, it is possible for you hike up the resolution enough that this kind of terrain will work fine.

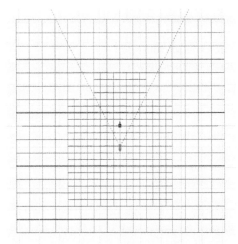

This top view of terrain wireframes shows a procedural terrain on the left and a standard heightfield terrain on the right. You'll notice that the graphing gets finer closer to the camera, showing an increase in detail for the procedural terrain. The closer the camera, the more detail is created. This is different from the heightfield terrain, where the detail is locked to the resolution.

Generally, procedural terrains will offer you an advantage for image quality, even if it comes at a cost of render time. You can add a procedural terrain by clicking on the Mountain icon with the f symbol on it. The f stands for fractal. The geometry of a procedural terrain is recalculated using fractal equations every time the camera changes position. This means that the closer your camera is to the terrain, the more detail it can pick up. These are the kinds of terrains you should be using whenever you have the camera moving and your terrains are visible.

Infinite Procedural Terrains

Right-clicking on the Procedural Terrain icon will enable you to browse through several preset terrains, including the infinite procedural terrains. Under default circumstances, these aren't actually infinite, but their length and width extend out by 200 kilometers. This is beyond the perceived horizon, and so it offers you a full landscape without needing to worry about combining several terrains.

Terrain Editor

You can change the geometry of your terrains in the Terrain Editor. To open this editor, you can double-click on an existing terrain, or right-click on it to bring in the dropdown menu where you will select "Edit Object." You can also right-click on the Heightfield Terrain icon to create your terrain in the Terrain Editor before you add it to the scene.

The Terrain Editor is organized with toolbars and panels around a visual preview of the terrain. You can rotate the terrain for better viewing by holding

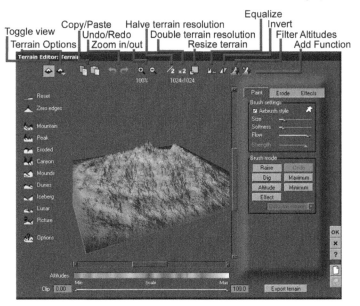

down your right mouse button and pulling the terrain around its up axis. If you do it fast enough, you might set the terrain to spinning. Simply right-clicking on it again will stop it. The left mouse button acts as the painting tool.

Terrain Editor Toolbars

The top bar contains common options such as copy/paste, undo/redo, and zoom, as well as a few specialized operations. To the right of the zoom options are the resolution and resizing options. Since the heightfield terrain is set in its resolution (by default this is 256 × 256), the only way you can increase the detail is to increase the resolution. It is also a good idea to edit your terrains while they have a higher resolution. You can reduce it later if necessary for use in your scene. Keep in mind that if you do change it, Vue may remember this setting in the future even if you restart the application.

During editing, you might happen to change the height to be lower or higher than the standard heights. The Equalize button will bring the terrain's height back into that 0–100 range if you need it. The Invert button will cause the highest elevations to become the lowest, and the lowest to be the highest. The Filter Altitudes and Add Function buttons will be explained later in this chapter.

In the left toolbar are tools that let you change your whole terrain at the push of a button. The Reset option will clear out all the altitudes. Zero Edges will pull the edges of your terrain down so that the altitude is, logically enough, zero at the edges. Under these two options are several terrain presets. Clicking on them will not clear out any terrain altitudes that are already there, but will add and subtract to get a terrain that is a combination of the old and new. You can get great effects using this, but if that isn't what you want, simply click on the Reset button first.

Under the presets are two powerful options that you'll learn about later in this chapter. Clicking on the Picture icon will open a menu that will enable you to import image data. Below that is the Options icon that opens up a menu where you'll be able to modify the algorithm used to generate the terrain. These are only useful when you're working with a heightfield terrain. Procedural terrains have their own powerful options, which will be discussed later.

At the bottom of the Terrain Editor is the color legend for your altitudes, representing minimum and maximum. There is no numeric value to them since, depending on how the elevation data are represented, these values could be different. Under that is the clipping tool. The sliders will clip off any terrain below or above them. Clipping off the bottom part of your terrain will let you get rid of the unnatural-looking square base. It can also be used to create custom rocks or geological features.

For heightfield terrains, the side panel contains three tabs: Paint, Erode, and Effects. If you're working with a procedural terrain, there is a fourth Procedural tab. You'll find these to be powerful tools to create your own terrains.

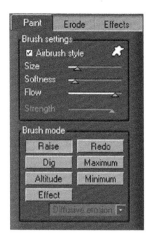

Paint Tab

The Paint tab gives you command of the paint tool. In the Brush Settings box you control the size, shape, and strength of the paint brush. In the default Raise mode, the brush basically paints height onto the terrain. Enabling Airbrush style will let you grow the terrain where you're holding the brush. Otherwise, the terrain will be heightened a set amount, depending on the Strength setting in the panel. The shape of the brush defines the area that is heightened. You can control your brush shape with the Brush Shape icon, affectionately known as the "blob" icon in the top right corner. Toggling it will turn the button orange and enable whatever shape was last loaded. Right-clicking will pull up a browser where you can load a brush shape.

There are several other modes you can paint with, available in the Brush Mode box. The Dig mode of the brush will let you take away height. Altitude will bring everything up or down to a specified height that you can set in the Brush Settings box. Likewise, Maximum and Minimum will bring the terrain to those heights. Using the Undo mode will only affect the most recent brush action you made. Effects lets you paint on all the erosion and effects that are available in those two tabs.

You'll find that some effects, such as wind and cracks, work in only one direction. In order to change the direction these apply, you'll need to rotate the terrain in a two-dimensional (2D) application. This is where the copy/paste function is useful. Simply click the Copy button, go into your favorite 2D software, and

paste it into a new file of the same size. Rotate the image (it will only work well in 90° increments), copy it from the 2D application, and then back in the Terrain Editor paste it. Of course, you can see that the paste option offers you more than just rotating a terrain you're working with. You'll be able to create your own terrain maps in your 2D application and quickly apply them to a Vue terrain.

Erode Tab

Using the effects in the Erode tab should be more than just making cool-looking land. A solid understanding of how erosion works will help you create a piece of earth that looks like it has been through ages of different climates. Rocks and land masses are subject to several different kinds of erosion.

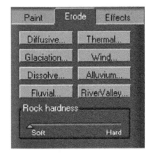

Diffusive and River Valley

These are both effects meant to simulate more general erosion with multiple causes. River Valley is a new appearance in Vue 7, and shows the effects of glacial wearing and thermal erosion, creating soft slopes punctuated by interesting peaks. This operation works more slowly than the other erosions, needing a long enough processing time that it isn't practical to hold the button down. Diffusive erosion in Vue is the result of vegetal and grazing processes, as well as others. It softens all features of the terrain.

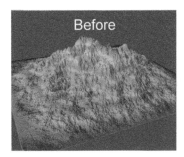
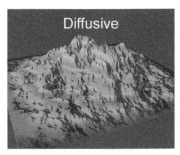
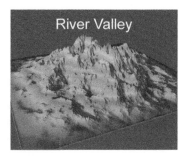

Standard heightfield terrain before, with Diffusive, and with River Valley erosion.

Thermal

Heating and cooling can cause several things to happen. Rock will expand under heat and then contract. This action can create cracks in the rock. Water then can get into these cracks and freeze, breaking apart the rock even further. Temperature extremes are common on mountaintops, so this is a major type of erosion there. As the rock debris breaks off, it falls down the mountainside into piles of sharp debris called scree. The remaining rock in the mountains can become rounded, though the sides will remain steep.

You can get this effect using Vue's Thermal erosion. The immediate effect of pressing the button will be a rounding out of most detail, with some sharp features remaining, and a growth of gentle slopes at the base of steep inclines. Continuing to press it will grow the slopes in bulk, but they'll soon stop extending out from the land mass. The Rock Hardness slider, in this case, doesn't actually refer to rock hardness. Thought of that way, it is geologically inaccurate. Instead, it controls the steepness of the scree slopes, with the hard setting giving you steeper scree slopes.

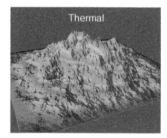

Same terrain from the previous figure, with Thermal erosion.

Glaciation

Glaciers eat away at the land. Troughs and valleys become deeper, wider, and more polished as the ice scrapes along the sides. The longer a glacier is in action, the steeper slopes become, leaving the tops of mountains usually untouched. Glaciation will achieve the effect shown in the following figure, with the softness of the rock speeding up this process.

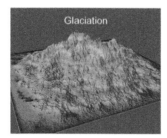

Wind

As wind blows, it picks up sand and dirt. These particles blast rock formations, eroding them down, often on only one side. Vue applies wind this way, with it blowing from left to right. If you want the wind erosion to occur on other sides of your terrain, you'll need to use the copy/paste method described earlier in the chapter. There are other limits to Vue's wind effects. Often, real wind can only lift abrasive material a relatively short distance from the ground, and therefore carve out only the lower elevations of a structure. Also, the softness of the rock can be variable across layers. This is how you get interesting features such as arches and other natural rock sculptures. However, the Vue effect will apply universally to all elevations with the same rock hardness everywhere. Still, combining terrains and rocks, and a few interesting techniques with terrain modeling, you can easily create your own.

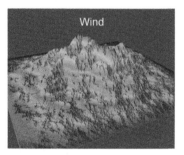

Dissolve, Fluvial, and Alluvium

It is useful to combine the three water-type erosions for this explanation. To get the best results for water erosion in Vue, it can help to use more than one of these effects. In Dissolve, rainwater seeps into the ground and eats away at it before it makes its way to the surface at lower elevations, producing streams. Fluvial erosion has water flowing down the surface of the land, gathering in larger streams, which create fewer but more prominent grooves than Dissolve. Alluvium shows the results of the land washing away: parts of the land are built up as the rocks and soil are deposited along the way, slowing down the water and creating shallower and wider waterways.

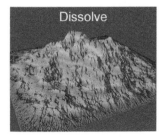
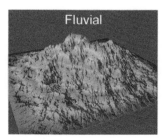
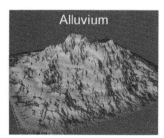

These erosions tend to apply in similar paths. Therefore, if you'd like to see some of the deep grooves of fluvial erosion coupled with the sedimentation of Alluvium, you can alternate between them until you get the look you want.

Effects Tab

The Effects tab gives you other things you may want to add to a landscape, such as stones, terraces, or even trees. Some of these effects are intended for long distances, but used well can help you add great-looking detail even for close-ups.

Like the Erode tab, holding down the button will develop the effect further. Growing the effect too much, however, will result in sharp, pixilated features that don't resemble anything natural. Some of them grow quite fast, so it's a good idea to experiment and get a feel for how they work.

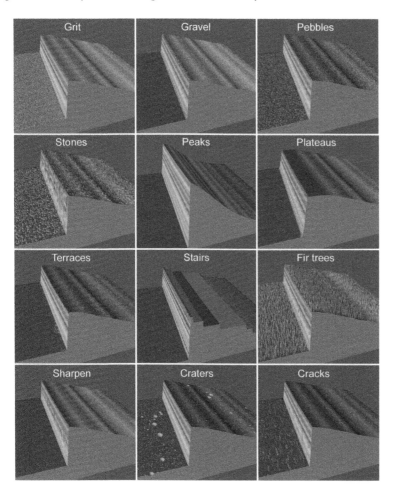

The first group of effects deals with rubble in different scales. Both Grit and Gravel add little pits and bumps all over the terrain, although grit is finer. Also, there is a very slight difference in how they apply to the terrain. Gravel goes mostly on slopes while grit applies mostly on flat surfaces, although enough of either will apply all over and become spikey. Pebbles and Stones are random, irregular bumps that grow into pillars if the button is held down too long.

The next effects give you certain features, human-made or natural, that might be part of a landscape. Peaks pull down lower elevations and exaggerate higher ones to create peaks. Plateaus will create flat areas at the highest elevations. Terraces are relatively small scale and work almost like the Erode option, adding plateaulike effects on peaks while diffusing into flat terraced areas on slopes and growing these out at the base of steep slopes. Applied well, this option can make nice beaches. Stairs simply "digitize" the slope.

The last group has some miscellaneous effects. Fir trees are great for getting that fringe of trees visible at a distance on mountains. Craters give you a nice lunar or primitive earth appearance. The Sharpen effect will increase the steepness of slopes, while leaving less-steep slopes alone. Depending on the terrain you already have, this could bring out some extra detail or noise. Cracks work better as an effect of fault or stress lines, since they only run in one direction. If you want a radial effect with cracks, both the Dissolve and Fluvial erosions in Vue work better.

Editing Heightfield Terrains

If you're working with a standard heightfield terrain, you have different ways to control your terrain, as well as a couple of tools that approximate what you can do with procedural terrains (described in later sections). In the left toolbar are the Picture and the Options buttons. In the top toolbar are the Filter Altitudes and Add Function buttons.

Importing Terrains

When you click on the Picture icon, this brings up the Import Terrain Data menu. Here, you'll see two previews: the existing terrain and the picture preview. Under the picture preview, you can load an image. You'll find that any image you use will automatically be fit to the square, and will convert to black and white. The range from black to white is a visual representation of the range of altitude, which is -1 to $+1$. Black represents the minimum altitude (-1) and white is the maximum altitude $(+1)$. If needed, you can invert the colors of the picture by pressing on the white circle icon at the upper right of the picture preview.

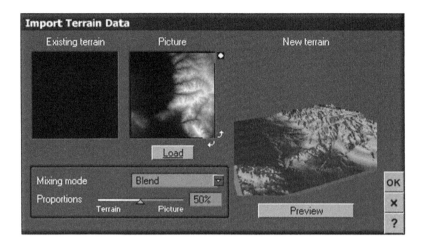

Once you've loaded a picture, you can choose to see only your picture or you can blend the existing terrain with the picture in a number of different modes. Blending is typically the most useful and most common.

Importing image data in this way not only enables you to create unusual features but also is a tool for importing terrains from other terrain-creation software, such as GeoControl, or using terrain elevation data to recreate lands that exist in reality. The best kinds of files to use for this are typically TGA, TIFF, JPG, or Digital Elevation Map (DEM).

How to Obtain Digital Elevation Maps

DEMs are digital representations of land topography. If you want to reproduce a real location, you'll need a DEM. The problem is that easily obtained land topography data aren't usually available as a DEM, but must be converted from other file types. You can get these for free from the National Seamless Map Server of the USGS found at *seamless.usgs.gov/*. These data come in varying resolutions. The highest are only available for land within the United States. Even there, several mountainous or desert areas are lacking in the higher-quality data. (I know, the mountains are probably exactly what you're looking for.) You can also find lower-resolution models of all land masses on Earth except Antarctica. There are other sources for land topography data such as DEMs with high qualities, but these are usually cost prohibitive for anyone but governments or large corporations.

Learning to use the USGS National Seamless Map Server doesn't take very long, but you'll find out that it is fairly slow to respond when you're trying to navigate to the area you want a model of. A tutorial is available on this book's web site, but the thing to take away is that you'll want to get your data from the USGS in the format of a geoTIFF.

There is also a good resource for higher-resolution land topography in Canada at *www.geobase.ca*. Happily, these files are provided in the DEM format usable for Vue, although sometimes a low resolution of the topography results in seeing mapping artifacts in the terrain model.

If you aren't lucky enough to be looking for Canadian landscapes, there are also several free programs to convert your files. The one most widely used, probably because of its simple and visual interface, is 3DEM. You can find this freeware at the 3DEM web site, *www.visualizationsoftware.com/3dem.html*. A tutorial on how to use this software is also available on the web site. For Macs, a similar piece of software called MacDEM can be found at *www.treeswallow .com/macdem/*.

Import Digital Elevation Maps as Image Data or Objects?

Once you have a file with a .dem extension, the question is how to import it into Vue. Do not use the Import Terrain Data dialog in the Terrain Editor and load the DEM as an image. The problem is that the altitudes will remain the same while the size of the model is forced into a smaller and perfect square unless you've adjusted for the size that it should be. This will deform the terrain so you get things like tall peaks where there were only hillocks. Even if you adjust the size, there is often a deformation due to fitting the altitudes into the maximum and minimum of the heightfield terrain.

The best way is to import your terrain directly as an object. To accomplish this, go to File > Import Object. This will open a browser into your files, where you can then retrieve the DEM. Once you've selected the DEM, an Import Options dialog will appear; for now, it is okay to keep everything at default. Then, a Terrain Offset dialog will appear, telling you that the terrain is very far from the center of the world. You'll have the option to offset its placement by the necessary amount. Click "OK" on that. At that point, you should have a terrain that is of appropriate proportions, although it will be scaled down quite a bit.

Options

Selecting the Options button will open the Fractal Terrain Options dialog. Fractal Terrain Options lets you control the variables used to randomly generate new terrains. When you change the settings here, they will remain through the session, letting you create terrains with similar features. However, the filter settings will remain even when Vue has been restarted, so take care when starting new projects that everything is set at default here.

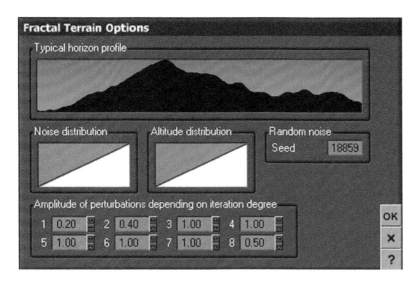

"Typical horizon profile" will give you an idea of what your terrain may look like. When working with noise distribution, this isn't always an accurate portrayal. Noise distribution is a semi-useful filter that changes the values used in the iteration steps for "Amplitude of perturbation..." described below. The horizontal bar represents the original number, and the vertical ruler is the number it will be changed into. See chapter 9 regarding how filters work.

Altitude distribution works the same way to convert numbers, but these values are directly related to the elevations. The profile of the filter will give you an idea of how the terrain will turn out. You can see the effect in the horizon profile preview.

The shape of terrains is generated by a randomly chosen number that drives the equation, seen in Random noise. Once the number has been selected, there is no variation involved. Every time you click on Options, it will pick a new number, and the terrain will be generated again once you've clicked "OK." This means you can actually pick a terrain, but unfortunately there is no real way to determine the seed of a terrain you liked, unless you recorded the number in the Options dialog before you clicked "OK."

Unless you're a math major, "Amplitude of perturbation depending on iteration degree" might just make you want to run away from this tool and never look back. A little explanation and experimentation can go a long way, however, and you'll find that this gives you control over your terrain in ways that no other tool can. You'll be able to create a terrain with certain features, like having large rolling hills or craggy mountains, while maintaining randomness.

First, let's break down that label. Amplitude can be understood as the range between the minimum and maximum height of a wave, or a perturbation. You can think of these perturbations as bumps in your terrain. Iterative means that a process will be cycled over and over again with the results of the process

being considered in the next cycle. Each degree of iteration adds narrower and narrower perturbations. One thing to take into consideration is that extreme values, over three, can generate artifacts such as sharp, polygonal angles. Even smaller ones can do this too, so rendering a big enough preview is a good idea. Remember to make a note of the random noise seed when exiting the Fractal Terrain Options dialog so that, if you like the resulting terrain, you can keep it. The default settings for this can be found in the previous figure.

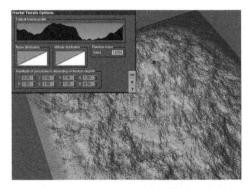 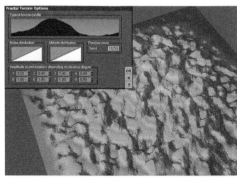

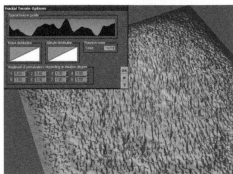 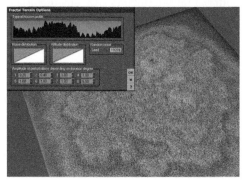

The top left corner image shows the "Amplitude of perturbation depending on iteration degree" at its default settings. With the same terrain seed, the top right has the fourth iteration degree increased to extreme, leaving the other values at default. The lower images show increases in the sixth and eighth iterations. This demonstrates how increasing each of the iteration degrees will increase the appearance of details of specified sizes.

Adding Functions to Heightfield Terrains

To the far right of the top toolbar in the Terrain Editor is an icon that lets you add a function to a standard heightfield terrain. In this new menu, you'll see a preview pane like the one in the Procedural tab. This works very much like functions for procedural terrains, except that it is applied to the terrain in the editor and then not called again. Scale works more like you would be used to here, with the results appearing that the view is zooming out of an image

rather than changing the numbers of an equation. Amplitude refers to the intensity with which the function will be applied. The higher the amplitude, the taller and noisier the features will be.

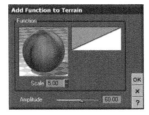

To see how your terrain will look, you'll need to click "OK." These functions do not regenerate a new terrain from scratch, but instead combine the terrain before and after the function was added. If you're hoping only to make adjustments to a function you've created, remember to reset the terrain to zero so that only the new function is represented in the terrain.

Editing Procedural Terrains

If your terrain is procedural, you can alter it in the Procedural tab, shown in the following figure. The preview pane, with the sphere, in Altitude production shows you the function that drives the altitude. Double-clicking on it will bring up a browser where you can choose from several different functions. In Collections are Terrain Altitudes, which has several different landscapes for you to choose from.

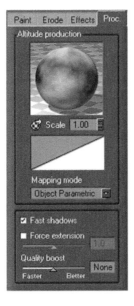

You can also change the function yourself by right-clicking on the preview pane. This will bring up a small menu with some standard options. Selecting "Edit Function" will open the Function Editor. To learn more about how to work here, see Chapter 9.

Under the function preview you'll be able to alter the scale. The scale here works a little differently from what you might be used to. Rather than working with the detail of your terrain as if you were zooming in or out, this changes how the fractal equation is mapped onto the terrain. The larger the scale, the bigger the features; the smaller the scale, the more detail will appear.

The filter is another way you can control the altitudes in your procedural terrain. Like the function preview, double-clicking will let you load several filters and right-clicking will bring up a menu of options. Filters work to change one number, usually from -1 to $+1$ and represented by the horizontal ruler, to another number in the same range, shown by the vertical ruler. You can learn more about filters and editing them in Chapter 9. In procedural terrains, these numbers don't directly describe height but determine the numbers used to generate height. It can take a bit of experimentation and becomes useful really only when you're familiar with the behavior of the function that is generating the terrain.

There are four different options under the Mapping mode. Object and World deal with whether the function will use the Object or the World Coordinate system to map the fractal equation against when generating the terrain. These have two modes, Standard and Parametric (though only Parametric will be labeled so), which describe how the function is mapped onto the terrain.

Object Parametric is the default mode for regular-size terrains, but World Parametric is used for infinite procedural terrains. It will cause the shape of the procedural terrain to remain the same no matter how you move or resize it. In Object Standard, moving the terrain around will not alter it, but changing its size will have the same effect as changing the scale. If the Mapping mode is set to World Standard, then moving or resizing the terrain will act as if you're moving or resizing a window onto different parts of the function. This changes what part of the function maps out the terrain and the scale. World Parametric acts similarly since the World Coordinate system remains constant.

When changing the Mapping mode for procedural terrains, it is important to know that this is accomplished by adding nodes to the Altitude function. These nodes aren't removed when a change is made, so if you change this several times, then it could slow down the generation of the terrain. A message will pop up asking you if you'd like to add a node to maintain the geometry. Select "yes" only if you must maintain the current geometry; otherwise,

select "no." It is a good idea to change the Mapping mode before you alter the function so that you can do so without the extra nodes.

A few other options exist for procedural terrains that don't have to do with the altitude of your terrain. Fast Shadows deals with a computation that allows a quick algorithm to map the shadow. Usually this works well, but in case it doesn't, you can toggle this off. You'll get a better shadow at the cost of slower rendering speed. Force Extension will change the range of altitudes used to calculate the topography of the terrain. To see the effect of this, you'll need to look at them in the OpenGL views. This setting rarely gives you any advantage over Vue's automatic determination of the best settings for force extension, so it is better to keep it off. Quality Boost lets you change the precision of how the terrain is rendered. However, not as much benefit is received from this as an overall quality boost in rendering (see Chapter 18). Only use it if you've found an artifact of the terrain in a render at your finished quality.

Editing infinite procedural terrains can be quite tricky. This can only be accomplished through advanced techniques in the Function Editor, explained in Chapter 9.

Exporting Terrains

To export any terrain, you have two routes. Going through File > Export Object will only give you a few file types you can use, being limited to object-type files. However, terrains can also be exported in different terrain formats usable for other applications. To do this, double-click on the terrain object in the OpenGL views of Object Browser to open the Terrain Editor and click on the Export Terrain button at the bottom right of the editor. You'll have several more options, including being able to convert your terrain to image data. Vue will convert its data to bump and color maps that can be used by other three-dimensional (3D) applications. You also have the options to change the mesh resolution and generate material maps. If you've carefully created a material for your terrain to get the exact look you want, generating a material map for your terrain will preserve your hard work.

Tutorial 3: A Desert Landscape

In this tutorial, you'll be using some of the things learned to combine terrains together to create a striking scene of desert sand and plateaus. You'll be adding simple materials to create the look as well as an arid atmosphere.

Step 1

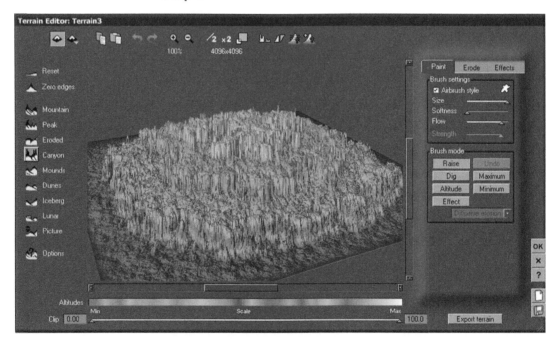

Open a new scene in Vue. Click on the Heightfield Terrain icon in the left toolbar to create a new terrain. Double-click on the terrain in the OpenGL, or right-click either in the OpenGL view or Object Browser and select "Edit Object" from the menu. In the Terrain Editor, click on the Reset button at the top of the left toolbar. Increase the resolution to 4096 × 4096. To gain the necessary extra detail, you need to increase resolution *before* you work on a terrain. If you do it after, then it will simply have the same low detail but with a higher resolution. Click on the Canyon icon in the Terrain Editor's left toolbar. Click "OK."

Step 2

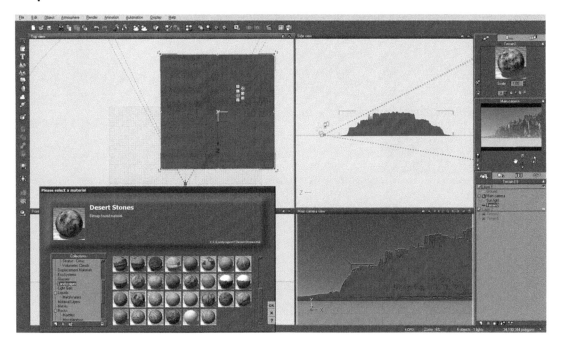

Resize your terrain, either using the size gizmo or the corner resizing dot. This will make it bigger while keeping the same proportions. It should be about two-thirds the size of the grid as shown in the OpenGL top view. If you want, you can also use the resizing dots in the middle of the edges to stretch out the terrain in only one direction. You could make it taller this way, working in the side or front views. Still in the top view, move the terrain so it is to the right of center and in front of the camera. In the Aspect tab, click on the Load Material icon; select "Landscapes > Desert Stones" from the material browser; and press "OK."

Step 3

Create another heightfield terrain. Stretch this one, using the middle sizing dots, so that it is about one-fifth the size of the grid. Move it so that it is all mostly in front of the camera, as in the screenshot. Load the "Rocks > Sand" material onto this terrain. You may want to adjust the camera, pointing it up a bit so that you can see the top of the canyon's terrain in the camera view.

Step 4

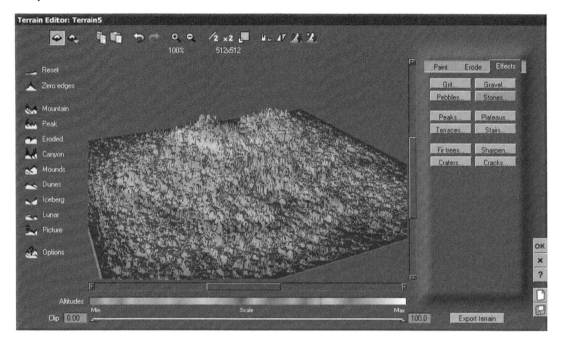

Create one more heightfield terrain. Double-click on it to open the Terrain Editor. Click on the Reset button, and then increase the resolution to 512 × 512. Make it a mountain again by clicking on the Mountain icon in the left toolbar. In the Effects tab click on the Stones button to easily create a tumble of rocks. If you don't like how that effect turned out, you can click the Undo button and try again. Also, the mountain generated by this will be different from the one in this tutorial. If you don't like the end result of this step, click on the Reset button again and try another mountain. Click "OK."

Step 5

Load the Desert Stones material onto this terrain. Resize the terrain with the size gizmo until it is only approximately 25 × 25 meters. Then make it a bit shorter by pushing it down along the up axis. Position it so that it is just to the left of center and is a few meters in front of the camera. Right-click on the Render button to bring up Render Options. Set the Aspect Ratio to Widescreen (16:10). Use previews liberally here as you adjust positions and the camera to get a composition you're satisfied with.

Step 6

For the finishing touch, you'll need the "Hot and Arid" atmosphere that was created for this tutorial. You can find it in the tutorial pack from the book's web site. Once you have it downloaded, click on Atmosphere > Load Atmosphere in the top menu bar. In the atmosphere browser, you'll find the Load icon, a file and arrow, under the Collections list. Click on this, and then browse for the "hotarid.atm" file that you downloaded. Once it is loaded, you're ready for your final render. Go back into the Render Options interface and change the preset render quality to Final or above and choose the resolution you want. Click on the Render button.

Waterscapes

Water has always been a part of the beautiful scenery in Vue. It is usually added into a scene with an infinite water plane. In the past, the only way to manipulate the look of the water was through complicated mechanisms in the Material Editor. In the latest version, Vue has introduced Water Surface Options. This gives you several useful settings by which you can create authentic-looking bodies of water.

One of the first steps to doing this is finding out how real water acts under different conditions. Get pictures, visit lakes or the ocean, and spend some time staring at waves or the shore. Take videos of it. Swim in it! Then look at other pictures and videos of water and oceans. While you're immersing yourself, do some creative work on Vue.

Water Surface Options

At the top of the left toolbar is the Infinite Planes button. Click and hold it until the three available options appear. The icon with little dots under it is the infinite water plane. When you select the water plane, it will appear a meter above the ground plane. Any terrains or other objects you may have added

into the scene before will be partially covered by the water. You can easily adjust the level of water with the position gizmo. Once you've added this to your scene, double-click or right-click and then select "Edit Object." This will open the new Water Surface Options interface.

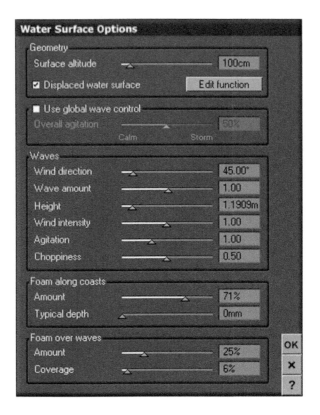

Geometry

In the box dealing with geometry is a slider for surface altitude. This deals with how high the water is above zero in the up axis, which is usually where the ground plane is. You can also change this in the Numerics tab or by changing its position in the OpenGL views, but this offers a convenient tool while working with water in the scene.

Here you can enable Displaced Water Surface. This option will have a huge effect on the appearance of your water. Without displacement, the water plane is completely flat. The appearance of waves is achieved by materials with areas of shadowing to simulate depth. When you enable displacement,

the actual geometry of the plane will have waves in it. Shadows and areas of reflection will be achieved by real interaction with light sources.

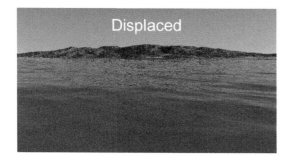
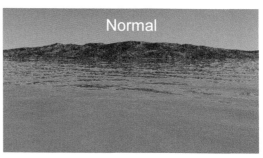

The appearance of waves on the right is achieved by darkened areas simulating shadows achieved with depth. The one on the left actually has the shape of the waves in its geometry.

A water surface that is displaced looks superior to one that isn't, but it does increase the amount of computation. If you're adding a body of water that will be far away from the camera, you may have something to gain by leaving it as only a flat, textured surface.

Waves

When working with waves, Global Wave Control gives you the option to control them with one simple slider plus wind direction. It is important to keep in mind that the wind direction in water options is not connected to the wind direction or wind intensity of plants nor is it connected to the wind options in the Atmosphere Editor (see Chapter 11). If you are going to have a windy scene with both water and plants, take care to make sure that these variables match up. One other wind variable to remember is the direction the clouds are moving, also accessed through the Atmosphere Editor.

If you're going for a very specific look, you can disable Global Wave Control to work with several settings. Most of these are fairly self-explanatory. To see how your settings affect the scene, you can click on the main camera preview or the water in one of the OpenGL views. Clicking elsewhere will hide the interface. The sliders give you an idea of what numbers are reasonable for these settings. However, it is possible to type in different values.

While creating the look of your water, take into consideration the environment it is a part of. In particular, how big is the terrain? If you have waves that are too large, especially with displacement, they may look odd in relation to the terrain and other elements you'll have in your scene. You probably don't want things to look like you've taken a picture of a toy boat in the real ocean.

Foam

Foam is one of the new effects that have been made available in Vue 7. The option gives you the ability to add a white, frothy texture along coasts and with waves. Foam in real life is caused in three ways, all of them related.

When the wind blows hard enough, at least 6 meters per second, the surface of the water is agitated enough that bubbles form, much like they would in a blender. At the shorelines there are hard land surfaces to break against. This causes agitation more intense than farther out in the ocean, and so there tends to be quite a bit more foam. Impurities in the water, usually from organic causes, can also create bubbles, which have a stronger surface tension and so last longer. On the open sea, these can be pulled under and then brought back up along shorelines by water currents. This creates even more foam along the shorelines. This chemical effect can vary a lot depending on the season and weather. Foam along coasts partially depends on how much turbulence occurs as the water crashes against the land. The deeper the water, the less turbulence there is.

In Vue, when a terrain or object meets the water plane, this creates a shoreline where foam is automatically generated using a function. You can control this in the Foam Along Coasts box. As well as specifying the amount, you can determine how deep, or rather how shallow, the water should be before foam forms. If you have a nice, sloping landmass, this setting will roughly affect how far out from the coast it goes. In Vue 7, the depth that foam is generated at is measured from any surface that is below it, including the ground plane. If you find you have too much foam over your whole water surface, but have your foam over waves set low, check the depth of your foam in relation to where the ground plane is.

Foam over waves also has a setting for amount and one for coverage. If you have the amount set low, but a high coverage, you'll get an overall sparse amount of foam. If you use a high amount with low coverage, you'll get white splotches of foam appearing at the tips of waves.

MetaWaters

MetaWaters are materials that have the functions in them to behave as has been described in this chapter, and in some cases take the simulation up a notch. You can change your water by right-clicking on your water plane and selecting "Change Material." This will bring up the material browser. In Liquids, you'll find a folder that has MetaWaters in it.

If you want a different kind of liquid to be your water than what is offered by the MetaWaters selections, you will lose the water surface effects unless you

apply it into one of the MetaWaters materials through the Function Editor. You can learn how to do this in Chapter 9.

Tutorial 4: Rocky Shores

This short tutorial will combine a terrain and a water plane to create a scene where the vastness of the ocean finally breaks on the shores of an unseen land. You'll change almost everything in the Water Surface Options interface to get the waves and foam looking just right.

Step 1

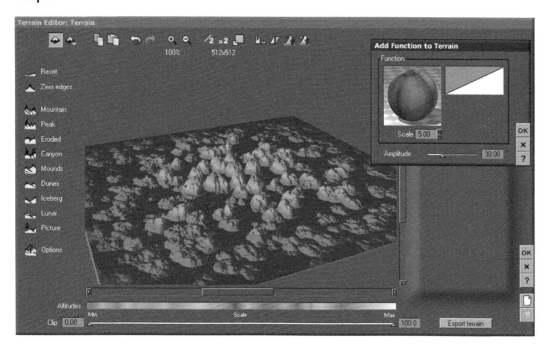

In a new scene in Vue, create a heightfield terrain. Open the Terrain Editor by double-clicking on the terrain. Click the Reset button and increase the resolution to 512 × 512. Click on the Add Function icon at the far right of the Terrain Editor's top toolbar. This will open the Add Function to Terrain interface. Right-click on the preview pane (the window with the sphere), and then select "Load Function." In the function browser, choose "Terrain Altitudes > Blurg"; reduce the Scale to 5; and click "OK." You don't want the abrupt edge clipping of the features, so click on Zero Edges in the left toolbar. Click "OK." Position the terrain so that it is in front of the camera and to the left.

Step 2

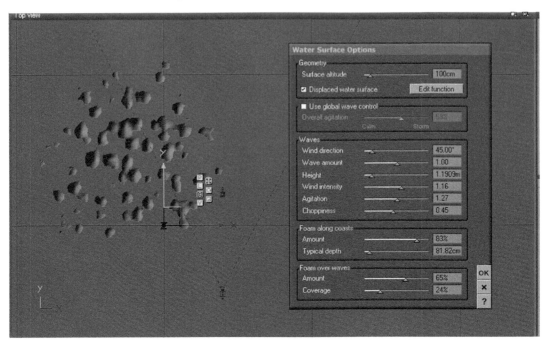

At the top of the left toolbar, click on the infinite plane, making sure to select the Water plane. Once this is present in the scene, double-click on it to open the Water Surface Options interface. First, enable Displaced Water Surface. Toggle off Use Global Wave Control. In the Waves group, change the Height to about 1.19 meters, increase the Wind Intensity to 1.16, the Agitation should be set at 1.27, the Choppiness should be decreased to 0.45, and the Foam Along the Coasts should have an amount of 83% and a Typical Depth of 81.82 centimeters. Decreasing the depth will increase the appearance of foam as the water becomes shallower. Also, increase the Foam Over Waves with an Amount of 65% and Coverage of 24%. Press "OK."

Step 3

Click on Atmosphere $>$ Load Atmosphere. Choose your own or use the Waterscape atmosphere ("waterscape.atm") provided with the supporting files on the book's web site. Right-click on the Render icon. In Render Options, change your Aspect Ratio to Widescreen (16:10). Choose the render quality you want, select "Render to screen," choose the size you need, and click on the Render button.

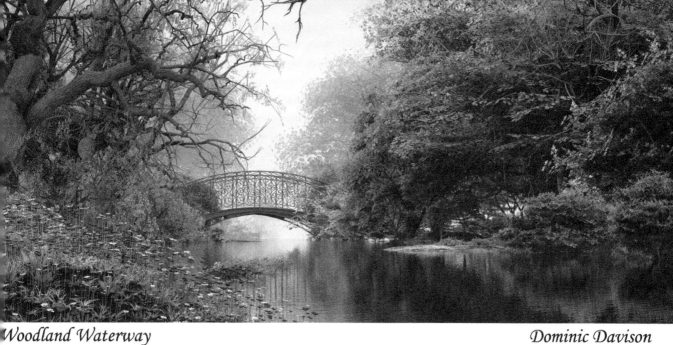

Woodland Waterway *Dominic Davison*

Plants

From soil and water come plants, which dress the land and evoke emotions. Vue has developed SolidGrowth™, a powerful technology that generates a unique individual of the selected species every time a new plant is added.

SolidGrowth works by having some of the characteristics of the plant be constant, while others are variable within ranges that can be controlled using the Plant Editor. Also, once in the scene, the plants can react to wind and breezes. A SolidGrowth species of plant is one with the same constant and variable settings. The basic structure of SolidGrowth plants can't be changed. However, many species can be created from those base structures. As a result, it can be said that plants coming from these base structures are members of a family of species.

You can create a plant by clicking on the Plant icon in the left toolbar. If you've not yet added a plant into any scene, one will be randomly chosen for you. Vue 7 has a lot of species of plants, more than ever before. To choose which species you want, right-click on the Plant icon to bring up the browser. There are several different plant collections where you're likely to find something to fit your needs. However, if you need something else, Vue's Plant Editor gives

you a powerful ability to create your own plants using their SolidGrowth technology.

When you're adding a plant into the scene, keep the scale in mind. Many of the plants are created at a much larger scale than the default terrains. For instance, a cherry tree is taller than the mountains in a Vue terrain. This has its advantages. It is easier to maintain quality in a model when making something smaller rather than trying to enlarge it. Many times, you'll be working with terrains that are much larger than the default. Just make sure that the scale of the plant matches the land.

If the plant is selected, you'll also notice a circle with a blue triangle next to the plant in the top view. This controls the wind. Grab the triangle with your mouse and pull it. Wind intensity is controlled by how far the triangle is from the circle. This actually refers to how much the plant will be deformed or bent by the wind. If it is animated, this will speak to how much the plant moves in the wind. Wind direction is naturally set by where you point the arrow. If you do nothing to the triangle, there will be no wind.

Note the blue wind arrow to the left of the tree. Its length determines intensity, and where it points is the wind direction. At the bottom left of the interface are number values for the intensity of wind and its direction in degrees. In this case, the wind intensity is 31.0 and direction is 147°.

Plant Editor

To get to the Plant Editor, right-click on your plant either in the OpenGL views or World Browser and select "Edit Object" from the dropdown menu. Alternately, you can double-click on the plant. Once you're in the Plant Editor, you can get an idea of the structure of your plant. Most plants have a combination of trunks, branches, leaves, and petals. Many have more than

one of these four elements. These are the things you'll be changing to make the plant your own creation.

The Plant Editor settings work with ranges of variables rather than a constant variable. This means that as you change something, like length in branches, then all individual plants generated by your new settings will have differing lengths of branches, but that variety is limited to being a bit shorter or longer than the value you set. This is part of Vue's SolidGrowth technology, so that you create boundaries within which individual plants can be generated with no two alike.

Top Toolbar

The top toolbar, like others, is devoted mostly to viewing, editing, and global effects tasks. You can change the view of the plant you see in the middle. The Plant Editor is unique of all the Vue editors in that it allows you to preview an actual render of the plant. This way, you can work with and tweak a plant without having to wait for a whole scene to render. If you want, you can even have the plant preview always rendered rather than in OpenGL. These options are found at the left of the top toolbar in the Plant Editor in two

buttons: Render Preview and Preview Options. If you have wind enabled on your plant, you can also choose to see the effect of that wind. This is not animated, so it can appear to simply deform your plant unless you know what you're looking at.

Since a new variation of the plant species is generated each time one is created, sometimes you'll get one that doesn't look very good for what you need. Just click on New Plant, and a different individual will be generated. Upon clicking "OK" in the editor, the new plant will replace the one you used to open the editor. Also, if you really like this plant as it is and think you might want to use it again, you can save it as a Vue object by clicking on Save Plant.

When you click on Response To Wind, you'll open up a dialog that allows you to change how the trunk and branches respond to wind, if it is enabled. This setting takes a bit of testing, but it can be useful. You may have wind set in your plants, but some of them may be more flexible and bend more than others. To get a rough idea of how this will affect your plant, you can enable Show Wind Effect in Preview Options.

Select Load Plant Species to open the plant browser and get a new species of plant. You may do this as you find that you can't alter that particular species to get the plant you want. If you do load a new plant, the name it had when you first added the plant into the scene will remain the same, so you may wish to change it in the World Browser. Once you've created a plant that you think looks great and you want to use again, you can save it with Save Plant Species.

The Undo and Redo icons work as they do in other parts of the program.

If you don't see all the plant after using the zoom options or moving the bar, you can select the Frame option. This will center and resize your plant so it just fills the screen.

Use the Refine and Simplify options to change how many polygons will be used in your plant. Vue 7 does a great job with smoothing out low-polygon artifacts, but if you're seeing angled steps as a branch tapers in your view, you can fix this by refining the plant. Refining the plant is always a good idea for close-up shots. Simplifying your plant will reduce your render times and is useful for plants in the background. This will not affect the resolution of the leaves, however. If you aren't happy with how the leaves look, you'll need to increase their resolution in a two-dimensional (2D) application (see the section on the Leaves/Petals panel later in this chapter for more information).

There is a default polygon count for each plant species base, so if you save a new plant species out of a plant you've refined or simplified, the new polygon count won't be saved. You'll have to change it every time you reload the plant.

The tree on the left has approximately double the number of polygons than the tree on the right.

Trunk/Branches Panel

Trunks, branches, and stems in Vue plants are basically irregular cylindrical objects that are shaped and set in a specific arrangement to look like plants. Some plants might have parts that aren't stemlike structures, but are the middles of flowers or fruit. Plants can have a lot of subsets, or sometimes when only leaves are used, they'll have none at all in the Trunk/Branches panel. Which subsets are included in your plant and how they are assembled is one of the things you cannot change. However, you can alter the bark or skin of the plant and several other settings. To choose which subset to use, select from the dropdown menu at the top of the Trunk/Branches panel.

Take a look at the trunks/branches panel in the Plant Editor screen shot. The preview pane under the subset menu shows which material is being used on the subset. If All Subsets is selected and there is more than one, you may see nothing if the materials are different. This preview pane works just like the one

in the Aspect tab. Directly under that, you can load a new material by clicking on the Load Material icon or work with the scale.

The settings underneath this offer lots of control over how your plant grows:

- *Length:* This controls how long the trunk or branch subset is. The setting for zero is the default setting that was set into the structure.
- *Falloff:* This refers to the length and how it applies to branches. You'll have a main branch with smaller ones forking off, with yet smaller ones branching from those, and so on. In real plants, the smallest branches are the youngest ones. Falloff controls the difference in how the length applies to the smallest branches compared to the main branch. When this value is zero, it means all the branches are affected the same. Negative values cause the larger "older" branches to increase in length faster, while positive values affect the smallest branches first. If you're working with a subset such as a carpel (the middle of a flower) or a fruit, you may not see much change from this setting.
- *Gnarl:* This creates curl in your branches or stems.
- *Diameter:* This increases how thick or thin your branches or stems are, as well as the middles of flowers.
- *Droop:* This refers to how the branch is affected by gravity. Higher values will cause the branches to bend to the ground, while ones lower than zero will cause them to reach toward the sky.
- *Angle:* This controls the angle that your branch grows from the next bigger branch, or how the trunk grows from the ground. The larger the number is, the more horizontal the branch will grow in relation to its parent branch, or in the case of the trunk, to the ground.

Leaves/Petals Panel

Leaves and petals of SolidGrowth plants are made from alpha planes (see Chapter 6) that have a hooking point where they join the tip of a stem or branch of the plant. These planes have on them the images of the leaves, flower petals, or branches with leaves or needles, with an alpha map that makes the rest of the plane invisible. Subsets in this panel can be variations of the leaves as well as petals. Some plants, like dead trees, don't have any leaf or petal subsets.

The panel (again, see the Plant Editor screenshot in this chapter for reference) is set up very much like the Trunk/Branches panel, with a dropdown menu for subsets, a preview pane, and several settings. It is possible to change the leaves by going into the Material Editor, but under the preview pane you'll also find a Leaf icon that allows you to go into the Leaf Editor.

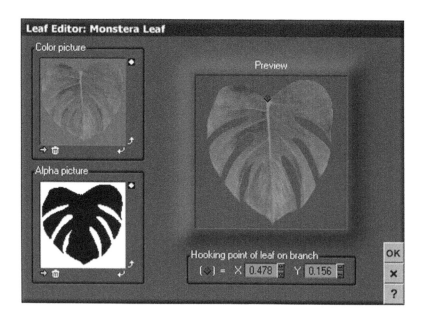

In the Leaf Editor, you can see the image that makes up the leaf along with its alpha picture for making the rest of the plane invisible. This is also where you'll see the hooking point, which appears as a red diamond on the preview window of the editor. To change the hook point, click on it and drag it to the new location. This can give a very different look to your plant. For more information about creating your own leaves, see the "Making Your Own Plants" section in this chapter.

Once you're happy with the base leaf image, you can start to give your leaves character using the Leaves/Petals settings.

Length and Width are self-explanatory. However, if your leaf or petal is set into the plant with the hooking point right in the middle or at the corner, it will behave differently, as this setting works with the entire alpha plane. In this case, to lengthen your leaves or petals, you'll need to work with both the length and the width. Working with the image this way will keep the proportion of width to length, since both must be changed. If this is something you need to change, try to find an appropriate plant where the leaves are hooked in the top middle.

Randomness controls how wide a range of sizes the leaves can be. There is always some variety in this, and a setting of zero will leave this alone. However, if you want more, with big leaves bigger and small ones smaller, you can move the slider up to positive values. Negative values will create fewer size differences in your leaves.

Flexibility and Curl both have to do with how the alpha planes bend. Flexibility deals with how they curl along their length. More flexibility will make your leaves or petals droop down; less will cause them to arch up toward the sky. Curl does the same thing, but at the edges of the leaves. Once again, where the hooking point is will affect this setting.

At the bottom you can use the overall color to overlay a color onto your leaf subset. Click on the small color field there to open up a color picker. With the new color, there will still be the variation between dark and light that was in the original leaf image. If there are several leaf subsets, make sure you get all of them when you change colors.

Making Your Own Plants

One of the fun challenges in Vue is to recreate a real species. The ease of the Plant Editor interface combined with the variety of SolidGrowth plants that already exist makes it possible, yet it takes a bit of questing to get the right ingredients together.

The best resources for plants, besides being next to them, are horticultural and botanical books or web sites. These often have line drawings as well as photos depicting whole plants, their structures, and details of what the flowers, leaves, and seeds look like. Also, you'll learn what kinds of environments they're likely to be found in and how they grow together and with other plants. Even if you're planning on having fantastic plants that have never existed, knowing how real plants grow will help you make your fantasy more believable.

Structure

To begin, match the structure of the plant you want to imitate to an existing Vue plant. For instance, let's say you're trying to reproduce the purple coneflower. This plant has a long stem with two or three minor leaves on it, with a bunch of smooth, narrow leaves at the base. The flower is large, with long purple petals that tend to droop away from a large central cone.

With this in mind, take a look at what is available in Vue's plant browser. Under the Flowers collection are two plants you may be able to use: Bonny Clump and Red Flowers. Both have flowers on long stems, solid flower centers that can be altered, and a bunch of leaves at the base. Neither of them has the minor leaves on the stem, so you'll have to let this detail go. You can further assess the structure of the SolidGrowth plants through the panels in the Plant Editor. With a bit of testing, it turns out that it's difficult to get the bonny clump petals to behave like coneflower petals. Red flowers have a much more complicated structure, but behave as we need, so they will work better.

Leaves

Leaf and petal images can be created in a variety of ways. You can draw them yourself, use texture-creation software to generate them, photograph them, and scan samples from real plants. Take a look at the Vue plant's original image first. This can be accessed through the Links tab of the World Browser. If you right-click on the desired image, you'll be able to export it. This will let you save it as an image that you can open up in your favorite 2D application.

There are some guidelines to keep in mind. First, even if the real leaf or petal is long and thin, consider proportioning it so that it fits the square better. You'll be able to make it long and thin again in the settings of the Plant Editor. Also, have the color leaf image placed on a background that has the midrange color of your leaf in it. This way, when the alpha picture clips away the nonleaf portions of the image you won't have white outlines on your leaves. As always, keep in mind the resolution of your image: too high will slow down the system, while too low looks bad. Vue's plants come with leaf images that are 256 × 256. Generally, that's a good standard to go by. However, if you're planning on a plant close-up to be the star of the show, it might be useful to have higher resolutions such as 512 or 1024.

Vue's red flowers plant and a coneflower (*Echinacea purpurea*). The coneflower image was retrieved from *www.plants.usda.gov* and is free domain.

Several plants, especially trees, have leaf images with hooking points in the center. Trees will have branches with leaves radiating out from the center. Flowers will have petals or sepals. In the case of the red flowers, the leaf image (petal subset) consists of four petals arranged in a cross. If you open the Leaf Editor, you'll see the hook is in the middle. (You may also notice the white outline due to not coloring the background of the color picture.) Before you create your new leaf, you need to decide where the best place for the hook

point is. For single leaves or petals, this is a little obvious, as it should be right where the real stem met the leaf. For branch/leaf combinations, you should have a rough middle that is the best place. If you've made a coniferous-type branch and needles image, then choose the point where the branch is "cut off" in the image.

Once you've got the right alpha and color pictures for your petal or leaf, you can load your images by clicking on the small yellow arrow beneath the picture previews. This will open the browser.

With the right image in place, you'll want to change the shape of the flower or leaf so that it looks more like your original. Play around with the settings until you're satisfied. In the case of the coneflower, the petals were made to droop more using both the Flexibility and Curl settings. Coneflower petals are uniform, so the randomness was reduced. They are also long, so the length and width were increased. Once the petals looked good, the leaves were made a bit wider.

Trunk/Branches

Since you can't change things like where branches hook from, your starting point for trunks and branches is when you choose the plant. The great variety of SolidGrowth plants available have many different structures. There are straight trunks and forking trunks and branches that radiate at regular intervals and others that grow out randomly. Chances are you'll find a plant similar enough that you'll be able to use it. On the book's companion website is a document of all the plant species that come with Vue Infinity and xStream, with descriptions of their structure to help you find the right one.

The settings can drastically alter the look of the plant. For instance, the Broad Leaf Straight Tree could become a holly bush. For the coneflower example, all that really needed to be done was to lengthen the stem and lessen the gnarl.

Vue's large European ash with nothing changed but the Trunk/Branches settings.

Since the preview is instant, it can be a lot of fun playing around with how tall or tiny or straight or gnarled up you can make things. It won't be time wasted, because it will help you get a feel for how it works. The art of making your own plant in Vue takes a fair amount of skill and creativity, but with practice you'll be able to craft realistic plants that will make your scene come alive.

Tutorial 5: New Beginnings

This tutorial will give you some experience editing the structure of trees. You'll start by creating a terrain. As you place several large dead trees and a wild plant, you'll be changing them. Also, to highlight the brave new growth, you'll get a taste of lighting by adding a volumetric spotlight and a point light to the scene.

Step 1

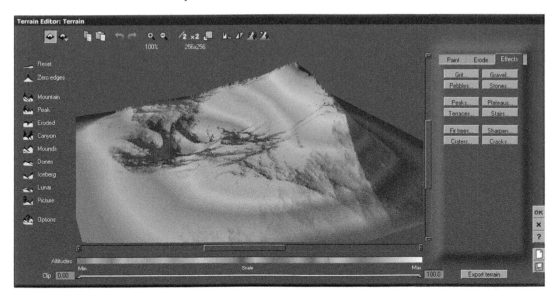

Start a new scene in Vue. Create a Standard Heightfield Terrain. Double-click on it to get to the Terrain Editor. Click the Reset button. What you're looking for here are the stark and relatively flat features of Peak, so click on that. Click "OK." Resize the terrain so that it is about 60–70 meters on a side. Also, squish it down so that it is only about 2 meters high. Move the terrain so that its "front" edge is just at the camera and the camera is centered widthwise. In the Aspect tab load the Sediment material (in Vue's Landscapes collection).

Step 2

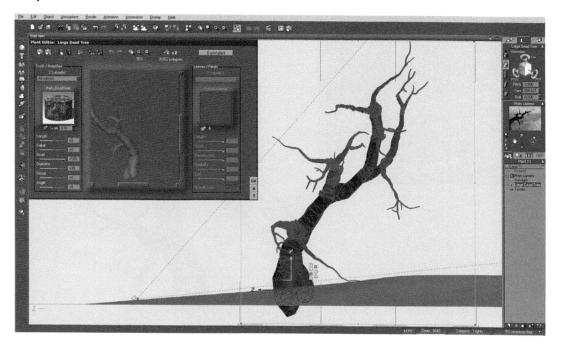

Right-click on the Plant icon to open the plant browser. Under Trees, select "Large Dead Tree." (If you don't have that plant, select a "Plum Tree." Make it about three times bigger. Double-click to open the Plant Editor, and then reduce the leaf Length and Width to −200. You'll need to type this in. That will get rid of the leaves and make it appear like the "Large Dead Tree.") Open the Plant Editor for the tree. Before editing the structure, double the number of polygons. If it isn't at least 20,000, then double it again. In the Trunk/Branches panel increase the Gnarl from +75 to +100. Increase the Diameter from +35 to +50.

Step 3

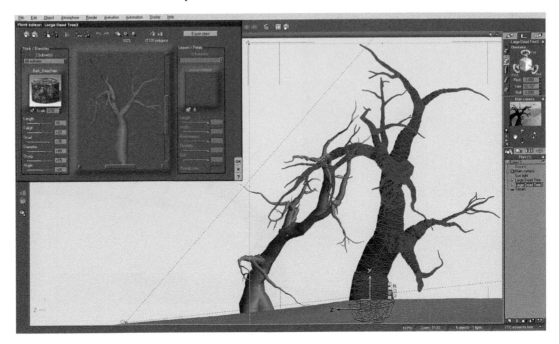

The reason no exact numbers were given for Gnarl or Diameter is that every tree gives you a unique instance and responds differently. The matter of your artistic taste is involved as well. If you really don't like how it's responding, try clicking on New Plant at the top of the editor. This will generate a new instance. When you have the tree the way you like it, click "OK." Move it so that it is near the camera. Left-click on the Plant icon again to create another tree, and then open the Plant Editor for it. This time, as well as Gnarl and Diameter, increase the Droop to about +15 to +25. See what Angle and Falloff can do for you as well, although you won't want either of those settings larger than 25.

Step 4

Overall, you'll want to have about six trees in the scene. You can make them each different through the Plant Editor. Also, if you have a tree you've worked on that you particularly like, save it so you can create more instances from it. To do this, click on the Save Plant Species icon at the top of the Plant Editor. (You'll especially want to do this if you converted a plum tree.) Make sure you rename it in the Title field of the Save dialog. Another way to create more trees is to take one of your trees and press the Alt key while moving to create an exact duplicate, which you can rotate so it looks different. Arrange the trees closely in about a 10-meter circle.

Step 5

Right-click on the Plant icon again to bring up the plant browser. In the Grasses—Plants collection choose "Wild Plant." If you don't have this plant, choose a plant with a single stalk and prominent leaves, resembling a sapling or young plant. Place it toward the middle of the trees but closer to the camera. Now you might want to do some arranging. You can sink the trees in the ground to make them shorter, or twist them around. Your goal is to have the old trees menacing over the young plant.

Step 6

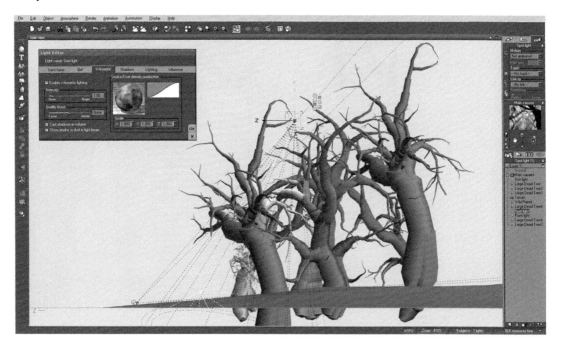

In the left toolbar, right-click on the Light icon and load a Spotlight. Move
the spotlight just above the trees. In the top view move the spotlight so that
it is a little up and to the right of the young plant. Point the spotlight at the
plant. Now double-click on the spotlight or right-click and select "Edit Object."
This will open the Light Editor. Go to the Volumetric tab. Click on Enable
Volumetric Lighting, Cast Shadows in Volume, and Show Smoke or Dust to
make the spotlight volumetric. After that, you may want to tweak the position
of your light to get just the right effect with the shadows the trees will now
cast in the light.

Step 7

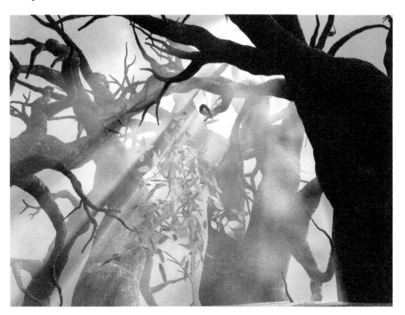

You may find that the plant needs a bit more light to really come out. Right-click on the Light icon again. This time select a Point Light. Move it between the plant and camera, moving it off to the right a bit. This is going to be a dramatic scene where the trees seem large and overpowering. For this effect, make sure the camera is rather close in and then point it up at the small plant with the large dead trees overhanging in the image. Even though the camera may no longer see the ground, the terrain and material interact with the light. For the atmosphere, load "Old Forest Fog" from the Tutorial Pack on this book's web site. Now you can tweak the arrangement of the trees, plant, camera, and lights for best results.

Mountain Village *Luigi Marini*

Objects

You've now worked with terrains, water, and plants. Vue has three types of basic objects that you can use to build your scene: infinite planes, alpha planes, and primitive objects. These are the kinds of objects this chapter will deal with. Vue also has other objects, such as clouds, cameras, and lights that you'll learn about in later chapters.

Infinite Planes

You can add one of the infinite planes to your scene using the icon at the top of your left toolbar. You'll find three kinds: a typical infinite plane, a water plane, and a cloud plane. Since they're infinite in length and width, but have no height, they technically don't have a volume. However, for the purposes of adding materials and other ways that Vue deals with objects, one side is considered the "inside." Normal infinite planes and water planes both have this inside on the bottom of the plane; cloud planes have it on the top.

Alpha Planes

Alpha planes, which aren't infinite, have the property of being able to have an image with transparent areas on them. These images can also be animated.

In this way, you can add effects into your scene such as fire, smoke, rain, waterfalls, and more. You can add one of these in by maintaining the Primitive Objects button to open up their selection, and then choosing the Alpha Plane icon. When you do that, an Alpha Plane Options interface will appear. You'll need the color picture, with the image you want to see, and an alpha map that directs where it should be transparent. Alpha maps are basically black-and-white pictures (remember to save them as grayscale images in your two-dimensional [2D] application). White areas become transparent and black areas are opaque. If you find your black and white are the opposite of what you want, you can inverse them using the small white circle icon. And of course, gray gives you varying degrees of transparency.

Your image does not have to be square. Clicking on Adjust Plane Proportions will keep it at its original height and width.

Billboards offer you the ability to make the alpha plane always face the camera when it is enabled, which is nice if you're using weather effects like rain or snow.

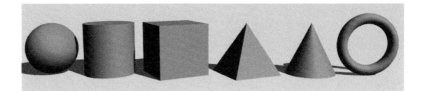

Primitive Objects

Although they may be simple, there is a lot you can do with basic objects like spheres and cubes. The rest of this chapter will go into detail about how to sculpt these into unique forms.

Grouping Objects

If it happens that you want two or more objects to keep their arrangement no matter where you put them, you can group them. Do this by selecting them all in the World Browser. To have more than one object, hold down the Ctrl key while selecting. Now click on the Group icon in the left toolbar. To break things up, you can ungroup them as well.

Once you've grouped them, the objects involved will become part of a group in the World Browser. If you want to work with any of the objects individually, you can expand the group to find them listed and select one of them. When you work with just one item in a group, manipulating it won't affect the others at all, but it will remain in the group. This lets you fine-tune arrangements.

If you have an object in a group and would like to move it to another group, you can simply drag and drop it into another group in the World Browser.

There are two special kinds of groupings that also change the shape of the objects: Boolean and Metablob. Usually, these types will appear as wireframes showing all the objects in a group. You can see these Booleans and Metablobs as solid objects in the OpenGL three-dimensional (3D) views if you want. Go to File > Options > Display Options. In the View Options group you'll be able to toggle the preference to Show Boolean and Metablob Previews. This can put a heavy load on the OpenGL display, so if it starts running slowly you'll need to disable their previews, among other things.

Boolean Operations

This is a way of taking away the volume of one or more objects from a single object. To do a Boolean operation, place one object partially in another. Select first the object you want to still be there. Then hold down the Ctrl key and select the other object. Once you have them both, click on the Boolean Difference button in the left toolbar. The second object will disappear, leaving a gap where it was in the first. You can subtract multiple objects from a single one.

Objects that were subtracted with a Boolean operation don't just disappear. They act as a group, and appear in the World Browser as a difference that can be expanded so that individual members can be worked on.

These models were done completely in Vue 7, using Group, Boolean Difference, and Metablob. (Use this figure as a reference for the tutorial at the end of this chapter.)

Metablobs

The Metablob operation smooths out all sharp edges while it combines two or more objects, as if they'd been shrink-wrapped by an envelope of latex. This lets you create things with clean, organic lines. You can use only one object or several. To create a Metablob, select your object(s) and click on the Create Metablob Object button.

You can edit the way your objects combine, either individually or as a group, in the Metablob Options interface. If individually, you can make the object you're working with subtract from the other similarly to the Boolean operation but with a more tapered effect. You can also affect how much the object contributes to the entire grouping. The less intense, the smaller it will be. When you have the whole Metablob selected, it will affect the contribution of all the objects in the group. Global Metablob Options affect how thick the envelope is. Shrinking it smaller than the objects won't make it disappear, but makes everything smaller.

Vue is not a true modeling program. However, there is a community of Vue artists who enjoy creating models using Boolean operations and Metablobs and are very successful at it. It can be a lot of fun, and you can find resources for modeling in online communities, found in Appendix A.

Baking

If you want any type of group to become a single object, you can bake it. This will create a polygon object. Once you do this, you can't undo it, so you may want to save the object group first. To bake your group, right-click on it and choose "Bake to Polygons" from the dropdown menu. You'll have the option to increase the bake quality. Increasing the quality increases the number of polygons. Like everything else, high quality comes at the price of time, both in OpenGL drawing and render. The couple of things to consider are: How complicated are the shapes? And how close will this be to the camera? If the shapes have fewer curved surfaces, you can get away with fewer polygons.

You can also bake a single object. By making the polygon count very low, you can actually change the shape of the objects with round surfaces like the sphere or torus. Once you do this, no matter what shape it ends up being, it will no longer be considered a primitive object, and so you can't use it with Metablobs.

Smart Drop and Alignment

Sometimes, when you load an object in Vue, or if you've moved an object, you'll find something floating above the ground. For this, you have the Drop

Objects button at the bottom of the left toolbar. This will drop the object onto the surface of anything that is below it (including a water plane), doing away with any kind of fiddling you might have to do with positioning the object to get it properly grounded. If the object appears below your ground surface, first you need to lift it above the ground and then drop it.

Smart Drop lets you drop things in a way that simulates how they would drop if gravity were at play. Things it takes into consideration are the shape of the object and the ratio of its height to length and width. If there is enough distance from the surface, Smart Drop will always put the object on its longest side. Also, if the object is "falling" onto a nonhorizontal surface, or more than two surfaces, it will align so that it leans against whatever is underneath it.

The Alignment tool, near the bottom of the left toolbar, helps you to quickly line up your objects by the global world axis. If you want all of your objects in a row, you'll need to use the axis that is perpendicular to the direction you want to line them up in. For instance, if you have your Y axis up, and you want your objects to line up along the X axis, you'll need to align them by the Z axis. This is because you're working with the value of the axis, not the direction things are lined up in. If Z is 3 meters for the center of all of the objects, then they'll all be in a row along X (see the following figure). This won't change the distance between those objects on the row. If you want them at regular intervals, you'll have to work with that.

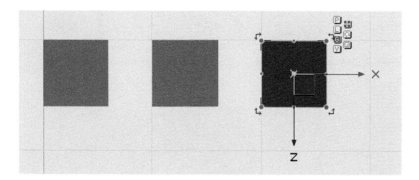

These cubes are aligned by the Z axis since their center values are all at the same place along that axis. Along the X axis, they each have a different value and so aren't aligned.

Scattering and Replicating Objects

Next to the Cut, Copy, and Paste buttons on the top toolbar is the button to duplicate or scatter and/or replicate your objects. Right-clicking will bring you to the Scatter/Replicate Objects interface. In this interface, you'll be able to generate a selected number of copies either randomly distributed across a range of position, size, rotation, and twist or regularly distributed with those same numeric characteristics. You can use this tool to do things like simulating swarm behavior and creating scattering that is regular in some ways while random in others.

Tutorial 6: Little Flying Machine

You'll be creating the cute little flying robot from the second figure in this chapter. You'll be using Difference, Metablob, and Boolean operations to build the model. You'll also apply materials to the primitive building blocks as you go along. Once you have some flying machines, you'll create a landscape with Boolean features. If it becomes too long to render, consider changing the bubble material of the cockpit to a simple glass.

Step 1

Open a new scene in Vue. Click on the Primitives icon, holding it if you need to select a Sphere. For the sphere, click Load Materials in the Aspect tab. Use "Body Paint—Red" from the Metals collection. Now create another sphere. Move this sphere a bit up and to the right of the first sphere, but still embedded in it. Load the "Aluminum" material from the Metals collection onto the second sphere. Now select the red sphere first, and then with the Ctrl key held down, select the aluminum sphere. Click the Boolean Difference icon in the left toolbar. You'll find that the material "Aluminium" on the second sphere will apply to the surface of the first sphere wherever the second sphere was subtracted from it. This will make the outside a metallic red and the inside a dulled silver.

Step 2

Create another sphere. Resize and flatten it so that it fits just inside the area you subtracted before, leaving a bit of a bulge out to the right. Click Load Materials, go to the Glasses collection, and choose "Bubble." Click on the Duplicate icon to make one copy of the new sphere. Use the size gizmo to shrink this one a bit. Now click on the first, bigger disk to select it first, hold the Ctrl key, and click the Boolean Difference icon again. This will be the cabin of your little machine.

Step 3

Now you'll make a spoiler for the machine. Right-click on the Primitives icon, and then select a Cube. Stretch it, and then flatten it on the sides so it is rectangular. Now set it on the side of the sphere (the front to the camera) and angle it up as if it where a pointing arm. From the Metals collection, load the "Body Paint—Silver" material. Hold the Alt key while moving the spoiler arm directly back so that it is on the opposite side of the sphere. These two will appear like arms reaching out. Now create one more cube. It should already have the silver material on it. Make it rectangular, similar to the other two, but then move it so that it bridges the arms, extending out a bit from them. Select all three of the rectangles and click on the Create Metablob Object icon.

Step 4

Next, you'll make the engines. Right-click on the Primitives icon and select a Cone. Load the "Techno 4—Dirty Rode" material from the Metals collection onto the cone. Now press the Alt key and move the cone to duplicate it, and pull it out a bit so that it is stacked within the first cone. Change this cone's material to "Cigar Tip" from Special Effects. Select the first metal cone, then the glowing cone, and click on the Boolean Difference icon. Resize and place it right in the back, pointing down a little bit. Use the Alt-Move method to create two more and place them to the sides of the first one.

Step 5

For the lights, create a sphere and make it very small. Place it right on the front of the model, across from where the middle engine is. Right-click on it, and select "Convert to Area Light." Now make a cylinder, resize it so it is as small as the sphere, and place it on the sphere so that the light is just peeking out in front. Load the "Metals > Aluminum" material onto the cylinder.

Step 6

Create another sphere, shrink it down so it fits right inside one of the cone engines. Convert it to an area light, as in Step 5. Now change the color of the light in the Aspect tab to a red-orange. Duplicate this sphere two more times and fit them each in one of the cones. For a final touch to the model, create another sphere, load the "Metals > Aluminum" material onto it, and make it about the size as the engine spheres. Place it right on the spoiler where a hinge would be. Duplicate it with Alt-Move and move the second one to be the hinge on the other side.

Step 7

Select all of the components of the model and click on the Group Objects icon. Name and save it as a .vob file. Now, for a bit of fun, create groups of two or three spheres together and click on Create Metablob Objects for them. Copy your flying robot and put a couple more into the scene. Load an interesting atmosphere into it, and now you have a fun scene modeled entirely in Vue.

Autumnal Walk *Dominic Davison*

Importing and Exporting Models

You'll find many reasons to want to import objects. You probably have several three-dimensional (3D) programs, each with its own strengths. There are also several places to purchase 3D objects, including the Cornucopia store with Vue-directed content. You may also find yourself wanting to export objects, such as clouds, Metablobs, and terrains. Both importing and exporting operations have a few settings and things to keep in mind to achieve optimal results.

Importing

If you aren't using an object created in Vue or specifically for Vue, Vue 7 has a robust ability to import objects with several file extensions including the recently established COLLADA standard. With COLLADA, file extension .dae, you'll be able to import objects consisting of polygon meshes and materials with full compatibility. Both the .3ds (of 3D Studio) and .lwo (of LightWave) also have very satisfying abilities to import materials with the objects. The Vue 7 manual has a good list of the possible file extensions.

One thing to remember is that Vue only works with polygon meshes. If you're creating a model using parametric surfaces, you'll need to convert it to polygons. Make sure you do something like freezing the geometry beforehand to avoid a reduction in details when you make the conversion.

Also, when exporting from the software you're using, make sure you export the material or texture as well. This is not always an automatic function. Although Vue does not apply its own materials with UV mapping, a common method of hooking materials on by an object's coordinates, it is very capable of using them. In some cases, you may find yourself reapplying them manually when an object is imported but their UV mapping will be remembered and used.

When importing an object for the first time in Vue, it is always a good idea to import it into a new scene or to save your scene just before you import. This way, if there proves to be some kind of incompatibility, you haven't crashed or ruined any work you may already have.

You can choose an object for import by clicking on the Load Object icon in the left toolbar, then selecting the Browse File icon at the bottom of the object browser or going to the File > Import Object option in the top menu. Within the browser is the option to Collapse Identical Materials; if you don't select this, you'll get a list of all the parts when accessing materials even when they have the same material. Unless you want this kind of access, enable that option. Once you've chosen an object, you'll see an Import Options menu pop up.

The Decimate Object on Import selection will reduce the number of polygons used for the object. This can be useful for a couple of reasons. First, sometimes the polygon meshes of imported objects can be very large, which can slow down the scene quite a bit. You may be able to decrease the number of polygons while maintaining a good-looking object. Also, if you want this object in the background, decreasing the number of polygons is a good idea since there is not such a need for detail. In that case, you can decimate the object considerably and save some rendering time.

If you select this option, a dialog will appear with a slider. The stronger the decimation is, the more it will push the object's geometry to a lower polygon count. In some cases you can reduce the polygon count dramatically without losing very much detail. You may want to experiment with this to see the effect of lowering the number of polygons. Sometimes every single polygon is needed.

In the Import Options menu is the option for Center Object. This will cause the center of the object to be aligned with the center of the active view. The last option is one to Resize Object. This is useful if you're aware of scale differences. Automatic resizing doesn't give you very much control. You'll want to use the Manual Resizing option, where you can set the scaling ratio. This value is what the size of your object will be multiplied by. So to get an object half the size of your import, enter 0.5, and for one double the size, enter 2.

Importing Poser Objects

One of the most popular applications to use with Vue is Poser. As well as importing .pz3 and .pzz objects from Poser, you can even run Poser in conjunction with Vue so that you can edit an object's animation from within Vue. First of all, to import Poser objects you'll need to have Poser 4 or above installed on your machine. If you don't, you'll be prompted if the object you've imported is from Poser. Next, you'll need to go to File > Options and then select the General Preferences tab. Here, in the Object options group, will be a button to Configure Poser Import. On selecting it, a Poser Import Setup dialog will appear. You'll need to make sure you select the correct version of Poser. Then you'll need to point Vue to where the Poser application is.

Any file that you've saved in Poser 6 or 7 for use in Vue should *not* be using file compression or external binary morph targets. To confirm these settings, in Poser, go to Edit > General Preferences > Misc.

Upon importing content from Poser to Vue, you'll get a Poser Import Options menu allowing you to control how an object acts within Vue. These are helpful for speeding up work within Vue or fixing possible animation artifacts. Also, if you're only doing a still image you'll want to select Import Single Frame from Poser Animation.

Poser Integration

If you enable "Allow Reposing Inside Vue" and/or "Render Materials Using Poser Shader Tree," Poser can work as a plug-in within Vue. You will need Poser 6 and above on your machine. When you click on "OK," a warning will appear regarding the memory requirements. This warning can be tricky. It isn't asking you to continue, to which you'd answer "yes." Rather, it is asking if you want to disable features that require handling by Poser; choose "no."

Keep in mind that Poser models themselves can have a very high polygon count. Also, working with Poser inside of Vue can take large amounts of resources. Pair these two facts together and you're going to be pushing the resources to the maximum, and if you aren't careful, beyond. If you happen to have a 64-bit machine with at least 4 GB, then this won't be a concern. Now that you have the Poser object in your scene, double-clicking on it or right-clicking and editing the object will bring up the Re-Poser interface. This contains a hierarchical list of the body parts and the dials to move them. At this point, your knowledge of Poser comes into play.

An option to editing movement within Vue is that you can do the same in the Poser application and then save. Vue will automatically detect this change and then ask you if you want to use the most recent file.

Another way that Poser integrates with Vue is with the ability to use the Poser shader tree. This reduces any loss you'll experience if converting the Poser shaders to Vue materials. You'll see the Poser logo in the material preview of the Aspect tab or the Material Editor, but you'll be unable to edit any of the Poser materials within Vue. If you do want to work with the materials from within Vue, you can convert it by selecting Simple Material in the Material Editor. For more on this, see Chapter 8. However, if you've changed the materials on your Poser model in Vue before editing the animation in any way, then the editing of your materials will be lost. The solution is to either save the materials and reapply them, or to make sure you have your object moving as you want it before working on materials.

Exporting

For all three different things that you can export—objects, skies, and scene—there is only one dialog box that you will need to get to know. This will appear when you've chosen to export any of these, an operation you can accomplish when you go to File > Export and choose "Object," "Sky," or "Entire Scene."

Here, you'll be able to choose what kind of file to export. Vue will automatically give you a selection appropriate for what you're exporting. It is usually a good idea to export your model or scene in the format most commonly used with the target application. For entire scenes, you'll only be able to export for 3D Studio as .3ds and LightWave as .lws. When you export a scene, Vue will convert all objects to polygon meshes, generate UV texture maps for each object, generate a sky image, and convert all lighting and camera information. This won't affect the scene in Vue, but will be saved in a separate file. When you export an entire scene, make sure you don't have any objects selected. This can

result in Export Selected Objects Only behavior even if that is unchecked. By default, this is, in fact, checked so you'll want to pay attention to that.

For objects, there are several other types of files you can export to. If you don't find the type for the software you choose to export to, you'll be most successful exporting with the .obj file extension. To fully take advantage of the material you've applied in Vue (see Chapter 8), you'll want to generate a color map, bump map, and alpha map for each of these.

When you export an object or scene you'll have the ability to control how many polygons are used in the Mesh Resolution group. As you move the slider, it will give you an estimate of the file size and the number of polygons and vertices. Adding smoothing faces will increase the number of polygons, but helps eliminate sharp angles and mapping artifacts. If exporting a scene, this will apply across all the objects in your scene.

You can also control the quality of your Texture Maps, another quality that will be universal in a scene export. The higher the resolution of the texture maps that Vue converts materials into, the better it will look, and unfortunately the more time it will take to convert. As you move the slider, you'll see the X and Y axis values increase. You can change the aspect ratio of this if you've unchecked Automatic Aspect Ratio. It is recommended you don't do this, however, unless you know the effect, as it can really change how the image is mapped back onto the object. Actual dimensions will make this resolution universal throughout your scene, but Effective resolution will adapt each map to get a good texture resolution for each object.

Vue uses a complex way of UV mapping the texture onto the object that, while very accurate and minimizing inconsistencies, can sometimes be difficult for the artist to mentally wrap around if you're editing the texture in a 2D application. Selecting Use Generic Parameterizer will produce a texture map that is easier to visualize.

Exporting the sky is not like exporting Vue's atmosphere. It reduces all of its calculations to a simple image map that can then be projected onto the type of geometry you choose. In the Export sky group is where you can choose your file's name and what kind of geometry you'd like to use. By default, Vue shows only the .BMP type of picture file, but you can export it as any kind that you'd like when you click on the Browse button. This image will be projected in one of four different ways: Cube, Octahedron, UV Sphere, and Octasphere.

- A *Cube* sky will be mapped as if a box were unfolded. This can cause quite a bit of distortion as parts of the image have to be stretched to fit, but it is the simplest geometry to work with.
- An *Octahedron* sky looks like a rectangle, with the sky on one side and under the sky on the other. This is mapped onto, not surprisingly, an octahedron. This geometry results in less distortion.

- A *UV Sphere* has the sky stretched across the rectangle. That rectangle is then wrapped around the sphere. Where it must meet at the top of the sky is where you'll experience the distortion. If you save this format as an HDR file, you can create a high dynamic range imaging (HDRI) map with it. See the "Environment Mapping" section in Chapter 11 for more on this.
- An *Octasphere* uses the same rectangle mapping as the Octahedron, with the top mapped onto the top half of the sphere. This results in less distortion than the UV sphere.

Cube

UV Sphere

Octasphere

Octahedron

Tutorial 7: Running

To see the difference between loading and importing, you'll be loading some Vue objects and then importing a running girl model from Daz Studio, a free figure posing and animation application available from Daz 3D (www.daz3d .com).

Step 1

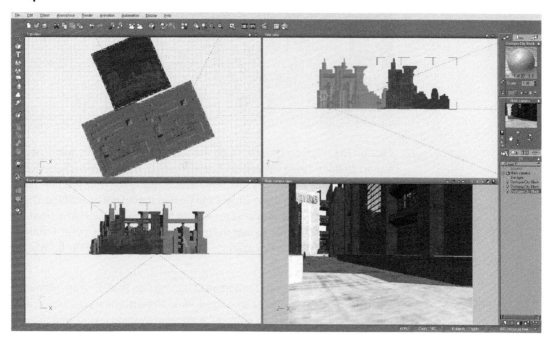

Before importing the running girl, you need to create a place for her to run. You can either click on the Load Object icon or go to File > Load Object. From the tutorials pack, load the "Dcityblock.vob" file. Move it just in front of the camera. Keep it rotated as it was when it loaded, but make sure you lift it above the ground plane and drop it. Duplicate this twice. Place one of them to the left of the first, edges overlapping. Arrange the second diagonally behind the first two, so that you see another city block at the end of the street in the camera's view. Fine-tune their placement using the camera's view.

Step 2

Click on File > Import Objects. Open the "vikirun.obj" file. At this point, the Import Options dialog will appear. You will want to enable Resize Object for this or the model will be very tiny. Automatic Resizing will work just fine. The other two options, Decimate Object and Center, should not be enabled. Don't worry if it takes a while to import the object. Move the running girl in front of the camera. Rotate her so that she is running parallel to the street. For an atmosphere, load the "dysmog.atm" file from tutorial pack from the book's web site.

A piece of advice: When you export an OBJ using Daz Studio, in the Advanced tab make sure Write Surfaces is enabled, Write Material Library is enabled, and select Collect Maps. This will embed the skin and clothing texture into the model itself and will make for an easier import.

Sic Transit Gloria Mundi *Artur Rosa*

Creating Your Own Materials

The success of your scene depends in great part on what you do with your materials. You could have the perfect terrain model, but the ground up close may look bad because the materials are not as realistic as they could and should be. Vue has a substantial collection of preset materials to use that are just the beginning of what is possible. With Vue's Material Editor, you can create any texture you can imagine: skin, mountain snow, car paint, and beyond. With the exception of the lack of UV mapping, Vue's Material Editor may be one of the most powerful texturing applications on the market.

To load a new material, click on the Load Material icon in the Aspect tab, right-click on the preview pane of the Aspect tab and select "Load a Material," or right-click on the object in the OpenGL views or World Browser and select "Change Material." Any of these actions will bring up the material browser, which can go a long way in getting you what you need in your scene. These dropdown menus also contain the "Edit Material" option.

Basic Material Editor

The first time you open up a material for editing, you'll probably start with the Basic Material Editor. You'll be able to work with either a simple material

or a mixed material, and have some control over several characteristics. If you're pretty much happy with the material you're using and want to change something simple like the color or the apparent depth of the bumpiness (Bump gain), then this might be a good place to be. Other things you can do here are change the transparency of a material, change the highlight intensity, and change the reflection amount. You'll also see the ability to add a texture map. Texture maps are usually black and white, representing values from −1 to +1, which drive a characteristic. In the case of bumps, the dark areas of a map will correspond to deep places and the light areas are raised areas. In general, the Basic Material Editor is the easiest method for simple textures, including bitmapped textures, offering a quick and uncluttered interface.

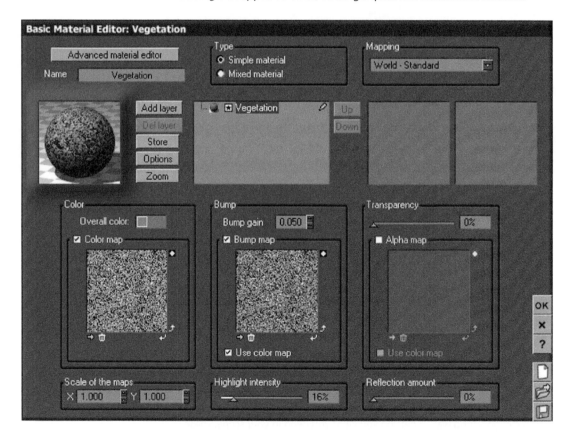

Advanced Material Editor

The Advanced Material Editor duplicates all the options found in the Basic one plus so many more that it becomes practical to only work in the Advanced one,

especially if you intend to animate your work. To get to the Advanced Material Editor, simply click on the Advanced Material Editor button at the top left of the Basic Material Editor. When you exit Vue, whichever editor was in use at the time will be the one that appears the next time you open the Material Editor.

Before really getting started here, notice that you have the option to name your material. As you create more complex materials, you'll want to take advantage of this so that you can keep things organized. Under that, you can change the overall scale of the entire material. You can also do this in the Aspect tab. As mentioned before, scale is important; for example, you don't want sand the size of large rocks in your scene. A scale of 1 corresponds to the original size of the features in the material, and does not reflect any standard within the Vue application. Therefore, you may find yourself with mixed materials where several of the layers have different individual scales.

The top half of the Advanced Material Editor.

Type

You have four types of materials:

- *Simple material:* A single-layer material that only applies on the surface of your object.
- *Mixed material:* Uses two or more simple material layers of any kind.
- *Volumetric material:* A single material that will fill up the boundaries of an object. Light can sometimes pass through these depending on the density, which can be variable.
- *EcoSystem:* A material layer where objects are automatically distributed across the surface of another material layer.

Toggling any of these will pull up the necessary material layers in the material browser (the list of materials) of the editor.

Effects

In the upper right, you'll find the Effects box with several options:

- *One sided:* When rendering, this will make the ray go through only one side of a transparent material.
- *Anti-aliased:* By default, this is set to be on, but can be disabled in cases where you want extra graininess or noise in your material.
- *Indirect lighting:* This lets you control whether lighting that has bounced off other objects would be calculated for the object with this material applied. Sometimes you may receive no real benefit in the picture quality by taking indirect lighting into consideration, while hugely increasing render time. This lets you control that factor.
- *Cast shadows:* If you can't see a shadow, why calculate it during a render? This lets you disable shadows from an object. You may also wish to disable cast shadows if you are working with something luminescent.
- *Receive shadows:* Similar to cast shadows, you might not want any shadows on an object that glows.
- *Only shadows:* This makes an object with this material on it invisible to the render while still casting a shadow on surrounding objects.

Mapping

The type of mapping you use will make a huge difference in how your material will apply to the object. World and Object mapping, as have been discussed, refer to whether the axes are measured from the center of the world, or if they originate from the center of the object. There are, however, different ways to measure this.

Standard and parametric are very similar, mapping the material according to the distance from the point of origin on each axis. However, parametric mapping will lock the size of the material features to the object, so that if you resize the object, the features will resize with it. This is very useful if you're using a material that you want applied to your object in a specific way, such as with an image map.

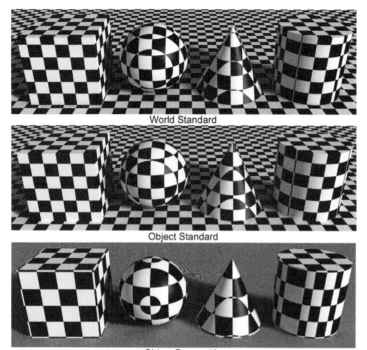

World Standard

Object Standard

Object Parametric

Cylindrical mapping uses a system where Y is the vertical elevation measured, X stands for the distance from the central Y axis, and Z measures the angle around the Y axis. This assumes that the Y axis is the up axis. Otherwise, Z is the vertical elevation, X is the distance, and Y measures the angle.

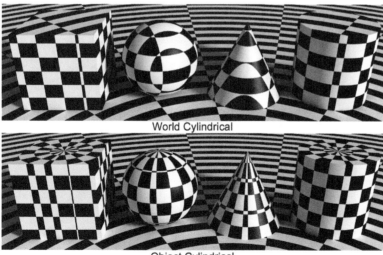

World Cylindrical

Object Cylindrical

Spherical mapping measures the distance from the vertical axis (X), the angle around the horizontal plane (Z), and the pitch or angle around the vertical plane (Y). Again, if Z is the up axis, then the values are X for distance, Y for angle, and Z for pitch.

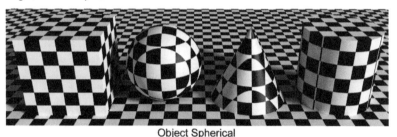

Object Spherical

If you find that a material is applying to your object in a way that looks unnatural, such as image tiling or some kind of distortion, evaluate what kind of object you're working with and what mapping system would work best.

Simple Materials

When working with a simple material or a single layer of a mixed or layered material there are seven different tabs dealing with material characteristics: Color and Alpha, Bumps, Highlights, Transparency, Reflections, Translucency, and Effects.

Color and Alpha Tab

In this tab, you'll find two ways to color your picture: mapped picture and procedural colors. Toggling between these will give you different options

to work with, although both have Color Correction where the overall color represents the average color. This is a very rough way to change the color, but as the label implies, it works well for color correction. Right-click on the color field for options; selecting "Edit Color" will bring you into the Color Selection interface, where you'll be able to choose the saturation, brightness, and hue. This Color Selection interface is common for all instances where you need to choose a color.

If you take the average color and simply change the saturation or brightness, for instance, then this will have an overall effect on all of the colors, while keeping them otherwise the same. Changing the hue, unless subtle, will change all of the colors drastically. If you find that you don't like the results, you can always reset the color to the original.

Procedural Colors offer you the ability to enter the Function Editor to drive the color production of your material. Outside of the Function Editor, you can work with a filter and a color map. The color map shows you a range of colors with assigned values between −1 and +1.

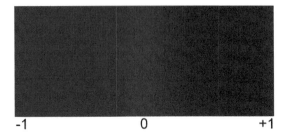

Right-clicking on the color map will enable you to load or edit a color map. Vue has several useful preset color maps in its collection, but if you don't find what you need, it isn't difficult to create your own. Selecting the edit option will bring up the Material Color interface.

Above and below the gradient, you'll see tiny little arrows. You can move these back and forth, "pushing" the color on the bottom, or the opacity on the top. These are called keycolors and key opacities. When one of them is selected, the little arrow is darkened and the color it represents can be seen in the field labeled Current Color. When there is more than one keycolor, the colors blend in a gradient, with the pure color at the point of the keycolor. If you change a keycolor, then the gradient will change with it. If you'd like more colors in the color map, click on a point along the bottom ruler and select New Keycolor. You can also delete keycolors.

On top of the map is where opacity is controlled. Where the color field was, there is a slider. Opacity at 100% will mean that the color is completely solid—you can't see through it. Anything less will make the pixels somewhat transparent. The alpha information of the pixel is what directs its transparency.

Along the top of your color map, you'll see the alpha information in a small strip. If it is all black, there is no transparency; white is completely transparent; and any gray in between represents partial transparency. The small arrow to the upper left will also let you control the opacity with a filter.

Next to your new and beautiful color map is a filter. Unfortunately, if the filter is left as is, the overall color will only be an exact average of the color map. Other filters will simply alter this average unless a function is in place. A function will allow different values of the color map to be applied across the material in different places. You can do this by right-clicking on the preview pane and selecting "Load Function" or "Edit Function." Choosing "Load Function," you'll find a collection of several preset functions that can give you interesting results. To select a function that drives your color, it is helpful to understand that dark areas represent low values and light areas are higher values. Filters work with functions by converting the value's output by the function to different ones. It is also through the function that alpha information, or opacity, can be applied. More on editing functions and filters will be covered in Chapter 9.

Mapped Picture coloring mode gives you the ability to load an image that will be mapped onto the object and control how it is mapped. A PNG image (with the file extension .png) can also have alpha information, which endows transparency, embedded in it. Before you load an image, take into consideration how high its resolution is. About 500 × 500 is average, but if this material will be on an object very close to the camera, then consider using a higher resolution. If you have something of a lower resolution, you still have options with Interpolation Type, which will add pixels into the picture. When interpolation is used, the image is increased in size, leaving gaps where there would be no pixels. Pixels are inserted with color and alpha (opacity) values based on the average of neighboring pixels. This can be done in three ways:

- *Bilinear* takes the average of the closest four pixels surrounding the new one.
- *Normalized* also takes that average, but weights it by how close the pixels are.
- *Bicubic* interpolation measures a weighted average of the surrounding four-by-four neighborhood of pixels.

Tiling is very useful if your image is smaller than the area it will be applied to. If this is the case, you may want to consider creating an image that will tile seamlessly, an effect achieved when the vertical and horizontal edges match. A method to simulate this is to mirror your tiles. Alternately, you can choose not to tile, having your image appear only once as a feature in the material.

Image Scaling enables you to change the proportions of your picture, increasing the scale if both X and Y are kept the same, and distorting it if they differ.

To place your image more exactly onto the object, you can use Image Offset. The values here represent pixels rather than units of measurement, giving you very fine control.

Vue has several different ways of mapping the image onto the object. This is different from mapping by coordinates, but deals with which shape will be used to project the image.

- *Automatic:* Detects the shape of your object and chooses the best type of mapping based on the object's shape.
- *Flat:* Projects the image as if with a projector on a wall.
- *Faces:* Projects the image at angles that point at where the pixel is facing.
- *Cylindrical:* Wraps the image around a cylinder before projecting it onto the object.

- *Spherical:* Wraps the image into a sphere.
- *Torical:* Wraps the image into a torus.

Color blend is found in the lower left of the Mapping tab. It has two ways of combining a chosen color with your image. You can simply blend the color so that the image is completely dominant and 0% and only the color can be seen at 100%. Using a color mask will overlay the color onto the image, so that you'll be controlling the apparent opacity of the color, with it being the most transparent at 0% and completely opaque at 100%.

Bumps Tab

The Bumps tab controls the texture of the surface of your material. With standard bump production, this happens by creating highlighted or shadowed areas to simulate holes and bumps. To get this effect, you'll need to load or edit a function that has a grayscale map on it into the Bump Production preview. Intuitively, the darker the gray, the lower the value is and the deeper the hole, with white representing high points of the surface. As before, these numbers are in the range of -1 to $+1$. However, the range between the maximum and minimum height can be increased or decreased using the Depth setting; the higher the value, the larger the range, which will make your texture appear bumpier. This is limited in standard bump production.

If you want real depth and height, you can do this simply by selecting Displacement Mapping. As you learned with water planes, displacement mapping will actually change the geometry of the surface. To generate this geometry, polygons will be added. Vue does a good job of determining how many polygons can accomplish the task, but if you start to see angles where curves should be on your material, you can increase the Quality Boost. This will increase the number of polygons used. This could slow down your rendering time quite a bit, so use this one with care. Alternately, decreasing the Quality

Boost will reduce render time. This is a good option for distant objects, but in those cases it may be best to remain with standard bump production anyway.

The sphere on the left has a normal bump map. It looks like it has deep and high places, but notice the smooth edges of the sphere. On the right, displacement mapping has been used, so there is actually a change in height and depth. The shadow and highlighting of standard bump maps are very effective, as you can't tell a difference between the two spheres in the middle, where they directly face the camera.

With the Displacement Mapping option, you have a couple of settings that are important to achieving a good effect. Force Extension will increase or decrease the range of your minimum and maximum heights by essentially clipping any values below or above. If you have any areas that have been clipped, they are said to be saturated. You can still have some apparent geometry in those areas by selecting Show Bumps on Saturating Displacements. Move EcoSystem Instances will prevent objects from being partially submerged or floating above the material because of the new geometry. If you have mixed materials, sometimes those materials will apply or not be based on the slope of an object. Since the material will now have slopes, it may be useful to add this information into the equation by selecting Reevaluate Material Distribution After Displacement.

Also, many times each mixed material may have its own bump map. Under Bump Production, the Add to Underlying Layer Bumps slider will control how these bumps are blended. For instance, a layer of snow may simply add height to underlying bumps, but is softened, so a setting in the midrange may serve you well. The deeper the snow, the more the underlying geometry will be obscured, so then the value should be even closer toward replacing the geometry of the layer underneath.

And finally, in the Bumps tab you can select Dependent on Slope to control whether bumps and holes are more likely to happen on vertical surfaces than horizontal ones. Of course, there could easily be a difference between the object's and the world's coordinates in what is vertical or not.

Highlights Tab

A certain amount of light bounces off the surface of everything, which is how we can see anything. The kind of light that allows us to see an object that doesn't glow itself is called diffusive, since as it bounces it tends to scatter. However, smoother surfaces cause less scattering, which can result in areas where the light returning from the surface is more intense, making spots of light. These are called highlights.

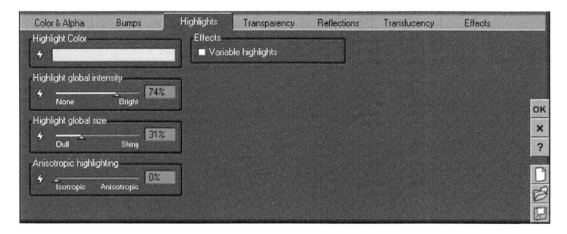

Three characteristics of highlights that you can control in this tab are color, intensity, and size. Under those is a slider for Anisotropic highlighting. Anisotropic means that, depending on the direction from which something is being seen, visible characteristics may change. In this case, the highlighting may differ depending on what direction you are viewing it from and the direction of the light. This is very useful for fibrous materials such as hair. Isotropic highlighting, on the other hand, remains the same in all directions.

To the right of those settings, you can enable variable highlights to drive color, intensity, and size with a function and filters. When enabled, you'll have a preview pane for the function and two filters governing intensity and size. These all work very much like what has been described before, with the function driving the values of the highlighting. Bright and shiny highlights are achieved with a value of 1, while −1 will return no highlighting.

Transparency Tab

Transparency is a complicated effect, as it really plays around with light. When light travels through transparent materials, it will bend. This is called refraction and can have several consequences such as distorted images and lens flares. It should be noted that alpha transparency doesn't replicate a transparent material, but represents an absence of anything for light to interact with. This

means that with alpha transparency, there will be no refraction. Light may also even bounce off transparent surfaces at certain angles.

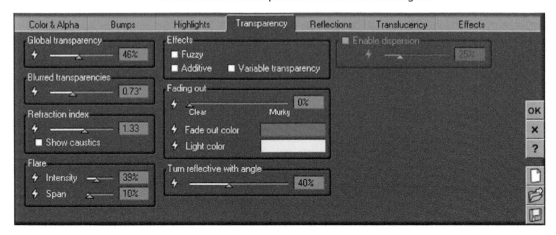

Global transparency controls how much light is allowed through the material. The more light, the more transparent the material will become. Impurities or distortions inside a transparent substance can cause some scattering of the light that is passing through it, making anything viewed through it become blurred. You can control this with Blurred transparencies. The unit used is degrees, because what is being measured is the difference of the angle of the scattered light rays. Five degrees will yield you good results. One thing to remember when using this blurred effect as well as the one in reflections is that because it is computing extra rays for every ray of light returned, it will increase the render time.

The Refraction Index of the material refers to how dense it is, in relation to air. As light passes from air to a material with a different density, it bends. A refraction of 1 equals air. Refractions less than 1 are rare on Earth, but higher refractions occur all the time in nature (see Table 8.1). Not only will this cause the light to bend, but light also partly reflects off of substances with a different refraction index than what it was traveling through. The higher this value is, the stronger both of these effects are.

TABLE 8.1 Refraction Indexes of Some Common Substances

Water (20°C), 1.33283	Alcohol, ethyl (grain), 1.36	Pearl, 1.53–1.69
Ice, 1.309	Crystal, 2.0	Peridot, 1.635–1.690
Milk, 1.35	Diamond, 2.417	Quartz, 1.544–1.553
Glass, crown, 1.52	Emerald, 1.560–1.605	Ruby, 1.757–1.779
Honey, 17% water, 1.494	Obsidian, 1.50	Eye, cornea, 1.38

Caustics occur when the light traveling through a material gets concentrated in an area because of refraction. When this happens, there is less light at the edges of the shadow, and so those are darker (see the following figure). You can enable this effect by clicking on Show Caustics.

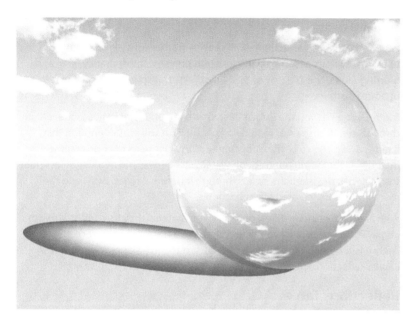

A glass sphere exhibiting several transparency effects including refraction, caustics, and flare. The sphere shape causes the refracted image to be upside down.

As light passes through an object, it can become dispersed much like it does with diffusive lighting, causing the object to seem to glow. This effect is called Flare, and it will occur on the object about where the light would reflect off from it. The previous figure has a good example, with flare surrounding the reflection of the sun. The Span will indicate how much of the surface is involved, and Intensity controls how bright it will be.

The Fuzzy effect will blur the edges of the object with this material and forces the One Sided effect. When you select this, it changes the fading-out slider to deal with fuzziness, having solid at one extreme and fuzzy at the other. The Refraction Index group will also be grayed out. This is a great way to create wispy materials such as clouds, especially when combined with variable transparency. If you've played around with this effect and then disable it, the slider will remain in the same place, but now determine the fading out of light. You'll need to return it to your desired setting.

The Additive effect will disable Cast Shadows in the effects group, and also forces the material to become one sided. Keep this in mind if you're switching

back and forth, since Cast Shadows will not be reenabled if you toggle off the Additive effect, nor will One Sided be disabled. Since this effect is only one sided, you lose some of the bending of the light. The Additive effect makes the color of the object blend into the background, with a tendency to glow where light passes through it. With a refraction index of 1 it can't even be seen below the horizon.

Enabling Variable transparency will cause a Transparency Production box to appear with its accompanying function preview, transparency filter, and blurring filters. This is a way of making objects transparent in some places, but opaque in others.

Fading out gives you the same effect as what happens to light as it travels through semitransparent materials. Eventually, it will scatter enough that it fades away. The color that it becomes as this happens depends on the material. Light fading out through water will be blue. The murkier or less pure the material, the less light travels through it before it fades away, and the more intense the colored effect becomes.

With a refractive index different than 1, the material may turn reflective with angle. The more parallel your line of site is to a transparent surface, the more likely it is for the light to bounce off that surface, like skipping stones. This causes reflection. The effect in Vue looks most realistic at around 40%.

Reflections Tab

In this tab, you can control how reflective your material is. A value of 0% in Global reflectivity will have no reflection beyond normal diffusive light. A value of 100% will reflect all of the light. If there are other effects in action that transmit light, such as Flare in the Transparency tab, you may have more light coming from the object than light that has been directed at the object, causing it to glow. With radiosity, it will in fact be emitting light.

Blurred reflections gives you the same effect as blurred transparencies did. The farther light travels through anything, including air, the more diffuse it becomes. This can cause blurring even if a surface reflects perfectly. Vue recreates this nicely, adding to the realism of your scene, but at the cost of increased render time.

Variable reflectivity enables you to have areas with more reflectivity than others. This is driven by a function. A value of -1, represented by the black areas, will have no reflection and a value of 1 is completely reflective. This is a good way to simulate things like scratched or smudged mirrors, rusted metals, snow and ice, oil puddles on water, and more.

The reflection map does not determine reflectivity. Instead, it is a way to simulate reflection. The reflection map will be wrapped around a sphere and then projected onto the object as if it were being reflected. Using this, rather than real reflections, can considerably reduce render time, but it will not be as accurate. It can be very useful if you have multiple small objects that are reflective. To create a reflection map, place the camera where your object is. Make the object invisible. In Render options, manually set the Aspect Ratio twice as much as the Height. Under that box, enable Panoramic, set it to 360°, and render the picture. Panoramic rendering can take a while. If you're only doing a reflection map consider using a simpler atmosphere that is easier to render (see Chapter 11). You may need to offset it using the U and V so that "reflected" features are in the right position. A good default reflection map will have mostly the large-scale features such as a horizon and sky that match your scene.

Translucency Tab

Unless they are metallic, all materials have some translucency. Light penetrates the surface of the material, bounces off particles within that

material a few times, and then exits the surface in a different direction than it would have if only reflected. This is called subsurface scattering. Things like skin, milk, and marble are very translucent. Translucency adds computation to your material, and will increase render time. So even though nearly everything in your scene could potentially have this trait, it is a good idea to limit it to things that are close enough in the camera to be noticeable.

You can show this effect when you click the box to Enable Subsurface Scattering. With this in place, you'll have several things to consider.

The first is Average Depth. The more translucent a material is, the deeper light penetrates before finding its way back out, so this is a way to control how translucent your material is. The slider has values ranging in increasing increments from 0 millimeter to 10 meters and by default will be found at 1 meter. For most of your needs, this is probably too much. Most real-life translucency occurs from a fraction of a millimeter to about 2 centimeters. However, if you're working with much larger models like snow-covered terrains, this tiny depth will add nothing to the appearance. If you need translucence at those scales, then is a good time for a higher depth.

Balance controls how much light is absorbed, never to be seen again, and how much is multiply scattered through the surface of the material. A value of 0% means that no light that penetrated the surface will exit. A value of 100% means that all of it will be scattered across the surface and seen, making it appear more like it was diffused.

The Refraction Index is the same exact control as in the Transparency tab. When Subsurface Scattering is enabled, this slider is disabled in the Transparency tab and can only be controlled in the Translucency tab. This deals with how much the light is bent as it travels across the boundary between air and a material with different density.

Absorption deals with what direction the light travels as it is scattered. The anisotropy, meaning the directions of scattering, is set at 0, which will cause the light to scatter in all directions. Usually, light tends to scatter forward. As it scatters through an object, some colors will be completely absorbed so that only certain colors are seen on the surface. You can control which colors are seen using the Absorption Filter Color. The light that is seen through skin, for instance, will often be a reddish orange color.

The Scattering Filter Color is basically the same color that you see on the object, which is the color of your material. For the best results, copy the color from Overall Color in your Color and Alpha tab and paste it into the Scattering Filter Color field of the Translucency tab. If you're working with a one-sided plane, then select Use Infinitely Thin Surface Model.

You also have a Quality Boost in Overall Effect Quality. Unless the star of your scene is a highly translucent object, you are not likely to get much benefit

from this. However, if you find you're getting some noise in a translucent material, this could be your solution. For speed of working with your scene, this should be one of the last settings you increase before rendering.

Effects Tab

The Effects tab holds lighting, animating, and a few other effects that are useful for your material.

Within the Lighting set of options you can affect how much diffuse or ambient lighting affects your material. This is set with Diffuse at 60% and Ambient at 40%. You'll notice this adds up to 100%. Changing that ratio would make objects appear too lighted or not lighted enough for the amount of lighting within the scene. In fact, unless you intend to change every single material in your scene, this is a setting to pretty much leave alone, although it can be useful for objects such as clouds (far away and up in the sky) or things that might be expected to act differently.

Luminous will make the material brighter, seeming to emit light. Unless you're working with Global Radiosity, however, it will not actually emit light that can affect other objects.

Contrast controls the edge between lighted areas and shadowed ones. A value of 100% will completely eliminate any blurred edges, while 0% contrast will have very soft edges, where it will be difficult to tell where the shadow begins. This effect does not work when subsurface scattering is enabled.

Metals are highly reflective, but will also change the color of the light. Use Color Reflected Light to get this effect.

If you have a stained-glass window, or some other kind of transparent but colored material, Color Transmitted Light will cause the color of the material to be applied to any light that passes through it.

For objects with no width, you can apply Backlight. This will simulate translucency if there is a light behind the plane. The object doesn't need to be one sided for this to work.

A glowing material will not only be luminescent, but the light will spread out from the material. You can make your object glow by enabling Glowing Material, where you can control the Intensity and the Radius of the light that extends from the object. This is a posteffect, and you won't see it appear until the render is finished. If you want this light to peek around objects that might be in front of your glowing material, you can enable that as well. Like luminosity, this light effect is not actually cast onto anything else in the scene unless you're using Global Radiosity.

If the material applies to your object or terrain with slightly different placement than you'd like, for instance you have a grassy area that you'd rather have in a flat area, you can alter the position where your material will generate from, using the coordinates in Origin of Material. These coordinates can also be used if you want to animate your material. They will correspond to the starting area of your material. Velocity of Material Origin will determine where the origin of material moves using the X and Y coordinates, with Z corresponding to the time it takes to get there. If you're not using the default, which makes Z the vertical axis, then Vue will convert your coordinates in this instance so that Z turns to Y, and Y becomes Z, while X remains X.

The last box in this tab gives you some Global Transformation effects. These will alter all parts of your material. Selecting any of these will let you call up an interface to edit the effect. Global Material Turbulence will apply distortions to things like color and bump maps, using a noise pattern and a method of blending. Chapter 9 will more fully explain noise patterns and blending. You can control the scale, amplitude (the average displacement—a value of 0 will have no distortion), and harmonics (this number will multiply by the scale and amplitude—a value of 1 will change nothing).

Rotation will rotate or twist your material based on the X, Y, and Z coordinates.

Cycling will add a large-scale type of disturbance to reduce repetitiveness. This could be useful if you've used an image map to be tiled across a large terrain. A larger amount will make smaller and more intense perturbations.

Multilayered Materials

You can layer two or more simple materials together to create more complexity in your materials. To do this, click on the Add Layer button between the material browser, which shows you a list of your materials, and the preview pane. This will open the material selection interface to let you choose a material. Mixed, volumetric, and cloud materials can't be used in material

layers. When you've chosen, that new simple material will appear above the old one in the material browser.

With multilayered materials, each layer applies separately onto the object, literally as layers. There are several ways that you can influence how these materials appear together.

Under the preview pane, when any layer but the bottom one is selected, you'll have an Alpha Boost slider. Negative values of this will cause the layer to gain alpha transparency, so that you can see the color of the material underneath. Positive values will make it stronger.

Environment Tab

There are three properties by which you can control how the layers come into view: Altitude constraint, Slope constraint, and Orientation constraint.

- *Altitude constraint* will cause a material to be seen only within a certain range of altitudes. The values range between −1 and +1, with the lowest value corresponding to the minimum altitude and the highest being the maximum.
- *Slope constraint* works on how much of an incline there is. A value of zero represents a vertical angle. Negative values show surfaces that curve to underneath the object and positive values to the right on the slider are gentle slopes leading into flat areas.
- *Orientation constraint* deals the direction that the material will appear in, measured in a span of 360°. The Preferred orientation won't make a difference unless you designate an Orientation Tightness. This will narrow the orientation that the material can be seen. A value of 85% will allow only a 15% span of the material to be seen. This can be useful in instances where wind may have blown debris or snow onto only one side of something.

Fuzziness for all these blends the edge between materials so they fade into each other.

Mixed Materials

Mixed materials work differently than multilayered materials, with each layer blending its properties together. For instance, if you had a layer of red plastic over blue plastic in a multilayer material you would only see the red plastic unless you assigned areas where it wouldn't appear or it had transparencies. In a mixed material, with the materials evenly mixed, it would appear purple. There are several tools to direct how the materials mix.

When you have a parent material selected in the material browser, you'll see a slider for Mixing Proportions just above the tabs. Values much out of the midrange will typically cause the dominant material to overwhelm the other.

When you are mixing materials, you might find it hard to distinguish between two similar materials. This will make it difficult to see their proportions and position. A simple solution is to temporarily replace the materials with contrasting colors. From Vue 6 onward, this is easily accomplished by turning on the markers to the right of each material in the browser list.

There are also two tabs for Mixed Materials: Materials to Mix and Influence of Environment.

Materials to Mix Tab

This tab shows the two materials being mixed, with controls for scale on both of them and an ability to swap them. Next to that is Distribution of Materials, a powerful tool that uses position to determine where each material appears. This is driven by a function and filter that work, as always, with values of -1 and $+1$, corresponding to material 1 and material 2, respectively.

There are several material mixing methods, each of them with subtle effects. For the most part, you'll likely leave it at Simple Blend, which is actually forced when mixed materials are being mixed. This will make both materials appear with their own bumps and coloring. Full Blend (Linear Bumps) will cause a beveled edge between the bumps of both materials, and Full Blend (Cubic Bumps) will have this same beveled edge but it is curved inward a bit. Cover will make it appear even more that material 2 overlays material 1. Color and Lighting Blend Only will cancel out the texture of material 2 so that only the bumps of material 1 can be seen, while the color and lighting of both are mixed.

The Smooth Blending strip causes fuzziness where the edges of the two materials meet.

Influence of Environment Tab

This tab works similarly to the Environment tab when you enable (get ready for the longest label) Distribution of Materials Dependent on Local Slope, Altitude, and Orientation. The controls are different, without as much fine-tuning abilities as those in the Environment tab. In each box you can work with the strength of the influence, slope, or orientation. These have controls to make "Material 2 appear rather" at certain altitudes or slopes or near an azimuth. Present is also the ability to change how the altitude range is determined: per object, per global material (which both act similarly), or absolute (which uses the World Coordinate system).

Speaking of the World Coordinate system, you can make all of this influence depend on that, or on object orientation, in the box labeled Coordinate System.

Using the skills you've learned so far, you'll be able to create highly detailed landscapes with several different layers. With careful attention to each setting

and a knowledge of how real surfaces interact with light, you can create beautiful, realistic textures to fit any object.

Volumetric Materials

These interesting materials fill up the volume rather than just applying to the surface of an object. Volumetric materials are often very popular in online stores and can be exciting to work with.

This is used for things such as smoke, clouds, and nebula in space, even the possibility of running water. You can also get interesting effects like flecks of colored plastic embedded in a glass marble. Using density control and functions, explained in Chapter 9, you can even add some modeling power. Adding luminosity to these kinds of materials can really up the "wow" factor.

You have four possible tabs: Color and Density, Lighting and Effects, Volumetric Color, Hypertexture Material. These last two tabs appear if you selected Volume Shaded or Hypertexture as your lighting model in the Lighting and Effects tab.

Color and Density Tab

The density of your material is somewhat similar to opacity. The denser your material is, the less you can see through it. This is controlled with a function and filter in Density Production, where −1 equals no density and 1 is completely solid. In visual terms, this means that black areas will have no density and white ones will be solid.

Volumetric Settings are where you can set your color. There is also a slider for Overall Density, which will direct the average density. Fuzziness blurs the border between different densities. Quality Boost can reduce artifacts such as graininess, but as in other cases, this isn't a front-line setting. Change it

if, after doing some test rendering, you find you're unsatisfied with how the volumetric material appears.

To simulate the effect of distance when looking through a semidense material, you can enable Use Distance Field. This works by making the material denser the deeper it is in the object.

Lighting and Effects Tab

There are five different lighting models for a volumetric material that instructs Vue how to compute their color, brightness, and effect on the scene.

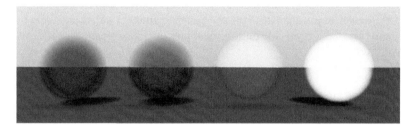

From left to right are Uniform, Shaded, Additive, and Volume-shaded lighting models. All the objects are the same density, and all but volume-shaded lighting are the same color.

Uniform lighting will only compute the color of the material, making it the fastest to render. With Shaded, the effect of light and shadows on the surface of the material is determined. The material appears a bit darker with shaded than with uniform. The Additive model will add the background color to the color of the material, making it more luminous. Volume-shaded lighting will measure the light contribution throughout the entire volume rather than just at the surface. This takes the longest to render of the nonsolid volumetric materials, but allows for multicolored materials. Hypertexture is not a lighting model, but is a combination of solid and volumetric that allows for deeply textured or porous materials.

The Diffuse, Ambient, and Luminous settings here are similar to the ones in the Effects tab of simple and mixed materials. Once again, Diffuse is the light that is scattered off the surface from direct lighting, Ambient is the light that comes from the overall lighting in an area, and Luminous controls if the object will seem to glow or not. Remember, of course, that it only emits light if the Global Radiosity lighting is being used.

Flare also works similarly to the Flare setting in the Transparent tab, except that it refers to lighting that passes through an object from behind.

The Lighting and Effects tab also has some settings like the ones in the Effects tab: The Origin of Material lets you offset the material, Velocity of Material will let you animate (think smoke, fire, or running water), and Global Transformation lets you add turbulence, rotate, or reduce repetitiveness with cycling.

Volumetric Color Tab

With Volume-shaded materials, you can work with more than one color. This requires an ability to direct color production, which you get in the Volumetric color tab. These controls work very much like the procedural colors in the Color and Alpha tab, except that now you could have colors differ throughout the volume. The functions distributing color will automatically take care of this extra calculation.

Hypertexture Material

When you create a hypertexture material, the first thing you should do is go into the Lighting and Effects tab and change the lighting model to Hypertexture. Any color or density information you might have entered before this will be discarded.

Once you're working with a hypertexture material, a simple tab with controls to choose a material appears. It isn't helpful to choose a volumetric material for this, since the information for creating the density will remain, but won't affect the appearance and would have to be duplicated. This could make your material bulky in terms of computation. However, layered and mixed materials can be used and can give some nice effects.

With a material to work with, now you can work with the density. This material will remain a solid no matter what. In overall density, if the value goes below 5, the material will disappear from view. This is also true if the density is driven by a function. Any value below 0 will cause the material to not be seen.

Tutorial 8: Cookies and Milk

In this delicious scene, you'll work with mixed materials and transparency
to create almost every material you see, plus the objects to use them with.
You'll be loading several functions and working with color maps, filters, and
different settings to achieve three different materials.

Step 1

Start a new scene in Vue. The first thing you'll do is to make a cookie. Create a
sphere, then double-click on it to edit the material. If you aren't already in the
Advanced Material Editor, switch to that. In the Color and Alpha tab, right-
click on the color map, then select "Edit Color Map." Right-click on the Current
Color, selecting "Edit Color." Make it a light tan. Create a new keycolor at the

far left, and using the same method, make a darker tan. This range of colors should resemble what you might see in the cookie.

Step 2

Now, in the Color Production preview, right-click > Load Function. While these functions have some specific purposes, many are very interchangeable. In the Bumps collection choose "Pitted surface." Now you do want some bumpiness in the cookie part of your material, so go to the Bumps tab. You'll also load a function here. "Simple Rock Soft" in Fractals will give the right slightly lumpy effect. To really make it work well, enable Displacement Mapping.

Step 3

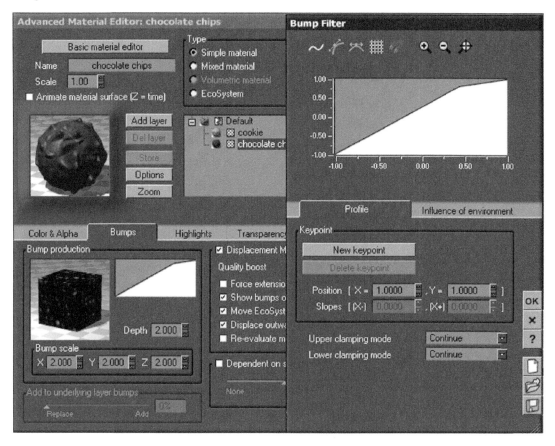

Click on Mixed Materials. In the new material, go to the Color and Alpha tab. Right-click on the color map, and select "Load Color Map." Choose "Rust" from Solid Colors. Click "OK," then right-click again and select "Edit Color Map." Change the Current Color so that it is a nice chocolate brown. Click "OK." Now in the Bumps tab, right-click on the Bump Production preview to load a function. For something really bumpy, choose "Basic > Pebble noise." Click on Displacement Mapping to enable it. They still won't be quite what you need. There are three things you can do. First, increase the Bump scale in X, Y, and Z each to 2. Now you have them about the right size, but you need them more prominent and tall. Increase the Depth to 2.0 and right-click on the Filter to edit it. About one-quarter of the way from the right, make a keypoint and bring it up a bit. This will give strong white areas, and so stronger bumps. Click "OK."

Step 4

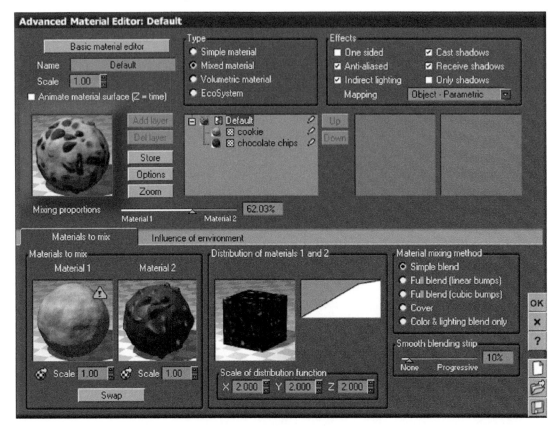

Now go to the Highlights tab. Make sure the Highlight Color is white. Bring the **Highlight** Global Intensity down to 19%. This finishes the chocolate. Clicking on the top, parent material you'll see how your materials are distributed. At this point, it doesn't work at all. What you need is the Distribution of Materials to reveal only the chocolate chip bumps. To do this, duplicate what you did in the Bumps tab. Load "Basic > Pebble noise" into the Distribution of Materials 1 and 2 function, increase the Scale of X, Y, and Z to 2, and copy the filter you made in the previous step. Now increase the Mixing Proportions (found under the material preview and list) to about 62%. This is very close, but one more thing might help. Go back to the chocolate chips material. In the Bumps tab, under Displacement Mapping, enable Displace Outwards Only. Now go back to the parent material and check. Click "OK."

Step 5

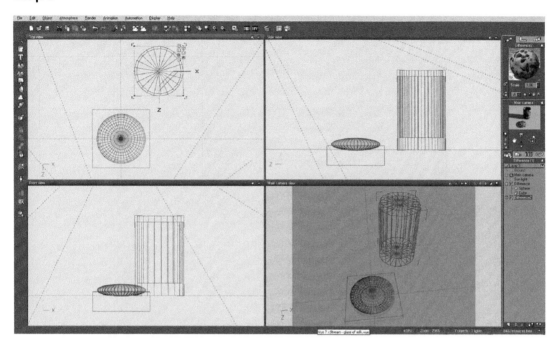

Take the sphere that you just created this material on and squish it down to a thin disk. Create a cube and make it a bit bigger. Position it on the sphere so you clip off the lower half, making a cookie shape out of the sphere. In the left toolbar, click Boolean operation. There is your cookie. To go with your cookie, you're going to want a glass of milk. Go to Primitive Objects and create a cylinder. Now duplicate the cylinder so it is in the same place. Scale the second cylinder down in size just a bit, and then lift that second, smaller cylinder up just a bit. Select the first cylinder, then the second, and carry out a Boolean difference on them. One thing you may notice is that the last material used (in this case, the chocolate chip cookie) is what is applied to newly created objects.

Step 6

With the new difference unfolded, select the first cylinder, the outer one.
Double-click on the preview in the Aspect tab. Now double-click on the
preview in the Material Editor. Choose "Light glass" from the Glasses collection.
For some texture on the glass, go to the Bumps tab. Under Bump Production
right-click and Load Function. Select "Spots > Soft spots." Now in the Highlights
tab make the Highlight Global Intensity 63% and the Highlight Global Size
59%. Click "OK." The second inner sphere will be the inside of the glass, which
you want smooth. Just click on the Load Materials icon in the Aspect tab and
choose the same "Light glass."

Step 7

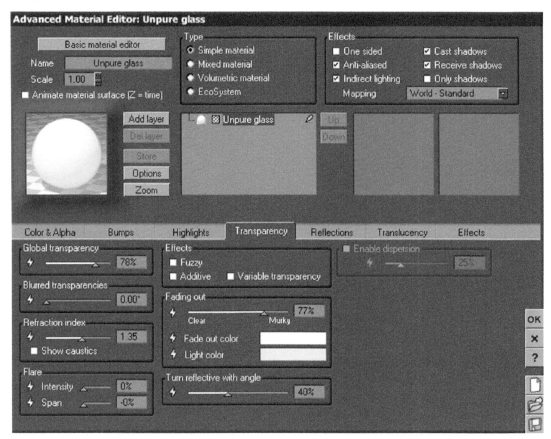

To create the milk, duplicate the second, inner cylinder. Keep this one in place but flatten it down, so that it is fully contained in the drinking glass you just created. Load a new material onto it, choosing "Unpure glass" from the Glasses collection. Double-click on the material sphere to open the Material Editor. Switch to the Transparency tab. Reduce Global Transparency to 78%. Change the Refraction Index to 1.35 for milk and disable Show Caustics. In the fading-out group, make the Murkiness 76%. Change the Light Color to an unsaturated light blue. Click "OK." You may want to group this cylinder with the glass to make sure that the milk stays in it when you move it.

Step 8

Now for a quick display, click on the Load Object icon and bring "Saucer" from the Interior collection of objects into the scene. If you want, you can edit the material of the plate to change its color. Arrange your plate and glass. Create a couple more cookies, move them over the plate, and use the Smart Drop feature by right-clicking on the Drop icon in the left toolbar to put the cookies on the plate. This will automatically place them so they lean on other cookies and the plate.

Happy Little Farm *Luigi Marini*

Fun with Functions and Filters

It is almost impossible to avoid functions or filters if you create any of your own materials. Up until now, you may have stuck to only loading functions, but sometimes found yourself a little frustrated because you couldn't get quite the mix of colors or transparency that you wanted. Though they may be daunting, these tools offer you the power to create an infinite variety of materials. In this chapter, you'll learn exactly how they interact and work to generate the colors and textures that make up your scene.

Filters

You'll see filters both inside and outside of the Function Editor. Filters take one value and convert it to another based on a graph that is both easy to see and change. You see the filter graph in lots of panels. To edit it, you'll need to right-click on the graph and select "Edit Filter." You can, of course, choose to load a graph instead, which may give you just the result you want. You can invert numbers, change things so that any number turns into a single constant, or make it so that only the highest numbers are reduced just a little.

The numbers along the horizontal ruler of the filter are the ones that are input into the filter. Those on the vertical ruler are the number that the filter will output. A filter that doesn't change the number at all will have a simple diagonal line moving from the bottom left to the top right. To change the shape of this line, you'll need to add a keypoint. This is easily accomplished by double-clicking on the line. If you maintain the second click, you'll be able to move the keypoint up and down the line and to any point in the graph. You'll see as you do this how the shape of the graph changes. The setup of this control creates a pleasantly intuitive way to alter the filter graph.

If you click on New Keypoint, the last point you clicked on the graph will be changed into a keypoint and the graph line will change shape so that it is connected to it. You can click on any keypoint on the line to move them, allowing you to tweak any shape that you've created. You'll also notice that you are unable to move any keypoint to the left or right of any other keypoint. This is simply because you can't have two of the same values along the horizontal line, as that line represents the original, static range of values.

You can also control any keypoint precisely with the number values of position and slope. Position X is along the horizontal axis, and Y is along the vertical axis. The slopes refer to the value above and below the keypoint on the vertical axis, and are measured from 0 to 2. For example, if you have a keypoint set with X at 0 and Y at −0.5 it will be right in the middle of the bottom ruler and be at −0.5

on the vertical one, which is one-quarter of the way up. The X− slope value is below the keypoint and is 0.5, while the X+ value above the keypoint is 1.5.

To make the graph curve, click on the Curve icon in the upper right. Every sharp angle will now be rounded out. Once you've done that, you'll be able to use tangents to alter the curves and smooth joints. You'll still be able add and move keypoints. Every change while the graph is in curve mode will be rounded out.

Clicking on the Grid icon will let you see a grid for more accurate visualization of the values. The magnet activates with the grid and will let you snap keypoints to the grid, another feature to allow more accurate control.

So, what is all this good for? Remember the color map in Chapter 8 and putting colors at points with exact values? With a filter, you can control whether certain colors on the map are suppressed or made more frequent. Similarly, it will control other values like height and transparency. You may recall the terrain filters in Chapter 4, or the fact that alpha values and maps have total transparency at 1, the white value, and total opacity at −1, the black value, with possibility for all values in between. Let's say you wanted to make everything that was opaque have just a bit of transparency without changing the alpha map. You could apply a filter that would convert 1 to something just below, like 0.75. You'd do this by adding a keypoint where X, Y is (1, 1) and then push it down so that X, Y is (1, 0.75).

Influence of Environment

If the filter is part of something that can be affected by the environment, you'll have a tab to deal with this in the Filter Editor. These controls work just like those in the Influence of Environment tab of the Material Editor. This could be useful, for instance, on a mountain in the early fall where the leaves have changed their color higher up, but remain green at the base. It could also make a gently sloping pile of rocks at the bottom of a steeper mountain have more exaggerated bumps. It is also a great way to subtly change the colors and textures of rocks at different altitudes in canyon-type scenes, adding a lot to the realism.

How Functions Work

Functions also convert one value to another value. There are three parts to a function: an input, a node, and an output. The input is the value you start out with. The node is where that value is changed, by an equation or some other operation. And the output is the number that results.

This function has a number value of 2 as the input, the very simple equation that adds 3 to any input number, resulting in an output of 5.

The node can be simple or complex and built up of several different nodes. Each node in a complex function will take the input from the node before it, convert that, and then pass along its output to the next node in line. Sometimes, a node will take two or more values and combine them to output a single value. They may also generate more than one output.

This more complex function describes what happens when you buy a candy bar at a store using a 10%-off coupon.

Functions in Vue

In Vue, functions are graphed in a straightforward manner that makes it easy for you to see and work with them. Along the top of the graph are several standard inputs. Nodes are placed in the middle, and outputs can be seen at the bottom of the graph. Because the inputs and outputs are not values themselves, but request and then output values from and to the environment, they are called input nodes and output nodes.

In this function graph you can see the function that creates the "Gray Mountain Rocks" material.

You'll also see in the figure here that there are colored links connecting the nodes. These colors represent what kind of value is being passed from node to node. Vue has four different kinds of values that it works with:

- *Numbers (blue links):* Numbers can be any value, but almost always you'll find the values range from −1 to +1. This doesn't mean that the value will always look like a number to you, the artist. Fractal and noise nodes, for example, both have graphic representations that make the effect they'll have quite clear.
- *Color information (green links):* This information is also very visible in the form of color maps.
- *Texture coordinates (purple links):* These are number values, but there are two that describe a two-dimensional (2D) position.
- *Vector data (red links):* Three numbers describe the X, Y, and Z coordinates of a three-dimensional (3D) position of a point.

If you see a gray link, it means that Vue cannot define what kind of value or data are being passed.

A good way to grasp how functions work in Vue is to go over a couple of examples. Color information comes in the form of color maps (see Chapter 8). These have a value range from −1 to +1 at each end. You may also remember that without anything else, only an average of the color will be seen. To get a variety of color over the surface, you need a node that will output different values across the surface of your material. A noise node will do this very well.

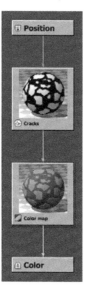

In the figures to the left and middle you see that the noise node has only values of black and white, illustrating how black outputs a −1 value, which corresponds to red in this color map, and white will give a value of 1, which is blue. If the noise node has grays in it, you'll see other colors in the color map, as shown at the right.

Function Editor

The function graph is accessed through the Function Editor. Surrounding the graph you'll find a layout similar to most Vue interfaces, with the top toolbar containing editing and interface operations, the left side containing a toolbar full of nodes, and the bottom showing you details about the selected link, node, or MetaNode, as well as their settings.

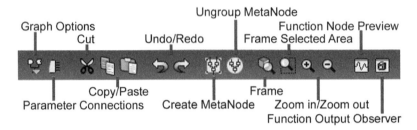

Graph Options will make it possible for you to decide if you want the nodes to show previews of what the function will output or not. You can find an option to make your links straight lines or if they take corners around all the nodes, and if they have arrows.

To see what inputs and outputs each node has, turn on Show Parameter Connections (it will be on if it is orange and the button appears pressed in). Two other tools unique to the Function Editor are the Create Metanode and Ungroup Metanode, which will be discussed more later on in the chapter. The last two function tools give you a window into what the node is doing.

To get a color or number value for each location, Vue calculates the output of the function for the vectors X, Y, and Z. Some artists might find this information useful, so the Function Node Preview is a graph showing those values. For color information, this shows each color at each vector. For other number values, you'll see a curve in the graph. If the output is a vector value itself, either texture coordinates or vector data, then there really isn't any other value to graph so it doesn't show up. You can access this by pressing the Graph icon in the top toolbar.

The Function Output Observer is a very useful tool that shows you what the simple material will look like with all the nodes working together in the function.

Function Nodes

The function nodes, seen in the left toolbar, are the math widgets that make up the machinery of functions. Some of these are simple, even having just a single value. Others may contain equations that are highly complex. Luckily,

these have a visual preview that will let you see just what they're doing. And what they do is pretty cool! You can have clouds or swirls of color, stripes, cracks, random dots or squares, ocean waves, and more. Now that you have the concept of a color or a height map with values from −1 to +1 and a grayscale map controlling them, you can create anything you can imagine with function nodes giving you precise control over them.

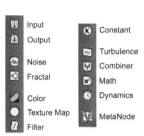

The following is a list of the nodes with an explanation of what they can do. At the end of the chapter, you'll find a guide that will go into detail about the different varieties available with each type of node.

- *Input Node:* These nodes offer the initial value that will be put through the function. You'll find them along the top of the function graph, with a few that are always there depending on what kind of object you're working with. These include Position, Normal, Altitude, Slope, Orientation, and Time. These default input nodes refer to characteristics that describe the object or global environment. There are quite a few other input nodes as well.
- *Output Node:* You'll find output nodes along the bottom of the function graph. These nodes drive the settings in the Material or Terrain Editors they refer to. For every setting with a lightning bolt or a function preview pane, there is an output node. Several of these are also default. They are Color, Alpha, Bump, Highlight, Transparency, and Reflection.
- *Noise Node:* A noise node gives you a patterned variation in the values from −1 to +1, visually shown in black and white, respectively. These are the source of a good, random appearance.
- *Fractal Node:* Similar to noise nodes, these will calculate the same patterns as noise nodes but with more complication. They'll calculate the pattern more than once, each time at a different frequency. This allows you to have much more detail.
- *Color Node:* The most often used color node is the color map, which you're already familiar with (see Chapter 8). However, there are quite a few other things that can be done with color information, such as color correction.
- *Texture Map Node:* This is the node you'll use if you want to use an image in your function—for instance, a texture created from a picture of real grass.
- *Filter Node:* This node will let you embed a filter right in your function. There are several other math operations as well that can convert numbers into other numbers.
- *Constant Node:* A constant node doesn't take any inputs, but will output a single value depending on what type it is.
- *Turbulence Node:* A turbulence node is like a noise node, except that it works with the geometry using vector values. It is most commonly used to produce waves such as you would see on sand or water.
- *Combiner Node:* This node will take two or more values and combine them to output one value.

- *Math Node:* This has some conversions similar to what the filter has, but offers quite a few other math operations and can perform conversions between different value types.
- *Dynamics Node (new to Vue 7):* These nodes work with links between different objects, and so are only useful in object graphs.
- *Load MetaNode (new to Vue 7):* MetaNodes are several different nodes combined into one node, usually with a few settings you can play around with. This will give you the ability to save complicated function setups for use later, and have the important settings from different nodes conveniently gathered in one place.

Creating Functions

Sometimes, when you enter the Function Editor, a few nodes will already be working on the properties of your object. For example, if you edit the function from the Color and Alpha tab of a default material, you'll find a constant node, followed by a filter, and a color map that outputs into both the color and

alpha output nodes. If you were to delete the color map, you'd find that the material will turn gray. If you want a different color in your color map, click on the color map node to select it. In the node details panel at the bottom, you'll see the color map field. Right-click and load or edit a color map just like in the Material Editor. For this example, a simple red, green, and blue color map can be used, as shown in the following figure.

At this point, the color output will still only give an average value for the map. For some variety of color on the surface of your material, you'll need to replace the constant node with a noise node or a fractal node, or possibly a grayscale image in the texture map. On the other hand, you could also use a texture map (for instance, a picture of bark) instead of a color map to generate the color. For now, just use a simple noise node. When you click on it, it will automatically be set to Perlin Noises, since this is the simplest calculation to get a "random" pattern, which is the most common use for noise nodes.

You'll notice that once you replaced the constant, the noise node connects itself to the position input node. This is because the color will vary by position

on the surface of the material, and so it needs that input. Vue anticipates this and automatically connects them. At this point, click on the Function Output Observer icon. You'll see the results of the combined nodes, which at this point you can also see in the color map. You'll notice that the filter node doesn't do anything. Therefore, you can just delete it. Do this by selecting the filter node and then clicking on the Scissors icon to cut it or pressing the Delete button on your keyboard. What will happen is that the function node disappears, but the link between the noise node and color map will remain. This is Vue's SmartGraph™ at work, in this case anticipating where to fix a broken link.

At this point, maybe some texture would be nice. To get texture, you would need to use the bump output node, which at this point has nothing. Even though you entered the Function Editor through the Color and Alpha tab, you can alter the function of any output node, no matter which property preview you entered through. However, keep in mind that if you save the function (by pressing the Disk icon at the lower right of the interface panel), only those nodes connected to the master node, the one you entered the Function Editor

through, will be saved. There is a way around this by creating a MetaNode, which is discussed in the next section.

To create a new node for the bump map, click somewhere above the bump node in the empty field of the function graph. A red rectangle will appear. When you select a node, the node will replace that rectangle. Choose another noise node, and this time in the dropdown menu in the details panel select "Cellular Patterns > Voronoi." The noise node will once again be connected to the position input, but won't automatically connect to the bump output node, since that could be connected to any of the output nodes. To connect the bump output node, hover your mouse over the connector line in the middle of the bump node. You should see a blue triangle appear.

Grab it. A line will appear that you can drag around. Also, a circle will appear around every area that you can connect the line to. Since you are connecting an output node, these circles will all be outputs of the nodes. They will also be reduced by what kind of value the bump map expects—that is, the bump map can only take in number values, so you can't connect it to the position

input since that gives vector coordinates. In this case, you want to connect your line to the new Voronoi noise node you just created.

At this point, you won't be able to see the result of what your function is doing by simply looking at the color map node. Click on the Function Output Observer icon to bring up a preview of the entire function. You can make this as big as you like.

Let's say you want the blue and the red to appear more strongly. If you try to edit the color map, you'll find you can only push the red farther in. The keypoint at value 1, which is blue, can't be moved. This is exactly where a filter will become useful, but you deleted the filter earlier. You can easily add it back.

When you need to have a node in between two other nodes, click on the link between them to highlight it, and then add your node in. With a filter now in place, right-click on the filter preview in the details panel. Red has the value of −1 in the color map. To make it appear more, you want to force that number to come through even with higher values. Remember, the horizontal ruler shows what values are input. Create a keypoint close to the bottom left. Then pull it all the way down and to the right a bit, so the output remains −1 up to where the input is −0.75. For the blue, create a keypoint near the top right and push it up and to the left. You'll see the results of your work with the

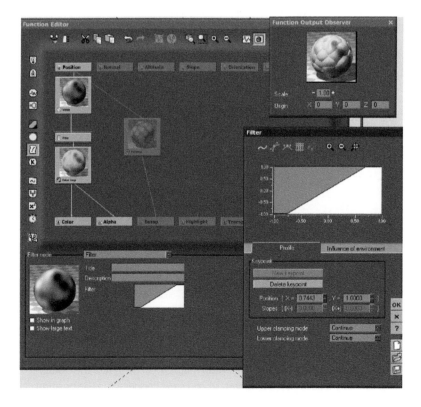

filter immediately in the color map preview and the output observer. Try playing around with it, making peaks or a solid line, or making the diagonal go in the opposite way. You'll find you can make some pretty cool results.

A Few More Tips

You can replace already existing nodes with other ones. For instance, you may decide you want to use a fractal node instead of a noise node. When you do this, Vue will determine what is the most appropriate kind of that node to use; for example, if you've used a Voronoi noise node, and replace it with a fractal, Vue will make it a Voronoi fractal. This fractal may behave differently from the way it would if you'd started with it instead of replacing a noise node. This is because it takes the value that was the noise node and recalculates it. If there was no node before, it uses its own default value.

Sometimes a node you replaced had extra nodes; for example, a texture map may have a UV Coordinates input node. These nodes are not always deleted, but will be left floating. Even though it may not affect your function, it's always a good idea to clean up by deleting them.

Also, while creating your function, you may find that parts of it go out of field, so you can't see it. You can easily get it by clicking on the Frame button in the top toolbar.

If you want to delete a link, but keep a node, you can grab the link and pull it off.

MetaNodes

You can combine all of your nodes into one single MetaNode. This could be useful for several reasons. If the function is very complicated, and there are only a handful of settings throughout all the nodes that you want to be able to change, this can help. Also, if you want to save the whole function, but many of the nodes don't connect to the master output nodes (the ones you entered the function editor through), you can save them as a MetaNode. Another advantage of MetaNodes is that you can use them in other scene files. You can even let other people use them.

To create a MetaNode, click in an empty corner of the field, and then drag the resulting rectangle to capture all the nodes you want included. This will select them. Click on the Create MetaNode icon in the top toolbar. When you've done that, all the nodes will collapse into one. You'll be able to change things inside of them by selecting the Edit Graph button in the details view below. When you're working on a MetaNode, sometimes the graph won't appear as it did when it was a simple function—that is, new position input nodes with no values appear with each branch. Don't worry too much about this. It will still work as it did before.

A good reason to edit your MetaNode is to make some settings available in the MetaNode details without having to go into it, which is especially useful if you intend to lock it. Click on the node with the setting you'd like to change. When you're editing MetaNodes, you'll see a bent little arrow next to each setting. Clicking on this will pull up a Publish As dialog, asking you to name the setting. Name it well, so you know what effect it will have, and click "OK." Now, click "OK" to exit the Metanode function editor. In the details view, you'll now see those settings there. Let's say you love the pattern you've got, but you'd like to be able to change the color. You'll need to go into the color node of your MetaNode function, click on the Publish icon next to the color map, and name it. Then you'll be able to change the color outside of the MetaNode.

Use the Lock button carefully, if you want to share your MetaNode, but not the secret combinations inside. Once locked, you'll never be able to edit it again. It's a good idea to save a version of it just before you lock the MetaNode. To save your MetaNode, simply click the Save button from your graph options. Clicking on the Disk icon in the lower right will only save a function. When you save it, be sure to enter a title and a description telling what to expect from it. Making mention of the inputs and outputs in the description may also be helpful to others.

When you load a MetaNode from the e-on collection or elsewhere, you'll see that it has several connectors. You'll need to connect the node to the appropriate input and output nodes. The colors of the connectors will give you a clue as to where to put it, should you not know. Also, as you connect a link from an output node, you'll see that it asks you which information you're asking for.

Inside a MetaNode, you'll see these connectors appear as extra inputs. Don't delete these. If you do, you won't be able to connect the MetaNode to any of the inputs it needs.

Object Graphing

Another new feature to Vue 7 is the Object Graph. This is the Function Editor by another name. It works with the location and size of objects instead of materials or terrains. This is a very powerful way to control your animation. Imagine causing one object to follow another, or the camera to do the same. A full balloon that has been let go will flutter about the room getting smaller and moving slower. You can easily control the flapping of wings, moving wheels on a car, etc.

Now that you know the basic anatomy of a Vue function and how to build one, it is time to discover all the different nodes there are. And there are a lot of them. You'll find a special bonus "Function Guide" section on the book's web site to help you know exactly what each function does.

Tutorial 9: Library Courtyard at Dawn

In this tutorial, you'll create a scene of a small courtyard with a bench and the light just coming into it. You'll start by creating an elaborate material with five layers to dress some old buildings. All of these layers work with the Function Editor and one will even be built from scratch. You'll work with color maps and filters. When the material is done, you'll arrange a couple of cubes and add a few plants, some lighting, and, for a finishing touch, a bench.

Step 1

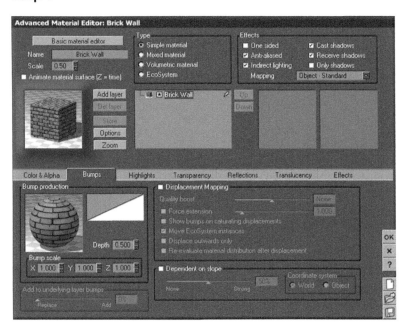

Start a new scene in Vue. Create a cube. With the cube selected, double-click on the material preview in the Aspect tab to open the Material Editor. Make sure you're using the Advanced Material Editor. Here, double-click on the material preview to open up the material browser. In the Displacement Materials collection, select "Brick Wall" for your base material. Because you'll only be looking at it from the front, you don't need the displacement mapping here. It will unnecessarily increase the render time. Go to the Bumps tab and disable Displacement Mapping.

Step 2

Now click on the Add Layer button. Close the material browser. In the Color and Alpha tab, double-click on the color map field to select a color map. Choose "Foliage" from the Rocks and Grass collection. Now right-click on the newly loaded color map and select "Edit color map." Move the middle keycolor to position 0.16 and right-click > Edit Color. Bring the color pointer down to create an olive green color. Click "OK." Now, click on the bottom color map ruler. Move that position to −0.50 and click on New Keycolor. Make a slightly desaturated yellow-tan, dead-grass-looking color. Click "OK."

Step 3

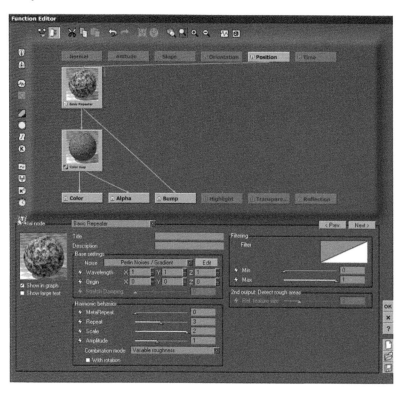

Right-click on the function preview in Color Production and select "Edit Function." You will already have some nodes there. Connect the Alpha output to the color map. Delete the Filter node between the color map and the K (constant) node. Select the constant node and replace it with a fractal node. In the dropdown list, select "Basic Repeater" for the fractal. By default, the base settings noise should be Perlin Noises/Gradient. You'll want a much smaller scale with more details. In the Harmonic behavior group, slide "Repeat to 3" (this is for smaller details) and type "0.2" in the Scale value. You'll get bigger variation with Amplitude at 1. Now you can use that same fractal to run the bump map as well. Connect the Bump output to the basic repeater node you just created.

Step 4

Now for some transparency, click in an empty area of the field over the transparency output. Choose a fractal node for this and once again make it a basic repeater with Perlin Noises. For smaller details, move the Repeat up to 4, slide the Scale down to 0.5, and make the Amplitude 0.7. Now connect the transparency output to the fractal node using the altitude input when prompted. Click "OK." In the Transparency tab, reduce Global transparency to about 85% so you can see this layer better. Name this layer "Global Moss." Make sure that in the Environment tab you have the full −1 to +1 altitude range in the Altitude constraint, so you don't have the material appearing just on the top or bottom. Now to get the right amount of moss covering the brick, slide the Alpha Boost to +44%.

Step 5

Add another layer. This time choose "Gray Clumps" from the Rocks and Grasses collection. In the Color and Alpha tab, on the color map right-click and select "Edit Color Map." Change the keycolor at the −.52 position to a reddish brown. For more brown in it, right-click on the filter and choose "Edit Filter." Bring the far-right keypoint down about one-third of the way. This will get rid of the white in the color map. Now at about 0 on the horizontal, double-click to create a keypoint and pull it down so Y is about −0.90. Click "OK."

Step 6

Now go to the Bump tab and right-click > Edit Function in the preview
window. Before working with bumps, make sure you have the Alpha tab
connected to the color map. The function for this material has some artifacts
in it. Go ahead and delete the orphaned color map node branch. There will
already be a simple fractal node for the Bump output, but something with
more contrast will give a better mud effect. Increase the Largest Feature to
about 17, make the Smallest Feature 0 or below, increase the Roughness to 1,
and make the Gain about 0.64.

Step 7

Now you'll want to use a slightly different version of this node for Transparency. With the node selected, click on the Copy icon. Next, click in an empty section of the field and select Paste. Connect the Transparency output to the new node and select Altitude when prompted. Now what you want is pure black and white contrast, making it simply transparent or not, just like mud. To do this, just increase the Gain all the way to 10. Click "OK." The last things you'll want to do for this are increase the Alpha Boost to 100 and use Standard for the Mapping Object.

Step 8

Add one more layer; this time it will be the stucco. Choose "Default" from the Rocks and Grasses collection. Slide the Alpha Boost to −15%. Now in the Color and Alpha tab change the color map to "Sand" from the Rocks and Grasses color maps. Right-click > Edit Function on the preview window. Delete the filter. Replace the constant node with a simple fractal node. For a slightly less subtle variability, in the settings, decrease the Largest Feature to about 6.7 and the increase the Roughness to 0.7. Connect the Alpha output to the color map node.

Step 9

Click on the empty field over the Transparency output and add another fractal node, making it a variable roughness fractal node. This node will give you more detail than the simple fractal node. Connect it to the Transparency output, choosing Altitude on prompting. Change the Largest Feature to 7.7, Roughness to 0.97, and Gain to 3.64. Now, in the Variable Roughness group, reduce Smooth Level to −1 and raise Creep In to 0.5 to add some white roughness into the black. Click "OK." There is an occasional bug where Transparency is ignored. If this happens to you, click on the lightning bolt in the Global Transparency group of the Transparency tab. This will bring you into the Function Editor with a new Global Transparency output. Connect this output to the fractal you just created. It's not perfect, but it's a good workaround.

Step 10

Very old stucco tends to wear out at the bottom first. So go into the Environment tab and narrow the Altitude range so that it is about 0–1. Increase the fuzziness on the bottom to 39%. Click "OK" on the Material Editor. Your cube may be too small to simulate a building, so resize it so that it is about 25 meters square. Also move it 25 meters in front of the camera and to the right. To create the little courtyard, you'll need another cube. Duplicate it by pressing the Alt key while moving the cube. Place this new one to the left side of the camera, moving it so there is a corner apparent to the camera, but leave a gap between the buildings for lighting purposes later.

Step 11

To grow some ivy onto the buildings, go back into the Material Editor by double-clicking on the Aspect tab of the second cube. With the Default layer selected, click on EcoSystem. In the General tab, you'll have the EcoSystem population. Click the Add button, choose Plant, and select "Small Grassfield Plant" from the Grasses and Plants collection. Now click on Paint. In the EcoSystem Painter change the Tool to Brush. Uncheck Limit Density and increase the Scale to about 5. In the side view start painting on some ivy. You won't be able to see the plant instances until you release the brush, so don't worry too much if they don't appear immediately. They might look more interesting if the plants are a bit denser at the corner. Now do the same with the first cube, but use the front view to paint it.

Step 12

Load the "bench.vob" file from the Tutorial Pack found on the book's web site. Place it against the second cube and near the corner. Edit the material for the bench, add an EcoSystem with the Small Grassfield Plant, and paint the bench as well. You might get better results here if you limit the density to 50. If you want, go back to the cube the bench is against and paint on a bit more ivy trailing up from the bench.

Step 13

At this point, it might be a good idea to set the camera up. First, change the Focal in the Aspect tab to 55 millimeters. Move it close to the ground and forward, so the bench is near the left edge, occupying about the first third of the image. Point it up just enough so that you can't see the ground. Now add some trees and place them in front of the bench. In this scene, three trees—Large European Ash-Spring Bright Green; Winter Tree D; and Alder, Late Spring—were arranged to give some nice foliage with branches appearing on the left side of the image. To get them just right, you might do things like resize and rotate them as well as move them around.

Step 14

The last step involves the lighting. Even though the sky is not seen, the atmosphere is part of the image. Load the "springmorning.atm" file from the Tutorial Pack from the book's web site. If all your EcoSystem instances disappear, select each object, Edit Material, and go into the Paint tool. This will remember what you painted and they will reappear. Now, right-click on the Light icon, and select a Point Light to add to the scene. Move it so that it

is near the second building, just out from between the gaps, and 13 meters up. To create a light beam, create a cube. Load the "Basic > Flat Black" material onto it. Move it between the gap of the cube buildings. Increase the height of the cube and shorten the width so it is a wall filling up the gap, about 11.5 meters high. When you're happy with the lighting and arrangement, select the right render settings and render your picture.

Populating Your World

As you can imagine, it could get tedious placing a plant or a rock one by one into your scene. Vue's EcoSystem is the solution to this problem. Accessed through the Advanced Material Editor, the EcoSystem is a material layer, with selected objects placed randomly wherever the material is. You can create a forest of trees in seconds. The EcoSystem has the Paint tool, where instead of an automatic scattered distribution, you paint single or several instances over an area. The Paint tool is also available outside of the EcoSystem, in the top toolbar. When you use it that way, it doesn't apply on a material but directly onto an object.

As you learn more about how the EcoSystem tool works, you'll see the benefits of having multiple layers in your material. Objects such as different plants, rocks, leaves, and other natural debris behave differently. This is true in cityscapes as well. People are scattered on sidewalks, where there may be lampposts at regular intervals and cars are only in streets.

EcoSystem

The EcoSystem is accessed from the Advanced Material Editor when you switch the material type to EcoSystem. At that point, a new layer will be created in the browser with a tree symbol next to it marking it as the

EcoSystem layer. You'll also have five different tabs appear to manage your population of objects: the General tab, Density tab, Scaling and Orientation tab, Color tab, and Environment tab.

General Tab

This tab is where it all begins. The first thing you'll need to do is add something. In EcoSystem Population you'll find two buttons to add and remove. Clicking on the Add button will bring you a dropdown menu asking if you like to add a rock, plant, or other object. Rocks are objects that Vue creates with a random polygon mesh designed to look, well, rocky. Outside of the EcoSystem you can apply different materials to rocks. Within it, you'll use the default rock material, but it will ask if you want the objects to have color variations. Whether or not you do really depends on the scene you're creating.

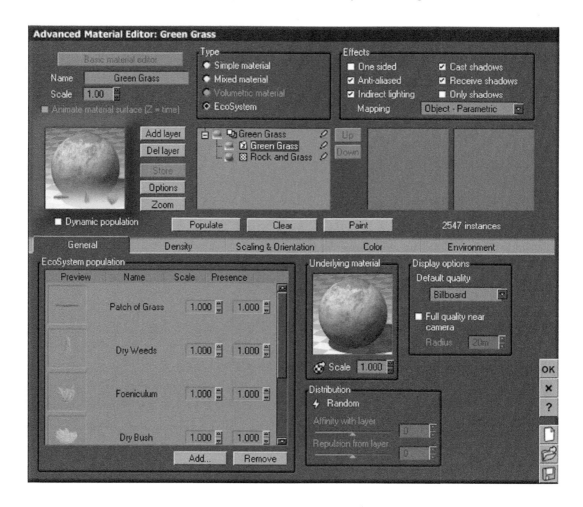

Plants are likely to be what you want to use the most, but require some consideration. In the OpenGL views they may appear different if using billboard display, but every instance generated by the EcoSystem has the same number of polygons as a typical SolidGrowth plant when rendering. This can increase your polygon count by hundreds of thousands instantly. The same is true of any other object. This will especially slow down the render, but even more so, the operation of the software. Because of this, EcoSystem plants should be one of the last things you add in.

To delete an item from your EcoSystem Population, select the unwanted thing by name, and then click "Remove."

You'll notice next to the name of your objects are the Scale and Presence options. Although the EcoSystem plants have a tendency to be slightly smaller than single plants added manually, the scale here works the same. If you aren't sure what the scale of a plant is, you can get a rough idea by loading one plant and seeing how it looks in your scene. Adjust the scale as you need, and then carry over that adjustment into the EcoSystem plants, although perhaps not quite as much.

The Presence refers to the ratio that plants will appear in relation to each other. For instance, if you want three grass plants to appear for every dry weeds bush, set the Presence of grass to 0.9 and that of dry weeds to 0.3. Increasing the Presence won't increase the total number of instances.

Next to the EcoSystem Population you can deal with the Underlying Material of the EcoSystem, by which things will be populated. This is useful when you've got several layers of materials. For instance, if you have a mountainside where trees don't grow after a certain altitude, you can control this by the distribution of the material directly underneath the EcoSystem.

The Distribution is usually set to "random," although it can be fun to run it with a function. Affinity and Repulsion of layer refer to how the plants will interact with other instances of plants that are in different EcoSystem layers. These are only enabled if there are other EcoSystem layers.

Display Options gives you control over how the objects appear in the OpenGL three-dimensional (3D) views. This is usually set to "Billboard," so that rough approximations of the plants at all three planes are shown. If you've set your EcoSystem the way you like it, but still need to work in the scene and Vue is responding slowly, you can reduce the working load by selecting something like "Wireframe" or even more if you use the "Wireframe Box". Another option is to show Full Quality Near Camera within a specified radius.

Density Tab

This is the tab where you'll be able to control how many instances of your objects will appear. However, there is no exact control of how many objects

will populate. There is a bit of a chaotic factor that involves enough influences that it can sometimes be difficult to predict how the instances will apply when you hit the Populate button.

In the Overall Density box you'll have a slider to control density. Further, you can choose whether or not things can overlap each other. Enabling "Avoid overlapping instances" will naturally reduce your population by quite a bit, even if the density is at 100%.

In Placement, you can make your plants grow very regularly or below overhangs and other plants. This works with Decay Near Foreign Objects. The Sampling Quality refers to how accurately the objects are placed within a controlled area, such as if an image map was used to drive their placement. The higher this setting is, the more closely the population will adhere to the image. This works with the Variable Density function, which you can access from this tab.

Offset from Surface lets you have your objects hover above the surface or be sunk into it. You can choose to offset it by a specified distance using Absolute Offset or by a percentage of its height using Proportional To Size. This is great for effects like flocks of birds or rocks that are a bit buried.

Decay Near Foreign Objects controls where EcoSystem objects will appear in relation to other objects. If they decay, then they will tend to not occur near another object, such as when grass doesn't grow around trees. Influence will make this tendency weak or strong. Falloff will control how gradually the objects will decay. A high value will create sudden empty spaces; while a low value lets the objects gradually stop appearing near the object.

New to Vue 7 in the EcoSystem is the Slope Influence. The steeper the slope, the less your objects will populate there. At 0% this doesn't happen at all—things just scatter whatever the slope—but at 100% nothing will appear on steep slopes, as typically occurs with most plants.

Scaling and Orientation Tab

In this tab, you could make such things as cars that always move in one direction on a side of a street and vary little, or an old ranch fence where the posts are leaning to and fro. It can help with a bird flock too, as they mostly go in one direction but have some slight variety.

The Overall Scaling does just what it says it does. It affects the scale of all the different kinds of objects you might have in your population, rather than each one in the General tab. If you want, you can run this by a function and filters when you enable Variable Scaling. One thing that Overall Scaling is useful for is changing how your instances are scattered. Very tiny changes in scale that aren't noticeable can really affect the placement of your population without messing with the density. This can be very helpful if you aren't really satisfied with how your EcoSystem populated.

You may want to have your objects be different sizes. Maximum Size Variation gives you a range of how much they can vary. A value of 0 will generate no variation. A value of 1, which is default, will give you objects that are half the size of the original, twice as big, and every size in between.

The Keep Proportions slider will determine whether X, Y, and Z remain in the same ratio. Using a simple cube with the sides 1 × 1 × 1 meters, if it remains

uniform, the sides will always remain the same in relation to each other no matter what size it becomes, such as 10 × 10 × 10 centimeters or 3 × 3 × 3 meters. If it is nonuniform, it could vary, becoming, for example, 1.2 × 0.7 × 1 meters.

This sphere object was originally populated into the scene with a size variation of 3, so the variation is wide. The three panels show the difference between nonuniform, 50% uniform, and uniform in the Keep Proportions setting.

In Direction from Surface, you'll be able to make your objects be vertical from the surface or perpendicular. So, what do those mean? Something that is vertical will always be straight up, parallel to the up axis of the world. Something that is perpendicular will stick straight out from where the direction of the surface is pointed. Another way to say this is that it will be at 90° to the surface. Trees, for instance, always try to grow up, while a car will always be perpendicular (unless it has experienced some sort of disaster).

Vertical Perpendicular

You can also have your objects rotate. In Rotation, things can either turn only by the up axis (appropriate for plants, standing animals, etc.) or by all axes (good for tumbled rocks). You may not want them to rotate at all, in which case set the Maximum rotation to 0°. Setting it to 360° will let your objects appear facing in any direction.

However, one of the limitations in Vue seems to be that objects that are taller than they are wide will not populate under a surface, no matter the settings. The closer to vertical the surface gets, the more aversion to populating

an object there seems to be. If you have a sphere with your material, with no slope or altitude constraints for EcoSystem Population, plus a 100% perpendicular setting, the result will still be that nothing is populated under the equator of the sphere, and the closer objects get to that, and to being horizontal, the sparser and smaller they become. This is true even if Shrink At Low Densities and Decay Near Foreign Objects are not in force. This tendency is gradual, so that rather flat objects like groundcover-type plants will populate all over, but plants with a bit of height like the anemone will go on slopes that are a little negative, a bit under the equator.

Often, there are fewer plants where there are fewer resources such as water, sunlight, or minerals. Because of this, those plants will also be smaller. The Shrink At Low Densities box lets you simulate this effect. Influence will control how much smaller they get. A negative value here has an interesting effect: it makes the objects bigger. The label Radius is deceiving for this setting, as it refers to what density is considered low and causes the shrinking (or growing) to take effect. And Falloff refers to how gradual the effect of shrinking is. Do they suddenly shrink when the density drops below the threshold in Radius (a positive value), shrink in direct proportion to the density (a zero value), or get smaller more slowly (a negative value)?

Color Tab

Your objects will already have a color, but you may find the need to alter their color, overall or based on how they populate. Overall Color works just like it does in the Color and Alpha tab (see Chapter 8): it is the average of the colors in your object, and changing it will let you do things like increase saturation (intensity of the color) or brightness as well as hue.

Just like the plants can grow smaller, they may also become browner, which you can accomplish by enabling Color At Low Densities. The controls of Influence, Radius, and Falloff work similarly to those in Shrink At Low Densities.

And of course, you can use a function to drive this in variable color. Now, remember that these functions can be driven by the same nodes, and so the variations can easily be connected together, giving you lots of power in making your plants populate the terrain in very realistic ways. For example, you could have plants growing along the edge of a pond.

Environment Tab

This tab is basically the same as the Environment tab in layered materials. It works well for plants since they have altitudes they may disappear on, and may or may not be able to grow on slopes. Another thing you'll notice with plants is that they may be more or less likely to grow on the south side of a hill, where it sees more direct sunlight, something you can control with orientation constraint, taking into consideration where your sun is.

EcoSystem Painter

Imagine, rather than painting color you can paint plants. Or maybe you want to get rid of some of the plants populated by the EcoSystem, but not all. That is what the EcoSystem Painter does. In Vue 7, it has become even more powerful, allowing you to paint instances in any of the OpenGL 3D views, where before you could only use the top view. When you're working with the Painter in the Materials tab, you'll be able to turn your object and paint more on it.

At the top of the Painter, you'll be able to clear everything you've painted, undo an action, or redo. Under that will be the number of instances of plants that have been painted, and a button for Display Options, to let you choose how the plants appear: as billboards, wireframes, or full OpenGL quality (smooth shaded).

The Toolbox lets you choose what you'll be doing. Selecting the Single Instance mode will add only one plant per click. You'll be able to specify a scale, average color, direction from surface, and rotation for each plant. These settings work like those in the Scaling and Orientation tab.

In the Brush mode, several plants will appear as you maintain your hold on the mouse button. You'll have the same options plus three more. The Brush Radius refers to the area your brush will cover, and the Brush Flow sets how many objects will be applied to the surface in a stroke. Also, there is an option to limit the density of the objects being painted on. These values are a percentage, with 100 letting you have complete density. Next to that value, you'll find a button that, when switched on, will let your instances grow if they have reached their density maximum.

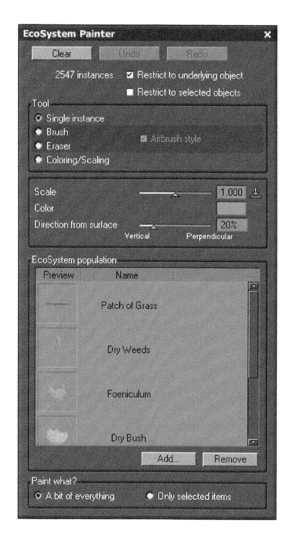

The Eraser tool works like the brush, except that it will remove the plants in the EcoSystem Population box rather than add them. Both of these let you choose between a normal and an airbrush style. When using it as an airbrush, the brush will continue to apply or erase instances when you keep the brush in one place. Otherwise, it will stop as soon as you stop moving the brush even if you keep pressing the mouse button.

The Coloring/Scaling tool will let you control these properties with a paint brush. The Coloring setting has the color swatch, which can be changed by right-clicking on it. The slider next to the swatch is actually a percentage of flow. The color will change completely at 100% and not at all at 0%. Anything in between lets you change the color as quickly or gradually as you want.

The slider for Scaling shows you how each instance will change in size as you paint over them. The size will be multiplied by the value shown. So a value of 1 means there will be no size change; more or less than that will make the objects bigger or smaller.

Each of these tools also lets you utilize a graphic tablet, where you can use variable pressure. Click on the Drive with Pressure icon next to each setting you'd like to work with this way.

At the bottom of the Painter interface you'll be able to add and remove objects just as you would in the General tab. If you called up the EcoSystem Painter from the Advanced Material Editor, then the objects you already had loaded into your EcoSystem will appear in this box. You can choose to work with all of them or one at a time.

Global EcoSystems

The EcoSystem Painter can also be accessed from the top toolbar. This is called a Global EcoSystem. You can only have one Global EcoSystem. For instance, if you want to paint rocks in one place and grass in another, you cannot do this with a Global EcoSystem. Deleting the rocks before painting the grass will cause the rocks you painted first to disappear. You can add things in and continue painting.

Global EcoSystems are not part of any material. When you open the Painter, the objects from an EcoSystem material won't automatically appear in the Population box. Objects will populate the same way they do when you use it from within the Advanced Material Editor; however, they will not be attached to anything. They'll remain where they were originally placed even if you move, resize, or rotate the object you were painting them onto. If you want them to always remain with that master object, you must first convert the EcoSystem instances to true objects, and then group them with it. You can do this by clicking the Select EcoSystem Instances icon in the top toolbar.

This great little tool will let you manipulate your EcoSystem instances. You have two ways to select: you can use a brush to select instances or select them

all with a button. The same way can be used to deselect them. Once you have some selected instances, you'll be able to select the Manipulate button. When you've done that, if you move your mouse over those instances in the active 3D-view window, you'll find that you can use the gizmo tool to move, rotate, or resize the group.

You may want to keep in memory which objects you selected. You can do this by selecting "Save." This won't save the objects, but which ones you chose. Once you've saved them, another group of buttons will appear for other sets of selections you may want to save. If you decide you don't need that information and want to discard it, you can choose "Discard." If you've selected something else or deselected it, you can load the selection you saved. Also, if you happen to close the selector, Vue will remember the last selection you had. What is this useful for? Well, let's say you have some plants you want to make smaller, so you select them and manipulate them. Then you want to make a couple of them bigger somewhere else, so you select those. Now you feel like you made the other ones too small. Rather than needing to go to the trouble of selecting them again one by one, you can just load the selection if you saved it.

Next to the Manipulate tool is a white triangle. Pressing on it will bring up a menu. Here, you can Convert to Objects, as discussed before in this chapter. This will not increase your polygon count, as it was already increased when you added the objects. But now, you'll have possibly hundreds of individual objects to deal with in the World Browser.

The Move Instances To option gives you another great solution to the problem of moving the object and leaving the instances behind. This will let you assign your instances to an EcoSystem material layer. This material needs to already exist, so if you have painted some plants onto a terrain and now want to move the terrain, you'll need to edit the material and create an EcoSystem layer there. At that point, you'll be able to move your selected instances to that material layer. Alternately, you could reassign instances to the Global Ecosystem.

And finally, if you have more than one type of object in your EcoSystem Population, you can change selections to a different type. For example, you have a mix of grass and rocks. You'd like more grass, so you can select a few of the rocks, then select "Change Instant Types To," and then choose the grass from the menu that appears.

Tutorial 10: Cityscape

This city will be created completely through the Advanced Material Editor using EcoSystem layers. You'll first create your own building model. Then, working on a base, you'll create a material that has roads, sidewalks, building spaces, and a park with grass and trees. You'll even add cars to the roads, driving in both directions. These will all be driven by texture maps in the Density tab. Using this as a starting point, you can create more elaborate cities using more than one building or car models. You could also add people and streetlights through EcoSystem layers.

Step 1

Open a new scene in Vue. For this tutorial, first set your Aspect Ratio to Widescreen in Render Options. To make a simple building model, create a cube and stretch it up. Now load a material onto it. Under the Special Effects collection in materials is a sub collection called Buildings. Within that, you'll find the "Mirror Building" material. Use that or something similar. Right-click on it and select "Save Object." Save it as type VOB and label it "Building." In the Title, name it "Mirrored Building" and click "Save." An object preview will be rendered—click "OK" for that. Now delete it from the scene.

Step 2

For the base of the city, create another cube. Resize it so that it is about 120 meters square. Then Flatten it so it is very thin. This cube will be the color of our sidewalks, so double-click on the Material preview in the Aspect tab (the material sphere in the upper right) to open up the Material Editor. If it is not already, make sure you're working in the Advanced Material Editor. In the Color and Alpha tab change the color to a tan or gray. Now click on Add Layer. Assign it the "Flat Gray" color from Basic. Set the Mapping Mode to "Object—Parametric."

Step 3

With this Flat Gray material, go to the Transparency tab. In the Global transparency group click on the lightning bolt icon to edit the function for Global transparency. Replace the K (constant) node with a texture map. Make sure the map type is "Projected Texture Map". Now click on the yellow arrow below to blank picture preview to load a texture map. Navigate to the book's Tutorial Pack and select the "road.jpg" file. Click "OK." Set the Alpha Boost to 100%. Name this layer "Road."

Step 4

Add a new layer. Don't select a material. Make sure it is set to "Object—Parametric" and name this layer "Park Grass." Increase the Alpha Boost to 100%. Sometimes only half the sphere is covered. In this case, fix the Altitude Range in the Environment tab so that it is the full −1 to +1 range. Go to the Color and Alpha tab; right-click on the color map and load the "Foliage" color map from the Rocks and Grasses collection. Go to the Transparency tab. Click on the Global transparency "Drive by a function" icon (the lightning bolt) again. On this layer, do the same as the previous step. Replace the constant with a

projected texture map node. For the texture map, load the "parkgrass.jpg" file. While you're in the Function Editor, replace the K (constant) node over the color map and output with a simple fractal node. You can decrease the largest feature a bit and increase the roughness and gain for more noticeable variation. Connect the Bump output to this node.

Step 5

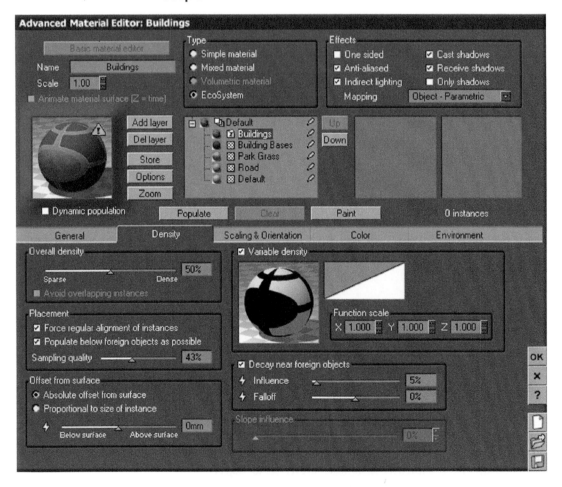

Add a new layer called "Building Bases." Select "Flat Gray," set the Mapping Mode to "Object—Parametric," and set the Alpha Boost to −13%. In the Color and Alpha tab edit the color map so that it is a dark asphalt gray. Go to the Transparency tab, and enter the Function Editor through the Global transparency icon. Replace the K (constant) node with a projected texture map node and load the "buildingbase.jpg" file. Click "OK." Click on EcoSystem.

This will automatically add another layer that you should name "Buildings."
You'll also have the EcoSystem tabs appear. In the General tab, click on the
Add button and select "Object." Navigate to the "building.vob" object that
you created in Step 1. Now go to the Density tab. Toggle on Force Regular
Alignment of Instances, enable the Variable Density, right-click on the
Function preview, and select "Edit Function." Add a projected texture map
node and connect it to the Density output. Now load in the "buildings.jpg" file.
You'll need to inverse this, because the buildings will populate only in white
areas. Click on the white circle at the corner of the image preview. Click "OK."

Step 6

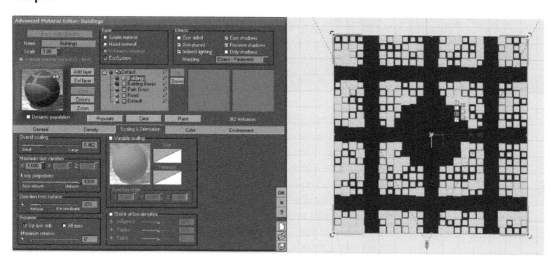

Now click on the Populate button. The buildings will populate based on where
their center is. If they are too large, their edges may go out of the building
bases. If they're too small, you'll have too many. You may also see that they're
not regular in where they face. To fix these problems, go to the Scaling and
Orientation tab. Slide the Maximum Rotation to 0° so all buildings remain
parallel. Play around with the Overall Scaling so you get just the right amount
of buildings properly placed. Click on Populate again.

Step 7

Select the "Building Bases" material layer again, and toggle on EcoSystem again. Name this new EcoSystem layer "Park Trees." In the General Tab, click Add > Plant and select a "Summer Cherry Tree." In the Density tab, make the Overall Density 100%. Enable the Variable Density. Right-click > Edit Function. Add a projected texture map node, connect it to the Density output, and load the "park.jpg" file. Press the Inverse icon so the field is black and the circle is white. This is a bit smaller than the "Park Grass" layer, so the trees don't go over the boundaries. Click Populate. If you wish, you can choose to decrease the size of the trees in the Scaling and Orientation tab. Every time you make changes like this, you'll need to click on the Populate button.

Step 8

You'll be creating several more EcoSystem layers for the cars. Each layer starts from the "Building Bases" layer. So, with that layer selected, click on EcoSystem again. Rename this layer "Cars1." In the General tab click Add > Object. Choose "Mercedes" from the Vehicles > Terrestrial collection. Now in the Scaling and Orientation tab, change the Maximum Rotation to 0°. Set the X of Maximum Size Variation to 0. Go to the Density tab and set the Overall Density to 15%. Enable Variable Density, and enter the Function Editor through there. Create a projected texture map node, connect it to the Density output, and load the "cars1h.jpg" file. Invert the picture. Click "OK," and Populate.

Step 9

Create a new EcoSystem layer through the "Building Bases" layer named "Cars2." Go through the same operations as the previous step, this time adding the "cars2h.jpg" file and inverting the picture. Here, in the Scaling and Orientation tab, keep Maximum Size Variation at 0. Now, to make the cars go in the opposite direction as the others, click on the Lightning icon for Maximum Rotation. There will be a K (constant) node with the value 0.333; change that to 1, click "OK," and then Populate.

Now you'll create two more cars EcoSystem layers, which will go vertically. For the "Cars3" layer, use the "cars1v.jpg" file. Remember to invert the picture. Connect the Maximum Rotation to the Function Editor. In this layer, make the K (constant) node value 0.5. For the "Cars4" layer, use the "cars2v.jpg" file and make the Maximum Rotation Constant −0.5. Click "OK" on the Material Editor. Adjust your camera, load a nice atmosphere, and render the image.

Atmospheres

Why is it that in so many movies, the sky is dark and cloudy if not raining during a funeral? Why is there always a beautiful, blue sky and shining sun for a happy ending? Or a sunset to ride off into? Even though the weather doesn't cooperate like that in real life, we definitely have emotional reactions to what it does. If you've created a bleak landscape, a blue sky with puffy clouds might look a little odd even if it does happen.

Vue 7's Atmosphere Editor is the most sophisticated atmosphere application on the market today. Not only can you create the most realistic-looking clouds, but the interface is easy to use and lets you build layers of clouds more quickly than any other application.

Atmospheres give you more than just the right backdrop. They intimately affect the look of your scene. A city needs pollution and a rainforest in the morning has mist. Even if such things aren't easy to pick out, they do affect the lighting.

Before delving into what Vue can do, let's take a look at what happens with light in the real atmosphere on Earth.

The sun, like other stars, emits all colors of light. There is a peak of light being emitted in the yellow range, but that is not the reason our sun appears yellow in the atmosphere. As the light from the sun travels through empty space, very little of it is lost or absorbed by other particles. Once it enters the atmosphere, however, it encounters molecules of air and other particles, such as droplets of water in clouds. The larger particles reflect all colors of the light. But the air molecules (mostly nitrogen and oxygen) absorb some of the blue light. When it does this, two things happen. First, since much of the blue is gone from the sun's spectrum, it appears yellow. Second, the molecules don't keep that light energy. They emit it again, causing light, which is blue, to come from the sky. And that is why the sky looks blue.

At the horizon, this effect is changed by how much air both the direct sunlight and the blue sky light must travel through. The blue of the sky becomes paler because it becomes scattered and the white light becomes dominant again. The sun has even more of its blue and green wavelengths of light absorbed and scattered, pushing its color into orange and then red.

Back to those bigger particles: they scatter the light also, but don't absorb light. Instead, they reflect what color they are. Light is affected by traveling through clouds, fog, pollution, etc. Once it reaches the surface, it bounces off of objects. When we see an object, we're looking at reflected light from the sun or another light source.

Vue 7 comes equipped with lots of different atmospheres, and you can easily purchase them online. But with knowledge of Vue's Atmosphere Editor, you'll have power over the sun and sky of all your scenes.

Atmosphere Models

Vue deals with the sun, sky, fog, haze, and clouds with four different atmosphere models: Standard, Volumetric, Spectral, and Environment Mapping. Which one is best for your scene depends on what you're trying to do.

The *Standard* atmosphere model works using a color gradient for the sky to simulate the effects of light in an atmosphere, with a blue that is much paler at the horizon. There are two kinds of lighting at work here: ambient light and sunlight. Ambient light comes from all directions. The sun, like in all the atmosphere models, is a directional light. This means that it has no finite source within the Vue environment. This model, used by most three-dimensional (3D) creation software, is the quickest to render and is very useful for cartoon animation-quality projects.

The *Volumetric* model does not use a color gradient for the sky. Instead, it calculates the color of the sky from how both the sunlight and ambient light interact with the fog and haze that are present. Within this model, fog refers to all larger particles in the atmosphere that can reflect, and therefore scatter, the light. Haze is the molecules of air causing the blue light of the sky and the yellow to red sun.

The *Spectral* model is even more sophisticated than the Volumetric model, and offers the most realistic skies achievable. It calculates the color of the sky and light from scattering of air molecules, fog, and haze. In this model, fog effects come from the particles of water vapor that make up real fog. Haze is the dust and pollution that could be in the sky. You can imagine that all of these calculations will increase the render time by a magnitude, but the photographic quality results are well worth it.

Environment Mapping uses a panoramic image that is wrapped around the environment as both the sky and the ground. This is best accomplished with a high-dynamic-range image (HDRI) using image-based lighting (IBL). This means that the image, which encompasses a full 360°, has information embedded in it that will basically emit light into your scene. Within this mapped sky, volumetric lighting is used, but there is no sun since that should

be simulated in the sky. This model is excellent for architectural visualization, as it lets you place a building right inside an HDRI of the area it will be built in.

Switching between any of these atmosphere models does not usually work well, as they all are so very different in their approach. If you want a Volumetric or a Standard atmosphere, of which there are very, very few in the collections, you'll need to build them up yourself, taking into consideration all that is discussed in this chapter. There is a zero atmosphere to be found in the atmosphere collection, which starts out with everything at default in a Standard atmosphere. *Tip:* To have any light from the sky in the volumetric atmosphere you need fog and haze (see the "Fog and Haze" section later in this chapter).

Atmosphere Editor

At the top of the Atmosphere Editor is where you'll be able to choose which of the four atmosphere models you'd like to use. Underneath that, you'll find several tabs. These tabs will differ depending on which kind of atmosphere you've selected. Both the Clouds and Wind tabs will be talked about in later chapters.

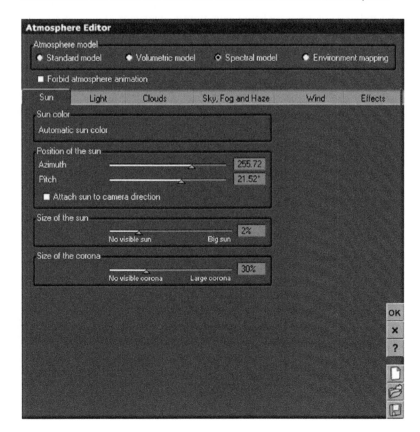

Sun

The Sun tab appears for all the models except Environment Mapping. You can only change the sun's color if you're using a Standard model. Otherwise, it is automatic, calculated by the sun's white light interacting with the atmosphere. Is it possible to change the color of the sun in Volumetric and Spectral atmospheres? Yes, in the Aspect tab of the Object Properties Panel. But it isn't good practice. Even suns on alien planets only have slight color peaks, like our sun's yellow peak. Otherwise, they emit white light. The color of the sun (and sky) on an alien planet has more to do with the atmosphere than the light coming from it.

The Position of the sun is changed according to Azimuth and Pitch. Azimuth, measured by 360°, is where the sun is positioned around the sky. Pitch refers to how high up the sun is. This can also be changed by grabbing the sun in any of the views and moving it. If you want to be accurate as to time of day, season, and place, you can find a chart and tutorial on the web site.

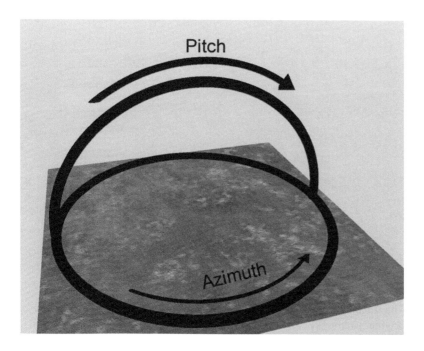

The Size of the sun deals with how big the disk you see is. The Size of the corona is the glare around the disk, like the little rays around the sun that we used to draw as children.

Light

The lighting that comes from the sky is responsible for a lot of the light that makes things visible in the day. This is called ambient lighting, and it comes from all directions. Indoors, light is reflected from the walls. Over the years, several different methods of calculating ambient light have been developed. Vue offers five different ways, allowing you the flexibility you need for render times, and for outdoor or indoor lighting.

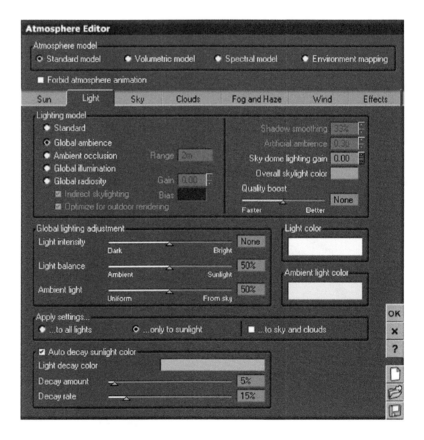

The *Standard* model works with basic ambient lighting that isn't affected by anything in the sky.

Global Ambience uses ambient lighting as well, but now it takes into consideration the color of the sky. Objects will tend to pick up this color.

Ambient Occlusion takes this one step further, and considers that each point in the sky is a light source that may be blocked. If an object comes in front of this light, it is occluding the light, and will have a shadowing effect on the

other things around it. This can have a tendency to make the scene darker. Increasing the ambient light will not only solve this problem, but it will enhance the effect as well. You can control how far away this light is with the Range setting. By default, this is set at 2 meters, appropriate for any indoor or portrait-type scene. The farther away you set the range, the longer it takes to calculate.

Global Illumination is like Ambient Occlusion except that it sets the range as far as possible with Vue: at the sky dome. In both Ambient Occlusion and Global Illumination, there is no reflection of light between objects, only shadows cast. In both, you may want to increase the ambient lighting.

Global Radiosity calculates not only the shadows that can occur when light is occluded, but also light that has bounced one object and onto another. It does this by allowing objects that have been hit by any light, including sunlight and light from other objects, to then emit some of that light. This means that the colors of objects will influence the scene around them. This is by far the most accurate of all the lighting models in Vue. When you choose this model, you have four settings to work with. Indirect Skylighting refers to the light that has come from the sky and bounced off an object. Turning this off can reduce render times, often with little impact. This is especially true if the ambient light color is set appropriately, using an average or dominant color of the objects. Enabling Optimize for Outdoor Rendering will eliminate the more indirect light calculations, since much of the light escapes back into the infinite setting. You can increase the intensity of the light with the Gain setting and Bias will let you add a color to the indirect light.

To the right side of the Lighting Model box are five more settings, available depending on which type of model you're using.

Shadow Smoothing is an interesting setting, letting you control the quality and look of your shadows. Very accurate shadow calculations in Ambient Occlusion, Global Illumination, and Global Radiosity can create sharp, pixilated edges if there aren't enough light ray samples taken. To get a more realistic softer shadow you'd need to increase the Quality Boost at the bottom. However, this also increases the render time and it shouldn't be tried unless you see problems in the higher quality rendering you wish to use for a final image. Another way to accomplish this is to have less accurate shadows with blurring. This is what Shadow Smoothing is for. It has a default value of 33%. The higher the value, the more the shadow is softened, although it does become less accurate.

Artificial Ambience is a nice setting for Ambient Occlusion and Global Illumination. It is not used for Global Radiosity. Remember that light doesn't

reflect off objects; it can only be blocked by them. This will let you add extra ambient light, such as that found in the Standard model, to the scene to make up for this lack. You can change the color of this light using the Ambient Light Color field.

Sky Dome Lighting gain will let you increase or decrease the amount of ambient lighting coming from the sky without the associated change in sunlight, as in Light Balance. You can change the color using Overall skylight color.

Quality Boost, mentioned before in this section and found in many other interfaces dealing with volumetric or light calculations, controls how many light rays are calculated. The more there are, the higher the quality and the longer it takes to calculate them. As always, this is a fine-tuning device to be used only when you're ready for your finishing render.

Global Lighting Adjustment is fairly straightforward. Three sliders give you Light Intensity, Light Balance, and what kind of Ambient Light. This last one refers to the direction the light is coming from. If it is Uniform, this means it is coming from all sides; From Sky will cause it to come from above.

Because of the way the Light Color is calculated, this is not a useful setting for Spectral atmospheres. Otherwise, it acts as a light filter for your sunlight, interacting with the color that your sun already is.

Ambient Light Color is just what it says: the color of the ambient light. In a typical Earth atmosphere this is going to be a pale blue, although some things might affect it like sunset or a volcanic eruption.

With Apply Settings, you have the option to make appropriate settings affect all lights in your scene or only the sunlight. You can also apply them to the sky and clouds. What kind of atmosphere you have, what kind of lighting model you're using, and what kinds of clouds are in your scene will determine how much of an effect this setting will have.

If you're using any atmosphere model except Spectral, you'll also have a Decay Color to deal with. It deals with how the sunlight changes color as it comes lower to the horizon, as in the case of sunsets or sunrises. In Standard atmospheres, this tool can be turned on or off. In Volumetric, it appears that disabling this tool does nothing in Vue 7, since it is absolutely required for how Vue calculates the color of the sun's light. The values in both can have drastic effects on the way your scene looks, even with subtle changes. It is a fairly good idea to keep the color at default or values that are paler but not a different hue.

If you are using the Standard or Volumetric atmosphere models, you'll also have an Auto Decay Sunlight Color. This will change the color of the light

coming from the sun as it comes closer to the horizon, since this detail doesn't take care of itself in these models. Changing this color can give you some odd results, but you can easily reset it to its default value by right-clicking and selecting "Reset Color."

Sky

Only the Standard model needs the Sky tab, since it deals with the color gradient of the sky dome.

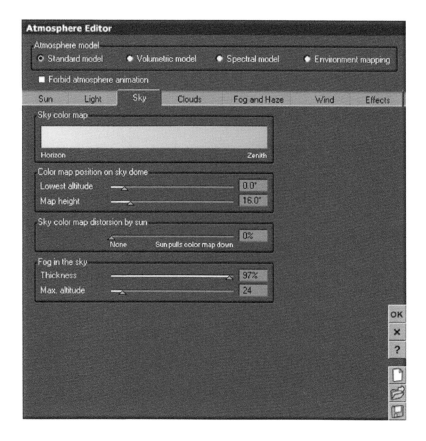

You'll see on top a Sky Color Map that you can edit like any other color map. But if you'd like to load in a new map you'll find a treasure trove of daytime and sunset skies in the color map collections.

Think of a band stretched around the sky dome. The top of this band is on the right side, or the +1 value of the color map. The bottom is the −1 value at the left. Each of these end values are applied above and below the band.

The Color Map Position on the sky dome determines where and how thick this color map is. The Lowest Altitude controls where the bottom of the color map band is, with 0° putting it right at the horizon, and 45° setting the bottom at the top center point in the dome, so that only the bottom color value is seen. Map Height shows where the top of the band is.

This is all true if there is no sun distortion. Color Map Distortion by Sun will let you pull the map toward the sun. A good way to figure out how this works, and the most useful application of it, is to use the rainbow color map in daytime skies and play with the distortion.

These show no distortion on the right and 59% distortion on the left. For illustration purposes, the sun has been made visible and there is no lens flare. You can easily have it not visible by selecting No Visible Sun for the Size in the Sun tab.

The Fog in the Sky adds some fog to this color gradient that complements the fog created in the Fog and Haze tab. The color is actually determined by the fog color in that tab. You'll be able to make this color stronger on the sky gradient with the Thickness slider, and change how high up it appears to be with the Max Altitude slider.

Fog and Haze

This tab is enough different both in content and what the settings actually mean and do for the Volumetric and Standard atmospheres that it becomes useful to break it down into two sections dealing with each. The Spectral atmosphere model has its own tab and section as well.

Standard Fog and Haze

For the Standard atmosphere model, Fog works like masks of color. The farther away the object is from the camera, the more this occurs so that eventually the fog color totally obscures the object's color altogether, leaving only the shape of the object with the color of the fog. The appearance of this fog looks more realistic if it is paired with the Fog in the Sky setting in the Sky tab.

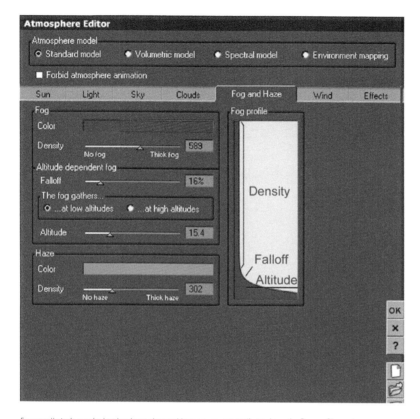

Fog usually isn't purple, but has been changed here so you can easily see how the Fog profile works.

There are two kinds of fog. One that simulates the always-present particles of dust and water that are in the air, no matter the altitude. This is controlled with the Density slider. The second kind of fog is that which we see with weather or smoke effects, and has an altitude and falloff dependency. The Falloff determines how quickly the fog fades away as altitudes get higher or lower, which is determined by where The Fog Gathers....

Haze has a similar but subtler effect. Rather than masking, the colors are blended together, because this represents light being scattered by interacting with air molecules.

On the side, the Fog profile will give you a rough idea of where the fog is in terms of altitude. The horizontal line shows altitude and the vertical shows thickness.

Volumetric Fog and Haze

Even though many of the settings are similar, they have a very different meaning for volumetric atmospheres. Fog refers to the kind of light scattering when it

reflects off of larger particles in the air such as water droplets or dust. Haze is the kind of scattering that occurs when light is absorbed and then emitted again by air molecules. This is where you will get your sky color for this atmosphere model.

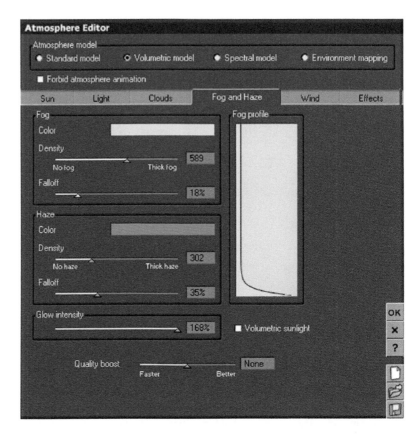

The Fog Color is what color the light will take on the more distance there is between objects and the camera. Not only will objects take on the color, their outline will also be obscured as all the air around them takes on the color. Density refers intuitively to thickness, but is basically a measure of how much distance will be needed before the color. Falloff, like before, controls how quickly density decreases at an altitude. Having a very high value will let you have thick fog that appears to hug the ground.

Haze, as stated, gives you the color of the sky. Because of this, the color you pick is very important. In general, it scatters light like fog does, but the effect is subtler and needs much longer distances to effectively change the color of the light. The interesting thing about Haze is that objects will be affected by it as well, and will take on more and more of the color of the haze until they're completely obscured, a nicely realistic effect.

The Glow Intensity is the glare that occurs around the sun as its light passes through the fog and haze.

Here, you also have a Quality Boost for more samples, useful if you start to get noise that originates from the fog or haze.

With Volumetric sunlight, objects can cast shadows into the atmosphere. The light is considered volumetric. This effect is very subtle, however, and render times are dramatically increased, so unless you can actually see a difference you want, avoid enabling this setting.

Spectral Sky, Fog, and Haze

Spectral atmospheres have a completely different tab, dealing with these properties in the most accurate way available. In this model, sky is determined by the absorb and emit effect of air molecules. Fog acts like humidity, particles of water that reflect light, and haze is the dust and pollution that can be in the environment.

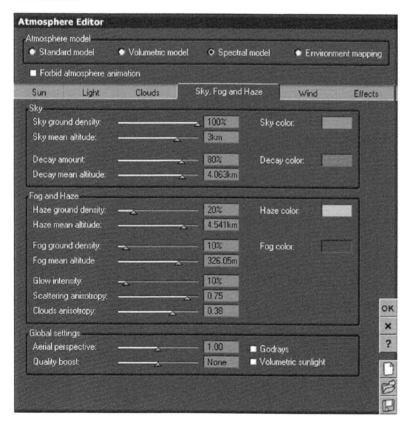

The Sky settings control the density of the air molecules in the atmosphere, with an overall setting in Sky Ground Density. These values are between 0 and

100%, with 0% meaning no air and 100% representing the maximum density possible in Vue. You'll notice that with no air, the sky is black because there is no scattering creating the glowing blue of the sky.

In real situations, air begins to thin at higher altitudes. The mean altitude is where the density is half of what it is on the ground. However, the mean altitude isn't halfway between the ground and the outer edge of the atmosphere. It decreases exponentially, at a much faster rate closer to the ground than farther away. In real life, the mean altitude is 5.5 miles or 8.8 kilometers, even though the atmosphere reaches an altitude of 60 miles (96 kilometers). Where you set the mean altitude will affect how quickly that density decreases. The visual effect of this is how fast the sky at the horizon of the sky becomes pale. A high Sky Mean Altitude will result in a lot of glare at the horizon and a pale sky, while a low one will have a darker sky with just a strip of weak glare.

The Decay Amount deals with how much the sunlight color changes, in natural situations becoming red as it nears the horizon. This decay also subtly reflects off clouds and warms up the blue of the sky, and so is important for a realistic sky. The Decay Mean Altitude will affect how close or far from the horizon this effect appears.

Sky Color and Decay Color have default settings for Earth's atmosphere. Changing these will change the color of the sky, simulating what might happen in other types of atmospheres.

Both Haze and Fog settings work the same as the Sky settings, with density and mean altitudes. But light reflects off these very different particles, dust and water droplets, in a way unique to each of them, changing how the light is propagated into the scene in a realistic way. Further, Fog is appropriately limited to only 1 kilometer in altitude.

Water droplets illuminated from behind will create a glow. With the sun right behind them, they'll cause a glare around the sun. Glow Intensity controls this. Scattering Anisotropy controls how the light from the water droplets is scattered. A negative value appears to cause a lot of glare to reflect off the water droplets, overexposing any scene, especially where the sun is behind the camera. A positive value brings the glare into a more uniform direction.

The Global settings affect how all of the particles are dealt with in this tab. Aerial Perspective is a measure of how "thick" the atmosphere is in a way that gives you control over the scale of the atmosphere. If you are working with smaller scales, it is appropriate to have a thicker atmosphere since this will equate the same number of particles as a regular atmosphere on a natural scale. The scale of the Earth atmosphere is set to 1, and this is the default setting for Vue 7. However, several atmospheres in the collection may contain an Aerial Perspective of 10. If you're finding that the haze and fog appear too thick for your scene, this is a good place to check.

Spectral atmospheres also have a Quality Boost setting to control how many samples are taken. Increasing the number of samples can quickly increase the

amount of render time. Only change this setting if you see noise (graininess) appearing in the atmosphere when you are rendering with the quality you are going to use for your finished image.

The Godray setting should only be enabled if you're actually seeking rays of light shining through clouds, as it increases the amount of computations and therefore render times. It creates a beautiful effect, but takes a lot of experimentation to get the sun position and clouds (which need to be thick, but with holes) just right for this to happen. One hint is to make sure your sun is above the clouds by checking it in the Numerics tab. Godrays only take into consideration the shadows cast by clouds, and ignore all other objects.

Volumetric Sunlight computes light shadows behind both clouds and objects. This can take quite a bit more time to render, and rarely adds anything more to the scene in outdoor settings.

Effects

This tab is the same for all the atmosphere models except for Environment Mapping, where it controls the image used to map the sky and ground. For the other atmospheres, you can add nice things like stars, rainbows, ice rings, etc.

When you've enabled stars, you can control their number, brightness, and twinkle. Twinkling only works for animations. Adding lens flares will give them all four points. You can also give color to your stars. You'll find that, unlike real life, you can even have stars in the daytime.

You can also have Rainbows in nighttime skies. To make your rainbow work, you'll need to make sure to have the sunlight directly behind the camera, as the rainbow appears opposite the sun. Intensity will make your rainbow brighter, Size will make it thicker, and Falloff will let you have only partial rainbows. You'll pretty much want to keep Realistic Colors enabled. The Secondary Bow is only visible if you've increased the angle of view in your camera (see Chapter 16). The rainbow, as in reality, is an effect that occurs at a certain distance from the viewpoint. You'll never catch it.

Ice Rings refer to haloes and other effects that occur around the sun as ice crystals form in the high atmosphere. Intensity controls how bright they appear, and Size controls the width of the halo. The Parhelic Arc is a secondary halo that occurs farther out, and like the rainbow, needs a wider angle to view it. Sundogs are arrow-shaped lights found on either side of the ring. A Pillar of light also sometimes appears at the sun, extending a bit up and then down to the ground.

The controls to the right—Default Lens Flares and Default Reflection Map— are ways you can affect global changes rather than having to go into each light or material to fix things. Default Lens Flares can be applied to directional lights (e.g., the sun) and to all other kinds of lights. In addition, you can globally edit these flares. More on lens flares can be found in Chapter 15.

The Default Reflection Map is what will be applied to the reflection that materials have. Reflection maps are images wrapped around an object to simulate that object reflecting the scene around it. Doing this, rather than calculating reflected images, can reduce render times. See more in Chapter 8 in the "Reflections Tab" section. They may very well be similar for all objects. You'll have the option, below the map, to change the position that map takes on the object with Map Offset. This default setting may be required to bring the map generally in line with the scene. However, for the most realistic results, it may be a good idea to change this offset for each individual object.

Environment Mapping

The Effects tab is where you accomplish your Environment Mapping. At the top left of the interface, you'll find where you can load the image for your environment map. For best results, this image should incorporate everything

you would see in an environment if you were able to see on all sides: a full 360° view, as well as everything from the center below you to the center of the sky above. These are called high-dynamic-range images (HDRIs). You can get them by carefully photographing at every angle and then stitching them together, with a special scanning camera, or using a highly reflective sphere. You can adjust how the image is fit into the sky using Map Offset.

To see how HDRIs look and act, Vue has a few in the image map collection, under the HDRI folder. When you load in one of these environment maps, a dialog will pop up, asking you if you want to automatically set your scene for image-based lighting. If you don't select "yes," the sun and ambient light will remain set as they were before, which may be very different from what is on the image. You no longer need those, since the image itself will be providing the light. Everywhere it looks light on the image, light will be emitted into the scene. If you find you need some adjustment, it is better to work on the sun and ambient light after you've loaded the image.

On that note, you'll be able to change the exposure and contrast of the image. Exposure will brighten up the image. If it gets too high, the details will melt as everything becomes white. The same thing in reverse happens as you reduce exposure. Contrast exaggerates bright areas and dark areas to make details easier to see. Both of these settings will not only affect how the image looks, but the light that it propagates into the scene.

Under those are three settings that will affect how the Environment Mapping is used. Map Upper Hemisphere only will cause the bottom of the image to be wrapped around the horizon, so that in whole it creates a dome rather than a sphere. This is very useful for panoramic images that stop at the horizon. If you'd like to create your own ground, you can disable Map Ground Plane. Vue typically does a fairly good job of matching the ground of a correctly captured environment map to the ground plane. Ignore Atmosphere on Map will make sure that any previous atmosphere settings such as fog aren't applied. Disabling it will cause all the lighting, fog, and haze settings that were in force before to work. These settings will be based on a Volumetric atmosphere model.

At the right of this interface, you'll have the lens flare options as in the other Effects tab, letting you globally control all lens flares. You'll also have two maps. By default, both the illumination and reflection maps will be set as the environment map you loaded. However, you do have the option to change those, if desired, with UV coordinate control as well.

With the full complement of atmosphere models, you'll be able to choose the one that works best for your needs to bring your scene to the next level.

Tutorial 11: First Dawn on Zephyr Colony

For dawn on an alien world, you'll be darkening the sky quite a bit and adding a pink glow and some effects. Most of this will be accomplished with unusual color settings and some standard twilight settings, although you will have some interesting simulated atmospheric effects around the corona of the sun.

Step 1

Start a new scene in Vue. Right-click on the Procedural Terrain icon to select a preset infinite terrain. Choose "Brown." You'll be asked if you want to discard the existing ground plane. Since there is no reason to have it, answer "yes." At this point, you'll want to move your camera up to around 100 meters (depending on the geometry of your terrain) and point the camera up just a bit. The goal is to have the terrain occupy about the lower third of the image. Now you'll put three ships into the scene. Load the model file "torpedo.vob." Place it so that it is flying just off to the upper left toward the camera. Place two more of these models (you can hold down the Alt key while moving to duplicate) considerably farther away so they are very tiny in the scene, each of them moving in the same direction.

Step 2

In the top menu, go to Atmosphere > Atmosphere Editor. You should be working with a Spectral model atmosphere. Start with the Sun tab. Move the sun's Azimuth to 321.32 and Pitch to 11.42. This positions it just off to the right of the camera's view. Make the Size of the sun 1% and the Size of the corona 33%. In the Light tab, you'll want to change the Overall Skylight Color (found in the Lighting Model group) to a very dark navy blue. Now set the Light intensity at −0.22, and to make it darker with the sun almost gone, increase the dependence on sunlight with the Light Balance at 62%. Edit the Light Color and simply make the default darker. Make the Ambient Light a grayish dark turquoise. In the screenshot, nothing has been changed but these atmosphere settings. Notice the overall change in color.

Step 3

Now move to the Sky, Fog, and Haze tab. Here, change the Sky Ground Density to 49%. Increase the Decay Amount to 89% and reduce Decay Mean Altitude to 2.42 kilometers. Here is where the magic occurs. Change the Sky Color to a bright pure blue (as you might see on a national flag), and the Decay Color to a pure red. That will produce the purple sky. Now, in Fog and Haze increase Haze Ground Density to 24% and decrease Haze Mean Altitude to 1.01 kilometers. Fog Ground Density should be 35% with the Fog Mean Altitude at 211 meters. Reduce Glow Intensity just a bit to 8%, while Scattering Anisotropy should be at 0.85. And last, in this tab, create a thicker atmosphere altogether by making Aerial Perspective 1.72. This will cause a more intense glow at the ground and horizon.

Step 4

Now, in the Effects tab, enable Stars and increase their number to 100%. Since it is dawn, you don't want them too dark, so decrease their Brightness to 9%. Also, enable Ice Rings. Make their Intensity 40% and their Size 24%. Make sure all of the accessories are enabled: the Parhelic arc, Sundogs, and Pillar. At this point, it is a matter of pointing your camera just right. The sun should be just at the right edge of your OpenGL camera view, but not in sight of the camera's field if its Aspect Ratio is set to Standard PC (4:3).

loud Carrier

Chipp Walters

Clouds

Look up at the sky on any day and you're more likely to see clouds than not. Clouds speak of what was and what will be. They reveal nature's moods. From dreamy stratus to cheerful cumulus, to threatening cumulonimbus, clouds dress the sky for any situation. As you start to contemplate the upper reaches of your artwork, you may find yourself rediscovering an art of childhood: cloud watching. And this is one of your best reference resources. However, there are plenty of formations that are unusual and highly desirable. People are enamored enough with the sky that you'll find many online photos.

Clouds are shaped by temperature, wind, humidity, altitude, and dust particles that may be in the air. Having an idea of this can give you a good foundation in creating clouds with the right kind of presence in your scene.

There are two ways you can add clouds in Vue 7. First, you can add them through the Atmosphere Editor. These are all either two- or three-dimensional layers made out of special cloud materials. These are very useful if you want general clouds in the sky, or effects like mountains peeking through a layer of clouds. There are several settings you can use to change things like altitude and cover. If you want your own or a slightly different shape to your clouds, you can use the Advanced Cloud Material Editor. This is just like the regular material editor except that there are a few locked settings.

For stronger clouds with more charisma, using MetaClouds will give you large, single clouds in different shapes. These will be objects right in your scene, created from spheres that have been shaped and grouped together in a sort of cloud sculpture. You'll have several of these already built to select from. You can also create your own clouds in this way. These you'll control by resizing and positioning them as with regular objects.

Cloud Layers

Within the Atmosphere dropdown menu on the top menu, you'll find a selection for "Add Cloud Layer." When you choose it, the Atmosphere Editor with the Clouds tab will pop up, and on top of that the material browser will open inside the Clouds collection. All of these different cloud materials could be used for cloud layers, but some of them don't work well. You'll also find that there are, mixed up in all of this collection, four different kinds of cloud materials. The way each of them acts can have a big difference on how your sky looks.

- *Standard* clouds are based on the technology when only the Standard atmosphere was available. They are a material applied to an infinite plane with no thickness that can be set at any altitude.
- *Volumetric* clouds are also flat material layers on infinite planes, but they simulate thickness and internal lighting using an algorithm to affect the light that comes through them. These will tend to give you a more realistic effect than standard clouds, but take a bit more time to calculate.
- *Spectral* clouds actually have thickness. Vue calculates their appearance by imitating how light interacts with water molecules. One of the huge advantages of these is that by controlling height and altitude you could have a bank of fog or the tops of mountains obscured. Because the appearance of Spectral clouds is calculated using the interaction of light with water particles, they don't work at all in Standard and Volumetric atmosphere models.
- *Spectral II* clouds use a more refined algorithm to give you the most realistic clouds with all the advantages of spectral clouds.

Even though both Volumetric and Standard clouds are made up of planes, when you layer them—for instance, a high cirrus above some puffy cumulus— you can get a good enough appearance in your skies if they're to take a distant background role. This is a good way to improve render times. But if clouds are to take a more important role, then using a Spectral atmosphere with Spectral II clouds is the way to go.

Cloud Tabs

Another way you may find yourself working with clouds is simply by going through each tab in the Atmosphere Editor as you create your own atmosphere. You'll find that on switching between the Standard, Volumetric, and Spectral atmosphere models (see Chapter 11), this tab will have some different settings on the right. No matter what kind of atmosphere you're using the settings on the left are the same. Underneath a cloud layers browser you'll have a material preview where you can right-click to edit the cloud material. Under that are the Cloud Animation controls.

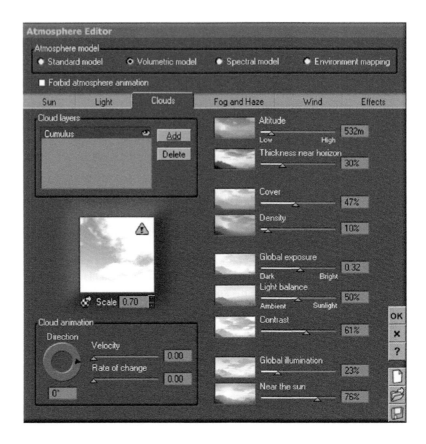

Clouds in Standard and Volumetric Atmospheres

You'll recall that you cannot use Spectral clouds that have thickness in Standard and Volumetric atmospheres. These settings are optimized for working with cloud layers on a single plane, as are the Standard and Volumetric clouds.

The Altitude setting determines where the plane's altitude is. When your camera is near the ground, you can't really see the altitude of your clouds in a plane. The effect is that the clouds seem to get smaller and fade as their altitude is increased. This is, of course, accurate for perspective but can also give you a bit of control over their size, especially when used with the thickness and lighting settings. They also can change shape in ways that aren't necessarily consistent with altitude.

Thickness Near Horizon affects the clouds nearest the horizon first, but extreme settings will affect all the clouds. Clouds nearer the horizon become brighter and more visible with higher settings. The lower the settings are, the more the clouds in the distance fade away, letting you either imply more expanse or haze in your scene. A 0% setting will make all the clouds of the layer fade, and a 100% setting will ensure they are all at maximum brightness.

Cover and Density go hand in hand, but work a little different from each other. Cover works very effectively to control how much of the sky is covered by clouds. Density will make your clouds thicken and become a bit brighter and larger at higher settings and dissolve away at lower settings. Using these, you could have a sky almost fully covered by thin clouds.

Global Exposure will have a drastic effect on how dark or light your clouds are. Light Balance adjusts between ambient or sunlight, but isn't available if you've set those in the Light tab by selecting Apply Settings to Sky and Clouds. The visual effect of this is that, with more ambient light, your clouds become more luminous. With sunlight, more shadows are seen. This also causes the clouds to take on the Light Color of the Light tab. This looks great for sunsets. Contrast darkens the dark areas and lightens the light ones.

Global Illumination is much subtler than Global Exposure, but will also change how bright your clouds are, while retaining their details.

If you have clouds Near the Sun, this setting will allow you to make only those specific ones brighter.

Clouds in Spectral Atmospheres

Many of these settings are very similar or exactly the same. For instance, you have Altitude, which does the same thing in both tabs. But the Height setting is different. This measures from the bottom of the cloud layer to the top. The higher it is, the thicker your cloud layer will be. It makes sense that this tab only comes available when using the Spectral clouds. It effectively alters the appearance of clouds at the horizon. One of the advantages of the Spectral clouds is that you can use the Altitude and Height settings to create a bank of fog right on the ground, or have the lovely effect of clouds collared about mountain peaks.

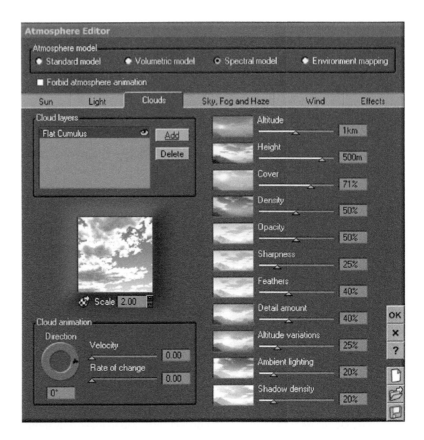

Cover and Density also work in a similar manner, but now there is depth involved. You can see the clouds actually becoming thinner top to bottom as density bottoms out. But also, as the density increases you see the clouds become darker on the bottom as the effect of the density on light is simulated. If you're working with Standard or Volumetric clouds they work pretty much the same, but without that darkening with thickness.

The rest of the settings below these are unique to the Spectral model atmosphere.

Opacity has the visual effect of thinning or thickening your clouds without changing their shape. It also will make objects set inside a cloud disappear depending on that thickness. The lower the value is on the Opacity setting, the thicker the cloud will be and the faster objects inside of it will disappear. However, this low value also lets lots of light through. There are no shadows at the lowest value of opacity.

Sharpness controls how abrupt the edges of your clouds will be. A high value will make your clouds very defined, almost as if they were objects you could hold. A low value will make them thin and wispy.

Only for Spectral II clouds do you get Feathers and Detail Amount. Feathers will cause little tendrils of clouds to wisp away from the cloud. These may have a tendency to pull bulk away from the cloud and thin it out. Detail amount can have a similar effect as well as it adds more variation to the density within the cloud.

Altitude Variations is mostly only visible far away at large scales and is easiest to see at the top of clouds.

Ambient Lighting will brighten up your clouds as it adds ambient light to them. This is especially effective with thicker clouds. Shadow Density increases the shadows. These last two work a lot like the lighting and contrast settings in the Volumetric Clouds tab when used together.

Cloud Materials

You have a lot more control over your clouds than just in the Atmosphere Editor. By editing the materials of clouds, you can gain even more variation in how your cloud layers appear. Vue comes equipped with several good preset cloud materials to start as a good basis.

Editing Standard Clouds

When you're in the Clouds tab of the Atmosphere Editor, you have a material preview screen, where you can change the material for your clouds. Right-click on it and select "Edit Material." This will pull up the Advanced Cloud Material Editor, which looks very much like the Advanced Material Editor for volumetric materials. Some controls will be locked (grayed out). The most important property to work with here is Transparency. Cloud shapes are controlled by this and to a much lesser extent by Bumps. Working with these properties will occur in the Function Editor with noise nodes.

Editing Volumetric Clouds

Opening the Advanced Cloud Material Editor for Volumetric clouds will reveal the tabs used for volumetric materials. Here, the Color and Density tab makes up your cloud shapes, again relying heavily on functions and filters. You'll find in the Lighting and Effects tab that there are specialized Lighting models. These will drastically change the appearance of your clouds. Using Flat-layer Lighting will lock up the use of the settings in the Lighting group, except Force Ambient Color. Using Volumetric Layer v1.0 or 2.0 will lock up the Flare settings, but also open up a new group at the bottom right. Dissolve Near Objects is an effect meant to let you make clouds thin out near mountains, houses, etc. The distance is not expressed in any units, and it can be difficult to get a very noticeable effect. Accuracy will determine how exactly the position of the object being used will be calculated. Softness will act to make it more or less a gradual thinning out.

Editing Spectral and Spectral II Clouds

Once again, the tabs used to edit Spectral clouds will be the volumetric materials tabs. In the case of Color and Density, you'll find unique settings available only for these kinds of clouds. You'll also find lighting details unique to these and MetaClouds.

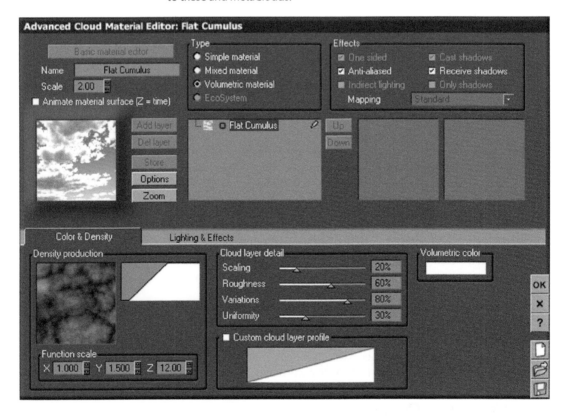

Cloud Layer Detail is a nice way to change the appearance of your clouds. Sliding the marker on Scaling will change how much detail is in your clouds. Now, in general, this value leads to more detail as it increases, although the effect can sometimes be of the natural change of clouds as they move through the sky, as some dissolve and others reappear. You can get a nice, big variation here, and it always bears experimenting with this setting to get just the right look to your clouds. The Roughness setting will give you a more constant change. Increasing its value will cause more feathering and ripped-looking edges to appear. Variation will cause the length to vary more, and can introduce interweaving of the wisps of clouds produced by Roughness. The uniform in Uniformity refers to roughness across altitude. The roughness is about the same across all altitudes with high values, and will be wispier on top and more rounded on the bottom with low values.

The Custom Cloud Layer Profile is a filter that enables you to change the density of the cloud according to altitude. In the Volumetric Cloud Profile editor, the horizontal bar refers to altitude, while the vertical bar shows the density.

The Lighting and Effects tab is similar to that in the Volumetric clouds; however, there are settings under the Lighting model that are different.

Internal Shadows will let parts of the cloud material cast shadows on other parts. Another setting useful for this is Cast Shadows. This lets shadows and light fall through in a way that could cause rays of light to fall through if Godrays are enabled.

The GI in GI Ambient Lighting stands for global illumination. This means that the ambient lighting will be calculated with Global Illumination, a more sophisticated model.

When light bounces off or goes through an object of a certain color, the color of the light will change and can be seen in the surrounding objects. If Vue uses the lighting from the sky, this color calculation can slow down a render. Instead, you can control the color of ambient lighting affected by your volumetric material by selecting Force Ambient Color.

Do keep in mind that you shouldn't change the lighting model to Flat for Spectral clouds as it will flatten out the layers into a single plane, thereby destroying all the careful detail created in the Color and Density tab.

MetaClouds

If you need your clouds to be a bit more prominent, or you want to control placement, creating a MetaCloud or several will be your solution. Just like plants, MetaClouds always generate a unique object with the ability to customize it to your needs.

On the left toolbar you'll see the MetaCloud icon with the other object-creation tools. Since MetaClouds are created using spectral computations, you can't have them in either Volumetric or Standard atmospheres. The icon will be grayed out. Otherwise, within a Spectral atmosphere, a left-click will produce a random MetaCloud or one from the last preset chosen. A right-click will open up a visual browser for MetaCloud models. Alternately, you can enter from the menu at Object > Create > MetaCloud or from the visual browser at MetaCloud from Preset. You'll find several presets, with approximations of how many spheres could be part of that cloud model. Spheres are the building blocks of MetaClouds, but since each cloud model is generated with a bit of randomness, their number could vary.

Once you have a MetaCloud in your scene, you can change each of these spheres slightly. You can't rotate them or change their proportions, but you can resize them and move them around within the cloud group. To do this,

you'll need to unfold the MetaCloud within the World Browser in the lower right. Click on the + icon next to the name of the cloud you've just created. You'll find a list with lots of spheres in it. You'll need to click on each one to determine which sphere you'd like to work with.

Also, you can add MetaCloud spheres to the cloud. When you have one of the spheres selected, a MetaCloud Primitive icon will replace the MetaCloud icon on the left toolbar. This option will also come available through the top menu path at Object > Create > MetaCloud Primitive. These will act like the spheres. You'll be able to resize and move them, but not rotate or change their shape. This ability to add, move, and resize the MetaCloud primitives gives you the power to design your own clouds.

MetaCloud Materials

To further customize your MetaClouds, you can change and edit the material they're made from. When you edit the material for a MetaCloud, the tabs will appear as they do with volumetric materials with one addition: Cloud Settings. This tab contains all but the Altitude and Height settings of the Spectral model clouds tab in the Material Editor. If the material you're using is a Spectral II–type cloud material, you'll be able to change the Feathers and Sharpness settings. Keep in mind that only one material is allowed for the overall cloud.

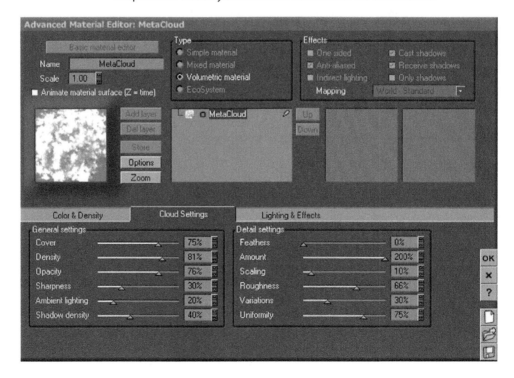

Tutorial 12: Cloud Precipice

You'll create a sunny scene where low-lying clouds build up to a precipice and speak to different weather below the hill that peeks above. You'll create two different kinds of cloud layers, one Standard and one Spectral. To sculpt up the clouds, you'll add a couple of MetaClouds.

Step 1

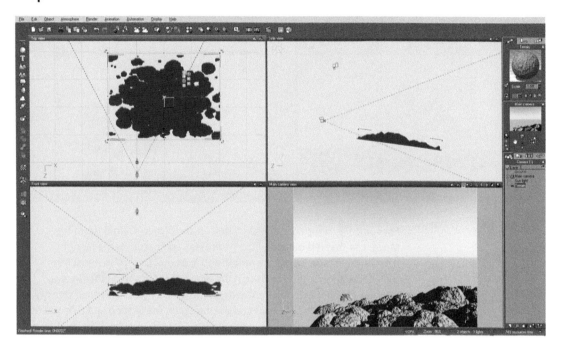

Start a new scene in Vue and create a terrain. Double-click on the terrain to open the Terrain Editor. Increase the Resolution to 1024 × 1024. Click on the Add Function button and load the Blurg function from Terrain Altitudes. Make the scale 20.00. Click "OK." For this scene, move the clip up a bit to get rid of the harsh corners of the terrain base. Click "OK." Scale down the terrain quite a bit and place it in front of and a bit to the right of the camera view. Move both the camera and terrain so they are about 25–30 meters off the ground. Tilt and position it downward, away from the camera so that you get a nice peak showing to the camera. You may want to rotate it first to get the part of the terrain you want facing the camera. You may also want to move the camera a bit up and point it down as well.

Step 2

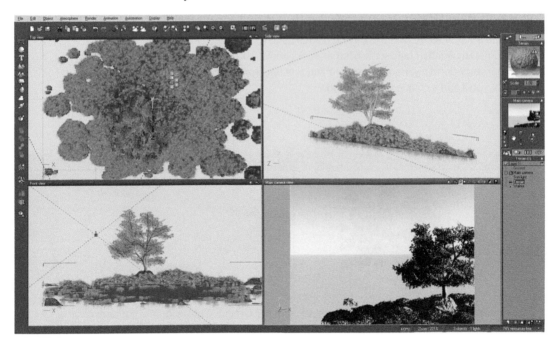

For some life, right-click on the Plant icon and select "Walnut" from Trees. Move it so that it is on one of the peak areas and occupies the far right third of the image. Select the terrain and load the "Desert" material from the Landscapes collection. Switch the type to EcoSystem. In the General tab click Add > Plants > Dry Weeds. In the Density tab, make their Density 87% and disable Decay Near Foreign Objects. In the Scaling and Orientation tab decrease their Overall Scaling to around 0.17 (it may be different if your terrain size is different). Now, to paint a different plant, click on Desert again and select EcoSystem again. In the General tab, add Small Grassfield Plant to the EcoSystem population. In the Scaling and Orientation tab make Overall Scaling about 0.30. Click on Paint. Uncheck Limit Density. Now paint on the Small Grassfield Plant with the Brush tool.

Step 3

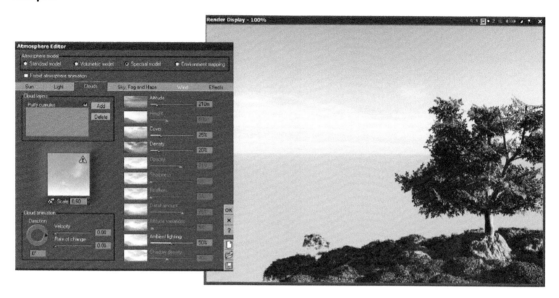

Now for the clouds, begin by clicking on Atmosphere > Atmosphere Editor. In the Clouds tab, click the Add button for a cloud layer. There are several different Clouds subcategories. Select the Cumulus category. These are standard clouds. Choose Puffy cumulus. You don't want heavy cloud cover from them, so reduce Cover to 25% and Density to 20%. A preview render now will be relatively quick because these clouds are only an image placed in the sky.

Step 4

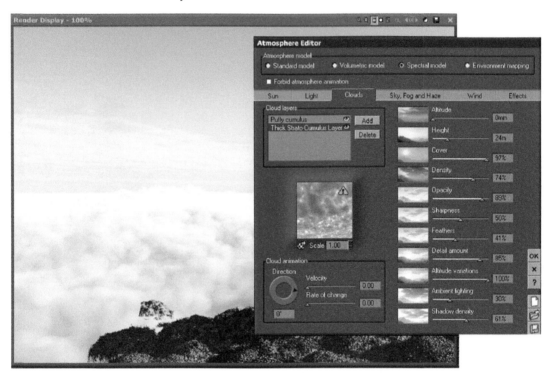

Now add another layer of clouds. This time, you'll be using the Thick Strato-Cumulus from the Spectral II clouds layer. For these, you'll need to manually type in the Altitude value, making it 0. Height should be about 24 meters. Increase the Cover to 97%, Opacity to 89%, Sharpness to 50%, and Feathers to 41%. You'll also want to increase the Detail amount to 85%. Click "OK." At this point, the render will take longer, but the detail is definitely worth it.

Step 5

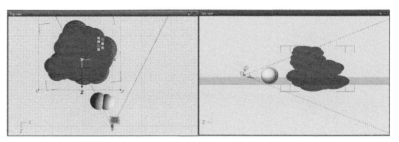

For the MetaClouds, right-click on the MetaCloud icon to bring up the browser. Here, choose the Ultra Simple Cloud. Increase it in size a bit and move this off to the left. This will help blend in the next MetaCloud you'll load. Right-click again on the MetaCloud icon and choose the Large Cumulonimbus. Position it to the left as well, behind the Ultra Simple Cloud. Rotate and arrange them until you get a cloud formation you like using the main camera preview.

Step 6

Fine-tune your atmosphere in the Sky, Fog, and Haze tab so the sky is a bit darker, decreasing the Sky Ground Density to 65% and Mean Altitude to 1.08 kilometers. Make the Decay Mean Altitude lower too, at 2.64 kilometers. At this point, try to render at higher settings, such as Final or higher. If you see graininess in your clouds, then you can increase the Quality Boost in the Global settings of the Sky, Fog, and Haze tab. This will really increase render times, but is often a great solution.

ɔmewhere in the Centaurus Constellation *Artur Rosa*

Planets

Above the sky and into the great beyond is the domain of planets and moons. Vue recreates the nine planets of the solar system and our own moon using specialized alpha planes. These have the images of the planets on them, surrounded by transparency, and being lit up enough to be seen. This is also the source of the visible sun disk.

These planet alpha planes always face the camera, no matter where it is placed in the scene. The easiest way to demonstrate this is to experiment with the sun in the three-dimensional (3D) views. By default, the sun is set to point at the camera in the Aspect tab. With this setting, grab the sun with your mouse and move it around. You'll see its arrow always pointing to the camera, perpendicular to the plane that makes up the sun.

There are some things to remember about planet behavior. The first is that they always remain the same size to the camera, no matter how far away they are placed from it. You can resize them if you want, using the gizmo tool. You may notice, as you move them around, that planets tend to drift off in the axes you aren't specifically pushing them in. This is because of how they're always directed at the camera. Just have patience as you place them. On that note, the farther to the side of your image that you place them, the more distortion there can be, although there usually isn't a whole lot.

The next thing is that no matter where a planet is, it will always appear behind all other objects, even the clouds, as happens in reality. What do you do if there are multiple planets in your scene? The order of their appearance is controlled in the World Browser. The one on top in the browser is the one in front in your scene.

Keeping these behaviors in mind will assist you as you arrange planets in your scene's background.

Controlling Planets

Planets are placed in the sky with one click of the Planet icon on the left toolbar. The moon is always the default planet and will be the one to appear. To use a different planet, go to the Object Properties Panel with the planet selected in your World Browser. On the left side of the Aspect tab there, you'll see a very small Moon icon with a gray arrow pointing down, indicating the available menu there, and a yellow arrow indicating you can load a file. Clicking on this button will, as advertised, bring a dropdown menu. In that menu, the moon will be selected. Under that, you'll find all the planets in the solar system. The sun, of course, isn't there because there is already a sun. At the very bottom of the menu, you have the option for a custom planet. Choosing this will bring you to the image visual browser, allowing you to load in your own planet image for use in the scene. Any image you use will automatically be cropped to the planet circle.

One special planet is Saturn, with its rings. This, unlike the other planets, is made of two different alpha planes. Using the gizmo in the OpenGL view, you can actually rotate the plane that the rings are on, letting you give Saturn a very different appearance. In this particular case, it will be easiest to do this using the rotation gizmo. For a custom planet with rings, make sure you have Saturn selected first, and then choose Custom Planet. All ringed planets will have rings just like Saturn's.

You can rotate the other planets as well, although this will only be useful to change the orientation of the image that will still always face the camera. Trying to do any of this rotation in the Numerics panel is likely to get you unpredictable results.

Once you have the planet you desire, you can further change its appearance. The most fun option here is the one dealing with Phase. At the right of the slider is the waxing phase, in the middle is a full view of the planet, and at the left is the waning phase. If you've ever had the fun of being able to see any of the closer planets through a telescope or, in the case of Venus, binoculars, you'll find that those have phases too. The outer planets, however, always appear to be facing the sun from our point of view and so it is best to show them in full.

Under the Phase is the Brightness setting, by which you can make your planet more or less bright in the sky. Softness tends to blend the edges between the dark and light areas of the planet, and the planet with the sky.

Many Vue artists use planets to great effect. They can create a sense of wonder and exploration. If you want to stay on Earth, adding the moon to the scene enhances your atmosphere. It can be large and magical or bright and engaging as it lies hidden behind clouds waiting.

Tutorial 13: Moon Over the Delta

We'll be keeping it down to Earth in this tutorial as you create a simple scene with water, a couple of terrains, and a large moon.

Step 1

Start a new scene in Vue. For the delta, add a water plane, and then add a terrain. Move it off to the side so that it is an island in the first third of the image. Resize the island, narrowing it so that it is more oval. Now load a material onto the terrain. Any grass material will do. Add one more terrain and push it way out to the background. You'll need to stretch it so that it fills up the camera's view. Double-click on it to edit the terrain. From there, go into the Effects tab and add some "Fir Trees." This will simulate plants in the background.

Step 2

Now let's add some foliage closer to the camera. Select the first island, right-click in the preview window of the Aspect tab, and go to "Edit Material." In the Material Editor, switch the Type to EcoSystem. In the General tab, click Add > Plant and select "Dry Weeds." Click on the Paint button. Using the brush tool and toggling off Limit Density, paint that section of the island that the camera will see. Then, add some "Rural Maple Trees," sinking them into the ground, and if needed, "Bush 1" for scrub brushes growing on the island.

Step 3

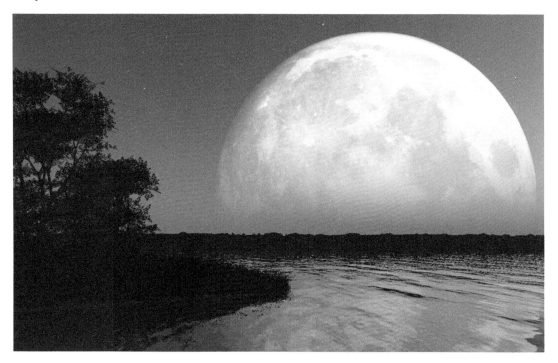

Before adding the planet, it is a good idea to have your atmosphere set first because the sky is the canvas the planet will be placed onto. Load the "bigredmoon.atm" atmosphere file from the Tutorial Pack into the scene. If you look at the settings you see the ambient light is much darker and the general sky altitude and density are lower for a darker sky. Also, the sun here is present, but low to the horizon and almost in view of the camera for the reddish glow. In the left toolbar, click on the Planet icon. A normal-sized crescent moon will appear. In the Aspect tab, change its Phase to Full. Now increase the size so that it is very large and about one-third of it is below the horizon. Choose your render settings and render.

Let the Wind Blow

U nseen, but powerful, the air moves. Wind pushes clouds, plays waves
on the water, dances with the leaves, and sandblasts the stones of the
desert. You can see all of these effects in Vue, indirectly through erosion and
water waves, and directly using wind effects with plants, cloud animation, and
ventilators. Although its effects are scattered throughout the software, it is
important to keep the wind direction and powers consistent. It's a good idea
to write down your wind values, so you can make them consistent with the
rest of your scene as you build it.

Atmospheric Wind

In the Atmosphere Editor, you'll have both the Wind tab and Cloud animation
to work with. The Wind tab doesn't propagate wind into the whole scene,
but instead gives the effect of wind and breeze on plants, the strongest
natural indicator of wind. The effect of wind that Vue is able to calculate on
the movements of the plants is really quite remarkable, as is the amount of
control you have over it.

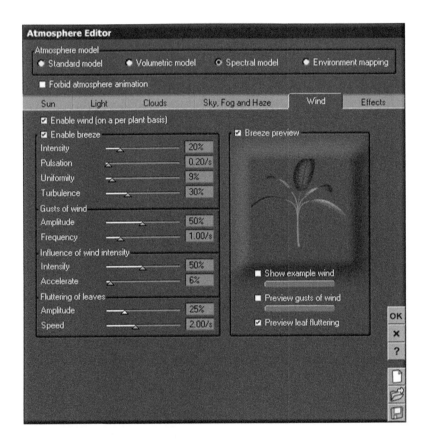

There are two types of wind in relation to the plants. One is wind that is controlled on a per plant basis with the Enable Wind (on a per plant basis) box checked—the default setting. This wind will affect the whole plant. If the plant is flexible enough and the wind strong, it can bend it all the way to the ground. The other kind of wind, the settings of which are accessed when Enable Breeze is selected, controls how wind affects the fluttering of leaves and the fluctuating of minor stems. The Breeze preview in this tab effectively animates the effect of both kinds of wind and is a great tool while working. This preview, however, is a bit of a memory hog. It might not be a good idea to spend lots of time staring at it. It offers you the ability to disable the preview of the wind (that which is controlled on a per plant basis), gusts of wind that give an overall undulating effect, or leaf fluttering. Being able to work with each of these effects without visual interference of the others can be quite helpful. You may find that you'll only want breeze enabled, except in the case of storms.

Close observation of the breeze settings, except those specifically for Fluttering of Leaves and Turbulence, will reveal that they are only working on the leaf stems, bringing the leaves with them. In Vue terms, these are the stem objects

that leaf alpha planes are hooked onto. Even though there may be branches and stems within those leaf alpha planes, as with trees, those will only be affected by the turbulence and leaf settings.

For breezes, Intensity is the same as controlling how strong the wind is. The higher this value, the more the plant will generally move. Pulsation refers to how fast this movement is, and a distance/seconds value defines it. This isn't an exact value, but an average of the random variations. The stronger a wind is, the more Uniform the movement of the plants. Otherwise, soft winds will cause a more independent trembling. Turbulence causes more randomized movement of each leaf.

Gusts of Wind are simulated by random stronger movements of the plants. The Amplitude of these refers to how big of a movement the plant will make, on average. The Frequency describes how often these gusts occur, on average.

The Influence of Wind Intensity gives a very subtle effect, adding the wind to the breeze settings. Intensify will increase this influence and Accelerate will determine how much faster the movement will become in relation to the wind.

Fluttering of Leaves is what makes the leaves themselves move, rather than being shaken up by the stems. Amplitude again controls how big this motion is, while Speed controls how fast the leaves flutter.

Cloud Animation

In the Clouds tab at the bottom left you'll find the box to direct Cloud animation. The controls here are simple: you have a direction, velocity, and how much the clouds change shape as they move.

When dealing with direction and velocity, it is important to consider the other wind set in your scene. While it is entirely possible that the clouds are moving in a different direction than the wind is, one should take care and thought to what is going on in the scene. These are the kinds of details that might be hard to actually point out, but could lead to an unconscious realization that something is wrong in the animation.

Wind on Plants

When you add a plant, you'll find a blue triangle in a circle next to it in the top view, if the Enable Wind (on a per plant basis) is toggled in the Wind tab of the Atmosphere Editor. Grabbing that blue triangle with your mouse and pulling it away from the circle will control your wind. The direction you pull it causes the direction of the wind. How far you pull it from the circle causes the intensity of the wind to increase. You'll be able to get these exact values at the bottom left of your screen.

Every new plant you add will always come with the default of no wind, which will need to be set to match the other plants of the scene. If you have a lot of plants, this can become problematic. The solution is to select all of your plants, by maintaining the Ctrl key while choosing them, and change the wind at the same time. If you've gotten the wind just right on a plant, select that plant first. You'll still need to move the wind arrow a bit to apply it to the other plants, but you don't have to totally recreate the settings for each plant.

This per plant wind effect is much larger than the breeze wind from the Atmosphere Editor. It also does not work on EcoSystems unless you switch all plant instances to objects and, keeping them selected, change their wind setting. A warning: if you have a lot of plants in the EcoSystem, converting them to objects may slow down your computer by a large, possibly terminal, amount. Make sure you save your scene before attempting it. Using Ventilators, explained later in this chapter, is also a solution to achieving wind on EcoSystem instances.

Wind on Water

In a totally separate setting, you have the wind on the water. The Water Surface Options is accessed by selecting a water plane and editing the object (see Chapter 4). Whether or not you're using Global Wave Control, you can change the wind direction, found in the Waves group of that interface. If you want to be more precise, disable Use Global Wave Control and work with the Wind Intensity, Agitation, etc. to more fully match the plants in your scene. You'll find that the values for wind intensity here and those for plants differ: for plants this can run up to the thousands, and for the ocean the values max at 2 (although you can type in larger numbers). However, this doesn't mean there is that much of a difference between the ranges. The water settings are dealing with a function, which is easier to calculate using smaller values. The numeric value of plant wind intensity is dealt with differently and appears to have an unlimited range. There is no easy translation between the two except by supposing a practical maximum value for plant wind after which there is little change in the plant. This is probably around 300. That would then correspond to the maximum value of 2 for water wind.

Ventilators

Like any good sound stage, Vue comes equipped with ventilators as well. This offers you control for a more localized wind such as that which could be

caused by flying machines or fans. However, these ventilators only directly affect plants. Water is not agitated and dust is not blown. These are separate things to deal with in the animation.

Ventilators come in two types: Directional and Omni. The Directional ventilator will blow wind in only one direction, while the Omni ventilator will cause wind in every direction coming from a single point. To control ventilators, you'll work with them in the Aspect tab of the Object Properties Panel. There, you can switch between the two as well as control other settings.

For Omni ventilators, you have three settings: Intensity, Cutoff, and Profile. Of course, with Intensity, the higher the number, the stronger the wind, but you can even set a negative number in this value. This will cause the ventilator to suck in air, creating a wind in the opposite direction. Cutoff, which describes how far away from the wind's origin it blows, is something to pay attention to. If you've set your cutoff lower than the distance it is from the plant, it will not affect the plant no matter how strong the intensity is. Profile uses a filter to define the intensity of the wind versus the distance from the ventilator; the horizontal bar is the distance and the vertical bar is the intensity. You can edit it as with any other filter.

Directional ventilators use the same three settings but have two additional controls. The wind from these ventilators doesn't technically blow in only one direction, but originates from a center like Omni ventilators. However, the wind is spread with a limited angle in the shape of a cone. This cone is controlled using the Spread settings, with values measured in degrees. Falloff describes how quickly the wind dissipates at the edges of the angle.

One other icon in the Aspect tab for both kinds of ventilators is the one that looks like tiny grass. Clicking on this will enable the wind from these ventilators to apply to EcoSystem instances. This is a fast and efficient solution to applying wind to EcoSystem plants. However, this can take up a lot of processing power, so it might be a good idea to save first.

Tutorial 14: The Dangers of Being Tiny

This is a fun scene with a fan and some little people. You'll use objects found within Vue and then add some SolidGrowth plants in pots and a ventilator working with the fan.

Step 1

Start a new scene in Vue. Click on the Load Object icon. In the Furniture collection, select the "Tea Table." Click on Drop Objects to bring the table down to Earth. Move the camera in close. Load the "Table Fan" from the Interior > Electronics collection. Place it to the left on the table and turn it so it is facing right. Holding down the Shift key while rotating will make it turn in clicks so you can turn it exactly 90° counterclockwise. Load one "Flower Pot" from Boolean Objects in the Miscellaneous collection. Scale this down, keeping proportions, so it is about one-third the height of the fan. You can use the Drop icon to get it on the table. Now hold the Alt key while moving the pot to make another pot, and do it again, so you'll have three pots. Arrange them on the table, with two in front of the fan and one off to the left of the fan.

Step 2

Right-click on the Plant icon. In the Grasses—Plants collection choose "Schefflera" or a similar tall and leafy plant. Place it in one of the pots. Click again on the Plant icon (Vue will use the plant you just chose) two more times and place those in the pots as well. Now click and hold on the Ventilator icon to choose a Directional ventilator. Move the ventilator behind the fan a couple of meters, and then point it up a bit so it is blowing in the same direction as where the fan appears to be blowing. At this point, the plants are probably bent over all the way. In the Aspect tab reduce the Intensity to 5. Notice how the plant set off to the side is blowing in a slightly different direction than the ones directly in front of the fan. This is because the ventilator blows outward from a single point, but in a cone, so that the direction of wind in the middle of the cone is different from at the edges.

Step 3

In the top menu, go to File > Import Object. Navigate to the Tutorial Pack on the book's web site and import the "Vikionfan.obj" file. Place her so that she appears to be hanging off the fan in the direction of the wind, natural to how the plants are being blown. Import one more model, "Vikionsw.obj," and place her so she's sitting on the switch plate of the fan, looking at the first model. To create an impression of being an interior, create a cube and flatten it into a wall that will stand about 5 meters behind the table so the sky is obscured from the camera.

Step 4

For lighting, load the "Physical > Threatening" atmosphere. Also, click on the
Light icon and choose a Quadratic spot. Move the light behind the table fan,
between it and the ventilator, at about the same height as the table. Point it
up a bit so that it is pointing in the same direction as the table fan. Double-
click on the light to edit it. In the Gel tab toggle on Enable Light Gel and make
it spherical. Load the "Spots Gel" material from the Light Gels collection. In the
Volumetric tab enable Volumetric Lighting. Position and point the camera so
that the table fan is at the left side of the image. Choose your render settings
and render the image.

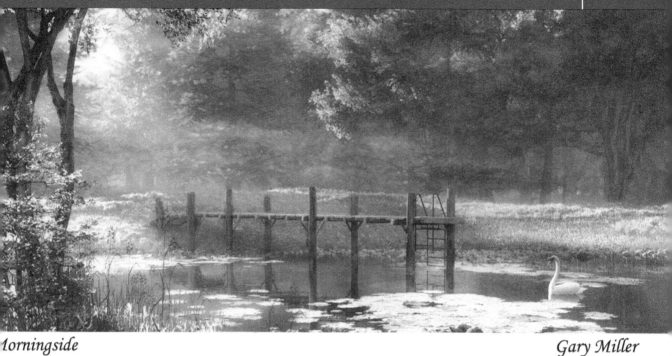

Morningside *Gary Miller*

Lighting

Lights in a digital environment simulating nature are just as important as in the real world. Beautiful summer day–lit scenes can cause harsh shadows, overcast skies may be too dark, you may have an object you want to bring more attention to, and more. The huge advantage of the digital lighting kit available in Vue is that you don't need to lug anything around, and you can choose whether or not you need to deal with lighting artifacts such as lens flares. Lighting itself is a specialized art form, with entire professions and books dedicated to getting it right. To get the most out of Vue's lighting, it is a good idea to study some of them and gain at least a basic understanding of lighting techniques.

Types of Lights

In the left toolbar you'll find the Light icon. Right-clicking on it, you'll see six different kinds of lights. You can also use the top menu by going to Object > Add Light to find the list of lights.

Point Light

Spotlight

Directional Light

- *Point Lights* emit light from a single point in all directions. *Quadratic Point Lights* are very similar, but the light gets dimmer faster with distance, and with a more abrupt falloff. Resizing these lights result in an alteration of how far out the light reaches. Notice in the following figure how the edges of the picture are darker in the quadratic point light than the regular point light, and how much faster the light dims.

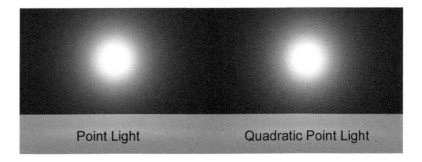

Point Light Quadratic Point Light

- *Spotlights* and *Quadratic Spotlights* behave in the same way as point lights except they emit only a cone of light from a point. You can see the effect of the quadratic light a little better.

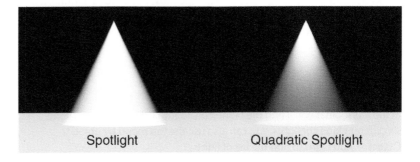

Spotlight Quadratic Spotlight

- *Directional Lights* simulate a very distant light source, with parallel light rays moving in one direction. In the 3D OpenGL views a directional light looks like another hexagon sun, with its arrow pointing in the direction of the light. The sun is, in fact, a directional light.
- *Light Panels* are plane objects that emit light from every point on their surface. This can give a very soft light without harsh shadows.
- *Area Light* is not on the list of lights, but is instead something that you can convert any object to. This will cause an object to emit light from every point on its surface, like light panels. You can accomplish this in the top menu by going to Objects > Convert to Area Light. Once you've done this, you cannot convert it back except with an Undo operation. One of the fun things about this ability is that any material you used before you converted will also color the light and cause variations in the power of the light being emitted.

Light Panel

Light Controls

You can control lights through the Aspect tab of the Object Properties Panel. On the left of this panel are four icons that can enable certain lighting characteristics and tools: Lens Flares, Gels, Volumetric, and Shadow. More will be discussed about these later in this chapter. There are several main settings in the main area of this tab too, although they differ depending on what kind of light you're working with. For every light but panels and area lights is the setting for Softness.

Softness is an important setting for the look of your shadows. Except for area lights, in Vue, light is either being emitted from a single mathematical point or is exactly parallel. This is not true to reality. The physics of this kind of light emission causes shadows that can be very sharp, with hard edges. To soften the shadows, it is better to have light come from more than one point. For instance, light comes from the whole surface of the lightbulb. Since it is coming from several different points, shadows tend to have soft, blurred edges.

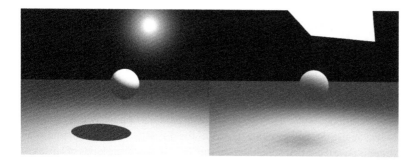

The softness control creates an artificial area from which the light comes, making the shadows softer. The higher the value, the softer they'll be. However, this requires considerably more calculations to achieve. Unfortunately, the price in render time is relatively high for this effect.

You'll be able to control the color for all lights. Power will increase the brightness of lights, but doesn't apply to directional lights. Spread and Falloff are characteristics of spotlights. Spread deals with how wide the cone is, and Falloff describes how quickly the light at the edge of the circle fades. One other useful characteristic about spotlights is that you can look through them as if they were a camera, in the OpenGL main camera view.

Light Editor

Here is where you'll be able to customize your lights to exactly what you need them to be. As well as making them do anything they'd do on live sets, you're able to make the lights do things not possible in the real world. For instance, you can make the light affect only selected objects in a scene, and you can choose whether or not you want a lens flare.

Lens Flares Tab

Lens flares aren't part of the light itself, but are an interaction between a light source and the lens system of a camera. The light can both reflect and scatter inside of the lens, causing glare, stars, rings, and other effects than tend to obscure the image. Different kinds of lenses will cause different kinds of flares. In real life, lens flares are usually a difficulty of lighting and camera work that photographers struggle against. In Vue, not having lens flares is the norm, and adding them in is an effect sometimes used to achieve a more photographic feel, or add the drama to the scene invoked by the veiling of the geometric light patterns.

Photographers familiar with the behavior of lens systems will recognize the different kinds of artifacts that can occur. When the Lens Flare tab is enabled, Vue has some default settings. To get to know the effects, it is useful to disable them all and look at them one at a time. But before you do that, at the top is a group to control the general effect of the lens flare. Intensity will let you make the flare strong or weak. Rotation will let you rotate the star streaks and random streaks in the flare. Anamorphism will cause the flare to flatten. This is an effect that occurs when a vertically distorted Panavision lens is used to film, and subsequently the Aspect Ratio of the image is made Widescreen. Therefore, this is an effect most useful when rendering widescreen images. The value of one will keep the lens flare with a normal aspect. Which positive value you use depends on the ratio 1:X of the distortion. The blue anamorphic streak is an artifact that sometimes occurs when using these kinds of lenses.

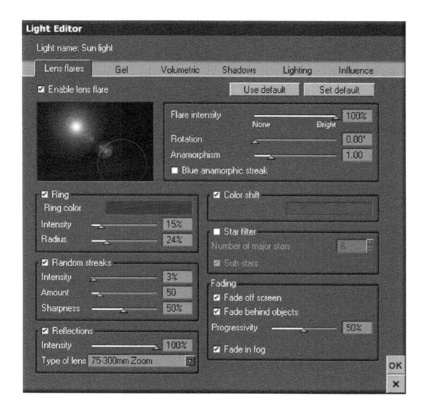

The controls for most of the artifacts are fairly self-explanatory. As you experiment with them, it might be helpful to look at photographs with examples of lens flares to get a good idea of what kinds of things are generally seen in them.

Gel Tab

Colored lighting can do quite a few things to the appearance of your scene, such as increasing contrast, bringing out or suppressing certain colors, and adding ambience.

To get colored lights, with or without variation in them, gels are used. In real life, they're usually flat pieces of acetate hooked on in front of a light. In Vue, they're materials that can either be placed in front as if an alpha plane were in front of the light or mapped around the light in a sphere, which could be useful for point lights and isn't available at all for directional lights. The colors in the materials will then be projected from the light. Only "flat"-type materials can be used for this, and some of those may get you poor results as well.

Volumetric Tab

Rather than the light just affecting the surfaces it touches, volumetric lighting lets you see the emission of light. A point light will become a ball of light. A spotlight takes on its familiar cone of light appearance. It is in volumetric lighting that the difference between quadratic lights and normal lights becomes most apparent, with the quadratics being very bright near the point of emission, and then quickly fading away. You can make the effect brighter with Intensity, and as with all volumetric effects, you can increase the number of samples taken (and thus the render time) in Quality Boost.

Cast Shadows in Volume is another Volumetric tab standard, where you can choose to have the effect of light not traveling through solid objects. This tab offers you one more bit of fun in letting you Show Smoke or Dust in Light Beam. Once you've toggled this on, a function and filter control will pop up to enable you to customize the smoke and dust.

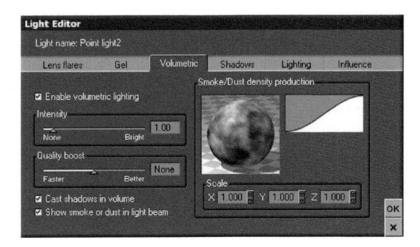

Shadows Tab

The first thing you can do in this tab is decide to not have shadows, which could be useful in portrait-type images. However, shadows are a natural part of what we see, and things quickly look wrong without them.

So, how much of a shadow do you want? In Shadow Density you can make it so that all light passes through and there is no shadow, or so that no light from that source will shine on anything in the shadow. The default for this is 100%, which produces dark shadows. Because light is scattered in an atmosphere, this isn't very realistic except in outer space.

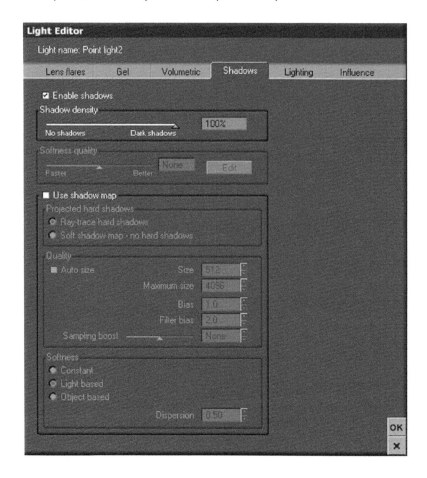

If you've added softness in the Aspect tab of the light you're working with, the Softness Quality setting will apply and be available. You have the general slide between better and faster, but pressing the Edit button will give you advanced control over quality. Quality in this case is a matter of how many rays are traced

per pixel to determine how much shadow the pixel will demonstrate, eventually leading to how accurate the overall soft shadow is. In the typical settings, a minimum of four rays are traced and, if there isn't enough information with those, more rays are requested for that pixel. The Max setting determines the most rays that can be used. Quality Threshold is about how exacting the software is in accuracy and requiring more pixels to be traced. The higher this value is, the more likely more rays will be used for each pixel. Thinking about these numbers, you can see how these settings can quickly increase the number of computations in a render and slow down render times.

The solution to the length of time it takes to render shadows with ray tracing is to use a shadow map. And yet, ray tracing is used for shadow maps, too. The difference is that a shadow map is obtained by tracing the ray only from the light's point of view of the object. Imagine that at the light's point is a square made of a certain number of pixellike cells. Where a ray detects an object, it causes that cell to be a shadow. This collection of shadowed or nonshadowed cells is then applied appropriately on surfaces behind the object as a shadow map.

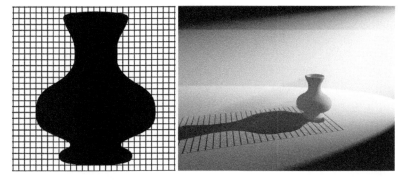

The image on the left, a shadow map, is what the light "sees." This shadow map then gets appropriately applied where the shadow should appear.

To take advantage of this, click Use Shadow Map. If you are not using softness in your lights (as set in the Aspect tab) then you'll have two choices for a shadow map. One is the shadow map operation just described. In volumetric lighting, soft shadow maps will always be used. The other is simple ray tracing, where a ray looking for shadow information is cast to the light and will be considered in shadow if an object is found before the light.

The Quality settings will determine how good your shadow map is by setting a size for the square area that casts the shadow map. The larger the size, the

more cells will be used to determine which pixels should have shadow applied. You can set this size for yourself or let Vue set it based on the resolution that the rendered image will be.

Bias and Filter Bias are sensitive and advanced controls used in case artifacts such as moiré patterning occur in scenes where shadow mapping is less appropriate. Changing these could get you poor results. It is generally better to either have a larger size of shadow map or not use a shadow map at all.

Sampling Boost will let you control the maximum number of samples taken. Too few may lead to noisy results and not enough will increase the render time.

The farther away either the light or the occluding object is from the surface where a shadow is cast, the softer and more dispersed that shadow will be. Shadow mapping does not handle this very well, and so there are some options to simulate it. The first one is to have a Constant softness, which is no dispersion as distance increases, which can sometimes be just fine. The next option, Light Based, will calculate the dispersion based on the distance from the light. This could end up dispersing the shadow unnaturally, even at the base of an object where shadows should be darkest. Object Based dispersion could be the solution to this. Here, dispersion is based on how far the object is from the cast shadow surface. Unfortunately, this effect can be unpredictable. You can also change how quickly the shadow disperses because of distance: the lower the value, the more gradual the dispersion.

If you're very concerned about the effect of dispersion, ray-traced soft shadows will give you much more accurate results than soft shadow maps.

Lighting Tab

This tab deals with how quickly the light decays. You can choose from three options: Linear, Quadratic, and Custom. Linear light will dim in equal proportion to its distance and is the way standard lights work. Quadratic light loses power much more quickly, with the square of the distance from the light source.

If you select Custom, you'll be able to control the decay of light through the filter, where the distance measured on the horizontal bar is determined by the cutoff distance setting just underneath it. For instance, if it is set at 10 meters, then the far left of the horizontal bar is 0 meter and the right is 10 meters. The vertical bar measures the intensity of the light. This should be a downward curve, with the light brightest where it is closest to the source.

If you want, you can also have variable color with distance, using a typical color map. Once again, the distance is measured on the horizontal with 0 at the left and the cutoff distance at the right.

Influence Tab

Here you'll be able to determine what objects the light influences and how. Specular light is that which bounces off, causing highlights. If you don't want any highlights caused by this, you can uncheck the Specular Lighting option. Diffuse Lighting is the light that bounces back off an object, but doesn't gain its color.

As well as those, you have the Objects Influenced By Light settings where you choose which objects you want the light to influence—a very nice advantage over lighting in real life.

Tutorial 15: Warm Grotto

In this scene of a homely cavern, you'll use terrains and a model creatively
here to create a cave with an interesting entrance. You'll add a few more rocks
for details, and then lighting takes the stage as you arrange several different
kinds of lights for an effect that warms up the place and makes it actually look
inviting.

Step 1

Create a terrain and stretch it out so it is long and just in front of the camera. Reduce its height so that is a very gentle slope. Load the material "Landscapes > Desert Stones" onto the terrain. Create another terrain. Stretch it out like the first, but now tilt it up on its side and position it so that it is a wall and the first terrain is a floor. Create another terrain and do the same, this time putting it on the opposite side. For the ceiling, create another terrain. On this one, double-click to enter the Terrain Editor. Increase the resolution to 2048 × 2048. Click the Reset button and then click on Mountains. That will recalculate the mountain with the higher resolution. Now click on Invert in the top toolbar of the editor. In the Terrain Editor view, tilt the terrain so you can see the inside of the hollow. Now Clip up until you see some holes. Take this terrain and tip it almost all the way over toward the camera so that it becomes the ceiling, with the holes readily seen. You may need another terrain to cover the gap between the floor and ceiling terrains in front of the camera. Confirm that all terrains have the "Desert Stones" material on them.

Step 2

Click on the Load Object icon in the left toolbar to bring in "Building 1" from the Houses and Cottages Historical collection. Resize it and place it on the left, facing the right to make an entrance. Make sure you get it appearing to be sunk into the ground a bit, as seen by the camera. Load another object, this time choosing "Building 2." Shrink it to less than half the size of the first building, and then place it right next to that and a bit above the ground. Add a few rocks scattered in the scene for some detail. Be sure you don't cover up any openings in the buildings. On both of the buildings, load the material "Stone Rubble" from the Landscapes collection.

Step 3

The lighting in any scene begins with its atmosphere. Load the atmosphere file "cave.atm" from the Tutorial Pack on the book's web site. This will give a dark, stuffy atmosphere. Now right-click on the Light icon in the left toolbar to create a point light. Put it in the front entrance of the first building. Make sure the light is deep in the entrance. Also position it toward the ceiling of that doorway and to the right. In the Aspect tab, change the color to a warm yellow-orange and decrease the Power to 30. For soft shadows, increase the Softness to 11. Create another point light, placing it in the window of the second, higher, and smaller building. Change its color in the Aspect tab to orange, increase its Softness to 26, and decrease its Power to 15. This should create a nice fire glow.

The cave is still too dark to see some of the details. Right-click on the Light icon again. Choose Spotlight. In the Aspect tab, increase the Softness all the way to 30. Also increase Spread to 55°, Falloff to 30, and decrease the Power to 15. Move the light toward the center of the cave, a little closer toward the camera than the two buildings, and then point it at the buildings.

Step 4

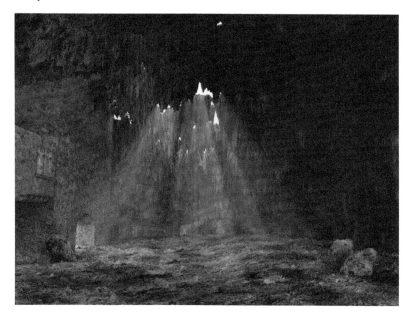

For the finishing touch, create one last point light. Move this light outside
of the cave, above the holes in the ceiling terrain. In the Aspect tab increase
its Softness to 32 and make its Power 55. Now right-click on this light in the
World Browser and select "Edit Object." This will open the Light Editor. In the
Gel tab, check the box to Enable Light Gel and choose a Spherical Gel type.
Click on the Load Material icon in this interface to choose "Caustics Gel" from
the Light Gels collection. In the Volumetric tab, toggle on Enable Volumetric
Lighting. By default, Cast Shadows in Volume should be on too. This should
create rays of light coming through to the cave, as if sunlight was coming
through. Vue's sun was not used because the atmosphere required for the
overall effect was much darker. Choose your render settings and render.

Cameras

Your creation is pretty as a picture, so it's time to make it one. In fact, the camera is always part of the scene, for the main camera view of the three-dimensional (3D) views and the preview render on the right. In Vue, you can be the director of cinematography as well as creator of the world. But, like with lighting, good image capturing through Vue's cameras takes skills beyond fluency with the software. Experience with photography would be very useful, and beyond that, reading a book or two about both camera work and cinematography will help you get the most out of what Vue has available to you as far as cameras go.

Scene Information Bar

Moving and manipulating the camera in the world space happens both in the 3D views and in the scene information bar, using the Camera Controls and the Object Properties Panel. You can move the camera in each, but with varying degrees of control.

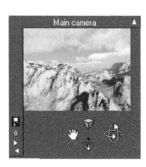

The easiest way is to move your camera around in the scene using the gizmo in the OpenGL views. For more precise movement, use the Camera controls just under the main camera render preview.

You can point the camera in any direction with the icon that looks like a gyro. If an object other than the camera is selected, then this movement will be centered on that object.

There are two ways to pan your viewpoint back and forward. On top, the Telescoping Cube icon lets you zoom the camera. This effectively changes the focal length of the camera, and you'll be able to see that if you have the Aspect tab open just above. When you move your view closer this way, the perspective does not change but remains the same because the distance hasn't changed.

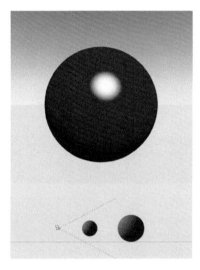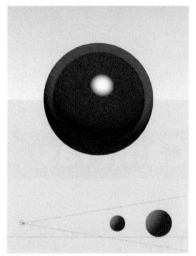

On the left the camera retains its default focal length of 35 mm but is moved closer to the two objects. On the right, the camera is farther away, but it has been zoomed in for a focal length of 110 mm. Notice that because of perspective the smaller sphere occludes the larger one when the camera moves closer.

If you want to avoid this distance versus perspective distortion, it is better to move the camera toward the objects in question. This is accomplished with the black-and-white Arrow icon.

The Hand icon lets you move the camera up, down, and side to side. This works as if you had a lever you were pulling down with the camera at the other end being pulled up, much like a real camera works.

All of these camera controls can be slowed down for more careful movement by pressing the Ctrl key while you work the controls.

Above the Camera control is the Object Properties Panel. There, in the Numerics tab, you'll be able to enter number values to position and point the camera exactly. The original position of the camera is set at 0, −10, and 1.8. The Size

and Twist properties are not available since these don't apply. The orientation, or direction the camera is pointed, bears some explanation. Pitch refers to how far up or down the camera is pointed. The default setting is 90°, making the camera pointed in a direction exactly parallel to the horizontal plane. 0° points the camera straight up, and 180° points it straight down. Yaw is where the camera is pointed around the scene, as if with a compass. Vue starts with the camera pointed at 180°, and in the top view this appears to be pointed directly up, with 0° pointing in the opposite direction. 90° points right in this top view and 270° points left. Roll is how the camera's image plane is rotated: 0.000 means that the top and bottom of the image, across the width, are parallel to the ground plane's default position. Anything else means that the camera is turned, basically as if on a skewer through the lens.

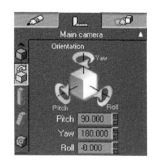

When combining live footage, it is important to make sure that the pitch, yaw, and roll of Vue's simulated camera match those of the one that took the footage. You'll need to make sure you record this information as you film.

There is, however, one characteristic of position that is kept in the Aspect tab. This is the Height of the camera. You'll notice a Lock icon beside that numeric value. By default, this is enabled and appears pressed in and highlighted. This locks the height to being above any surface under it at exactly that measurement. By default, this is set at 1.8 meters, about the height of an average person. If only the ground plane is below it, the camera will be exactly 1.8 meters above that. But if anything is put above or inside or surrounding it, the camera will move so that it is 1.8 meters above that object. When the height is locked, nothing can be over the camera except lights, sky, and clouds. Pressing on the icon so that it turns gray will disable this characteristic.

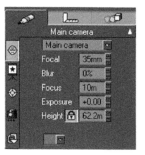

The other settings in the Aspect tab enable you to change the lens system of your cameras. This is where a good knowledge of cameras can be helpful. At the top, you can choose which camera you want to work with. Under that is where the Focal Length is, which lets you zoom in, to make objects appear closer without actually moving toward them or widen your camera's view to take in more of the scene. The Blur setting refers to your Depth of Field. In natural lens systems, only a small range of distance is in focus. The higher the blur value here, the narrower will be the range of the visual field that is in focus. To control where this Depth of Field is, you have the Focus setting.

The Exposure setting lets you simulate how much light gets to the film. Higher values give more light to the film, making it brighter, while lower values make it darker. This doesn't act naturally, as it doesn't change things like Depth of Field. You can also make this automatic and appropriate to other camera settings in the Advanced Camera Options interface.

On the left of the camera's Aspect tab you can add a backdrop, link the camera to other objects, and manage cameras. These will be talked about later.

Advanced Camera Options

These options are accessed when you double-click on the camera or right-click and select "Edit Object." Under the camera preview of this interface is the group dealing with Aspect Ratio. At the top of this is a dropdown menu where you have a wide selection of different aspect ratios. You can also select this from the render options. At the bottom of this dropdown menu you'll find the ability to create your own aspect ratio. If you select this in the camera options, you'll need to go to the render options in order to define the width and height.

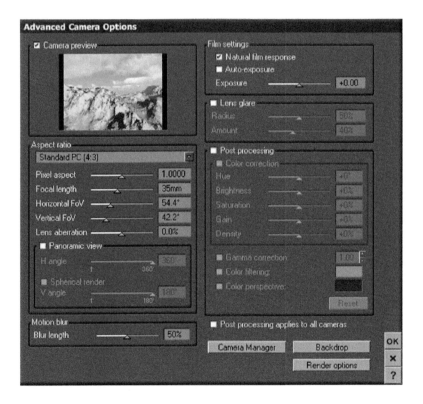

Often during filming, the photography takes place with an anamorphic lens, which stretches the image from top to bottom, letting the cinematographer use all of a 35 mm area of film rather than leaving the top and bottom blank when capturing a widescreen image. This image is then flattened to get the widescreen aspect ratio. When this happens, the "pixels" of the film also get flattened. If you're creating scenes in Vue that are meant to work with footage in which this has occurred, it is a good idea to match this pixel distortion. The value you set here depends on the type of film and its final aspect ratio.

As well as the Focal Length setting, you have Horizontal FoV and Vertical FoV. Many photographers may be more familiar with those than focal length. The Fields of View are the angle of the camera's view. If you change them, you'll see the lines showing the border of the camera's field of view angle wider apart, demonstrating how it works. It doesn't, however, change the aspect ratio, but the perspective in the camera view. You should also see this as you change focal length, and see the FoV values change.

Lens Aberration is new to Vue 7. This refers to the distortion that can happen with telescopic or wide-angle lenses. When you use a telescopic lens to view something very close, the image may appear to bow inward in a distortion called pincushion distortion. To get this effect, move the value into the negative range. On the other end, when you are viewing things with a very wide angle, the image may bulge out. This is called barrel distortion and is most obvious in pictures taken with fish-eye lenses. Positive values will show this.

Under that you have the option to create images with a Panoramic View. That is, the image could include the entire vista from all around the camera, although you can choose to see less than the whole 360°. If you enable Spherical Render, the image will also include everything from the ground (0°) to the top of the sky (180°). This is highly useful for such things as reflection maps and Environmental Mapping.

In Motion Blur, the Blur Length setting controls the overall amount of blur, with an effect similar to setting the exposure. The speed of objects will still be a huge factor in how much motion blur occurs.

At the top right of the interface is the Film Settings box. Natural Film Response lets you simulate the saturation effect of light on film. The longer film is exposed to light, the less it is able to record that light information. This cuts off some of the brightness. In fact, this is one of the advantages of digital imaging, that more light information can be retained. However, to maintain the look of real photography you'll want to simulate this effect. Another problem of light exposure is how much ambient light there is when the sun is high in the sky versus near the horizon. Enabling Auto-exposure will let Vue automatically compensate for this, adding more exposure if needed. You can also manually lessen or add exposure.

The next settings don't deal so much with the camera, but what will happen to the image after it has been rendered.

Lens Glare is what happens in some lens systems, when a bright light scatters within the system and causes a subtle glare that can soften the scene, giving it a more dreamlike quality. Although, of course, in real life this occurs with the

image capture, you'll see this effect appear in your Vue image right after the render has finished.

Then you have some Postprocessing options, letting you correct or change your image within Vue itself rather than needing another application. You'll have the standard set of Color Correction tools: Hue, Brightness, Saturation, Gain, and Density. In case you're not familiar with them:

- *Hue* refers to what relative color your image is. Changing it will move all the colors across the spectrum.
- *Brightness* is how bright, or in effect how much closer to white, each pixel is.
- *Saturation* is how much color there is (for instance, blue as opposed to gray-blue).
- *Gain* creates smooth contrast.
- *Density* refers to how bright the highlights are.

Gamma Correction is important when creating images that are meant to be looked at on video monitors. Monitors often change the brightness and color saturation of pixels from the linear values they were to a curve. Gamma Correction will solve this. The visual effect is that things get a bit brighter with higher values. A value of 1 here means no correction.

Color Filtering is like putting a color gel in front of the camera to get a certain look.

Color Perspective will replace the darkest color with the one shown here. With brighter areas of the image, this color is blended in. The results can be both subtle and very dramatic. One fun thing to do is to completely remove the saturation from the image in Color Correction and then change the darkest color to a dark brown in Color Perspective. This will give you a nice sepia look.

A Reset button at the bottom is a convenient way to return all the postprocessing back to normal. There is also an option to apply this to all the cameras.

Creating and Managing Cameras

By clicking on the Camera Manager, you can have more than one camera in your scene. This is useful if you'd like to take different shots of the same scene throughout an animation. The Camera Manager is, well, a bit awkward at first but easy enough when you know how it works.

To create a new camera, type the name of the camera you want. Click "OK" and that camera will replace your main camera in the browser. Both are still there, but only one camera can be shown in the World Browser. If you move your

new camera in the OpenGL views you'll see the main camera where it was. To switch between cameras, click on the Camera Manager again if the Advanced Camera Options interface is still open. If not, there are two other ways. One is to click on the Camera icon in the lower left of the Aspect tab. The other fastest way is to use the arrows at the lower left corner of the Camera Control Center.

Another way to quickly create a new camera is to click on the Store button in the Main Camera Controls. This is the Disk icon to the left of the main camera preview. When you click on the Store button it will create a new camera, named with a number, in exactly the same place as the camera you were using when you clicked Store. Not only is this an easy way to add another camera, but the original purpose of "storing" the camera for the view you wanted to keep is very useful too. Make sure you name the new camera appropriately, so you know which one it is when you have seven cameras in your scene (at no extra cost!). To delete any camera, you'll need to go into the Camera Manager.

Backdrops

Another button at the bottom of the Advanced Camera Options is the Backdrop, which you can also add through the Star Screen icon in the Aspect tab. Backdrops are another type of specialized alpha plane. This plane is attached to the camera view such that no matter where you point the camera, it is always there. The edges of the alpha plane image always line up with the edges of the camera's field of view and it never appears in front of any objects you set into the scene. This lets you add effects onto preexisting images.

One object, the ground that is part of every new scene, will "clip" the image, so that some of it disappears behind the horizon. Once you've clicked Backdrop, a Camera Backdrop Options interface will appear. After you enable Use Backdrop, you'll be able to load the image you want to use. It can be a still image or animated. A word of caution, however: Vue only uses AVI animations compressed in certain formats for PCs, and MOV animations for Macs. Without the right format, your backdrop won't appear in the render. The Zoom Factor at Render setting controls how big the image is in the screen. If this value is smaller than 1, then the backdrop image will be smaller than the image field and will start to tile. Values larger than 1 zoom into the image and crop off the edges. A value of 1 keeps it set right in the background.

You'll be able to see a placement of this backdrop in the camera angle in the 3D views. You can move this toward or away from the camera using OpenGL Preview Distance. However, this is only an indicator of the backdrop. Moving it will not change its size in the camera's view, although it may feel more intuitive to place it behind all the objects.

If you're using an animation, you can enable Animated OpenGL Preview, which will show the appropriate frame of the animation for where you are in the timeline. Not having it enabled will cause only the first frame to be shown in the OpenGL camera view no matter where you are in the animation.

The last button in the Advanced Camera Options is the Render Options button, discussed in Chapter 17.

Tutorial 16: Ant Close-up

This scene of a tiny creature will be easy to put together, but the camera has a complicated setup to demonstrate Depth of Field.

Step 1

Start a new scene in Vue. Move the sun to the left of the camera at about 7:30. Click on the Object icon to load the "ant.vob" file from the Tutorial Pack. Click on the Drop button to put the ant on the ground. Now right-click on the Plant icon to get to the browser and choose "Dry Weeds." You'll need to

increase its scale to the plant to make it taller than the ant. Arrange three of these in a crowded, shallow arch behind the ant. Now load in a "Small Grassfield Plant" from the Plants collection and place it right in front of the ant and scale it up so the leaves appear to be about half the size of the ant's head.

Step 2

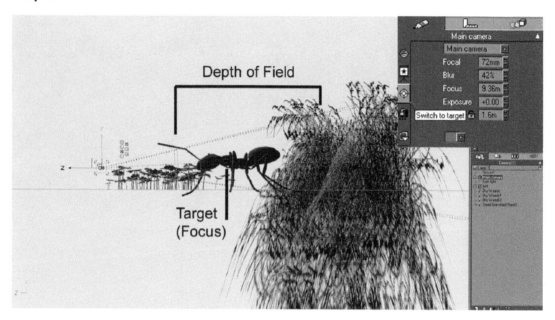

You'll want to move your camera right into the scene and you may want to adjust the ant a bit so its eye is looking right at the camera. In the Aspect tab, you'll want your Focal to be set at 72 millimeters. This will zoom into the ant. Now, set the Blur to 42%. This will approximately encompass the ant. There are two ways to set the Focus or focal point. The first is using math to set it to the distance between the ant and the camera. This is where the grid comes in. But another way to get a more exact number is to subtract the camera's distance on the Z axis (with Y being the up axis) from the ant's distance. In the case of this scene, that was 8.77 meters. The manual way is to click on the Switch to Target icon in the Aspect tab of your camera. Now you can move this point where you'd like in the scene. When that is done, get your render options set and render. Open the Render Options screen. Select the User Setting. Make sure the Depth of Field box is selected. Click the Edit box. Select the Hybrid

2.5 D for the Blur rendering method. Set the number of passes to 2. Click "OK." When you render the picture, the first pass will not have any blur. Just let the render finish. You can see what depth of field does in the following picture.

Animation

Through the magic of animations, you can breathe life into your world. As you create your scene, you sow the seeds of this animation: clouds, breezes on plants, waves on the water. These are things that will be in motion if you only add time to the image. Then you can add objects that move through the scene, sparking the scene into a narrative of motion.

The skills of animation that you need beyond knowing how to use Vue are an understanding of how things move and how objects interact. Some physics understanding is useful here, such as the acceleration caused by gravity. Vue has some very helpful automation for some of this, especially vehicular movement. Also on the book's web site are a few equations and how to implement them that you may find helpful. However, one of the most useful devices here is careful observation and questioning. How do people walk? How do mammals and bugs walk? When a butterfly moves its wings, where is the pivot point? How does a floating object behave on waves?

Some of this has been captured with slow-motion photography, giving us useful insight. Motion capture technology has also been helpful not only for animating characters, but for showing us how the human body moves. This kind of animation often occurs outside of Vue, with the motion of an object imported in another file, such as with Poser objects.

With all the different kinds of animation you're accomplishing in Vue—environmental, object, and material animations, as well as imported animations—it is important to weave all the strands into a cohesive whole. It is useful to record a list of everything that is animated, and how they may possibly be linked, so that you can check through it all to make sure all the elements are working together properly.

Animation Properties Tab

The most present animation tool is in the Object Properties Panel in the upper right of the interface, in the Animation tab. You'll need to define which kind of motion you want your object to have. This is where you can make use of Vue's several preset behaviors, letting you easily animate vehicles without needing to worry about the way they turn, accelerate, etc. There are a few other motion types that bear talking about: Basic, Standard, and Smooth.

Standard motion is that used by most three-dimensional (3D) applications. When this is used, objects may appear to speed up around turns, especially sharp turns. The solution to this is to use Smooth motion. This will slow down objects at turns so it better resembles real movement. Basic motion slows objects down just a touch more than Smooth. At the bottom of this menu, you'll also see Synchronization. This has more to do with importing camera and object animations from other software and will be explained in Chapter 20 on software integration.

You'll probably also need to choose a main axis. The main axis determines which way the object will face as it moves. It is the main axis that is aligned to the path so that the object is always facing forward or backward. You can see a preview of this direction in the Animation Wizard, which will be talked about in the next section.

Under this, you'll have Track and Link options, which are ways to connect objects. Track will make the direction of an object, most usually the camera, always pointed toward another object. The dropdown menu will list all the objects in the scene. Link will make the object move with another object in some manner, and also has a list of scene objects. Choosing either one of these items will make available the Response slider, which is an option new to Vue 7. Response will control how closely an object tracks or is linked to another object. When it is too perfect for things like camera tracking, this is unnatural. Such following would require prediction in real life, which never happens. With the Response slider you'll be able to make it closer to reality. About a quarter of the way toward Loose mimics a human controlling a camera.

If you want a more careful control of this and other tracked or linked factors, you can right-click on either the Target or Link icon in the Animation tab. This will

bring up the Forward Dynamic Options interface, which allows you to customize how objects are tracked or linked. You'll have the ability to link objects only by their position, rotation, or size, or to choose not to join the two object's centers (for things like rotation and resizing). However, if the object you're linking to is set to any motion that includes Look Ahead, or is linked to another object, you won't be able to uncheck any of these. The solution then is to link the objects first and then set the parent object to Look Ahead or another link. When you're doing this, you may want to change the object's position, orientation, or size before you link it to the other object to ensure that its individual behavior is what you want it to be.

You'll also have more control over the response in the Loose dynamics group in the Forward Dynamic Options dialog. There you can set how loose the response is. These settings will control the algorithm used to create loose responses. The regular slider, found here and in the Animation tab, controls the Delay in the Custom response. This delay refers to how much time before a difference is reacted to. For people, this is about 0.2 seconds. Under Delay you'll find Proportional, Integral, and Derivative values. These are the kinds of controllers used to correct the difference and get things back in alignment.

Proportional refers to how much of a move will be made for the error to be corrected. Too low, and it may not respond enough. Too high and it may overshoot and never stabilize into the range you want.

Integral measures the same thing as Proportional and also adds in the factor of time. This will cause a quicker movement toward creation, but can also overshoot. However, this will tend to oscillate down to a perfect response (barring more input such as the delay).

Derivative can slow down the response, and therefore reduce overshoot, but if the value is too high, making it too slow, the controller won't be responsive enough. As you can tell, these values should be altered with a bit of care, and knowing what the default values are: Proportional is 0.50, Integral is 0.50, and Derivative is 0.00. Used well, they can be helpful in customizing things and creating shaky camera effects without manually animating the camera for it.

Animation Wizard

When you assign a type of motion to an object, the Animation Wizard will appear. This wizard brings together the important aspects of animating your object while clearly explaining the results of your choices. It can make things very easy, especially for the beginning animator. One thing to keep in mind is that the wizard can only work with one object at a time. You'll be unable to switch between objects until you've finished with the wizard. If you exit the

wizard before you press the Finish button, the changes you've made will not be applied. If you want the Animation Wizard to stop popping up every time you start animating, you can uncheck the box to Display This Wizard for New Object Animation.

Animation Toolbox

The Animation Toolbox has most of the tools found in the Animation Wizard, without having to go through a screen-by-screen process. Tools not found here will be accessible through the Timeline, explained later. Before you can open this, your selected object will need some kind of animation. You can do this by simply assigning it a kind of motion. To get to the toolbox, click on the Clapperboard and Box icon in the lower left of the Animation tab, the Clapperboard icon at the right of the Timeline, or access it through Animation > Animation Toolbox. You'll find the motion controls there, and an Options button that will open up the

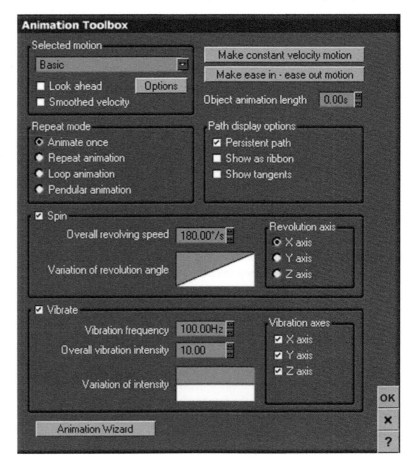

Motion Options interface, where you can fine-tune some of the automatically produced motions such as banking and looking up when accelerating. Also, rather than needing to use a dropdown menu, you can simply choose Look Ahead or Smoothed Velocity, or both. As discussed before, Smoothed Velocity will reduce hard accelerations and decelerations due to things like turning.

To the right you'll have two buttons. Make Constant Velocity Motion will give you an instant 0–60 mph. Basically, it causes your object to have the same speed from beginning to end with no acceleration or deceleration. This is useful of course for scenes that are taken while objects are right in the middle of their action. If you want the speeding up or slowing down to a stop motions, choose Make Ease In–Ease Out Motion.

Under that you will find the Object Animation Length. If you haven't already set a length (by setting a keyframe in the Timeline) then this length won't apply. However, this can alter an already established length.

As well as choosing whether or not you want your animation to repeat, you can choose how it will in Repeat Mode. By default, this is set to Animate Once. Repeat Animation will make it simply start again at the beginning if the overall animation runs longer than the object's animation. If you choose Loop Animation, Vue will calculate movement to make the transition from the end to the beginning of the animation smooth. Pendular Animation will create animation to reverse itself once it reaches the end, and then reverse itself again at the beginning so it moves back and forth through the animation path.

The grouping for Path Display Options gives you freedom over how the object's path will look in the OpenGL views. Enabling Persistent Path will keep the path visible even if the object is not selected. Show as Ribbon will make the path a ribbon instead of a line, so the object's orientation is visible with the ribbon twists. Show Tangents will make the tangents at each waypoint visible, but you'll be unable to change them except in the Timeline. (Note: A tangent is the line pointing in the direction of a curve or path at a single point. Moving the tangent will change the direction of the path at that point.) Making them visible will help you see how your work in the Timeline appears on the object's path.

The Spin and Vibrate settings let you add those movements to your object's animation more easily than trying to add them manually. For the spin, the Overall Revolving Speed is measured by degrees per second, with 360° making a full revolution. The Variation of Revolution Angle is a filter that has a range of the maximum number of revolutions possible with the revolving speed over the length of the animation. So, if you have a speed of 360° per second and a length of 4 seconds, the filter will have a range of −1440 to +1440.

With a lot of movements, there could be some kind of vibration involved. For instance, the viewpoint from a runner may move up and down at a regular

pace. Giving this vibration to the camera will simulate this. You'll be able to control how quick the vibration is with Vibration Frequency and how big it is with Overall Vibration Intensity. A filter here can also control intensity.

Animation Timeline

The Timeline is the command center of your scene's animation. There, the animation of all the objects can be seen and controlled. Except in the Animation Wizard, this is the only place you can direct the path of your object, and you can do it with exacting precision using keyframes and splines. Keyframes are where the values of object properties are defined. Between each keyframe, Vue calculates a smooth path or curve of change. Keyframes can be used for almost any property, including such things as light power, color, and geography, as well as position, orientation, and size. Splines are the curves between keyframes.

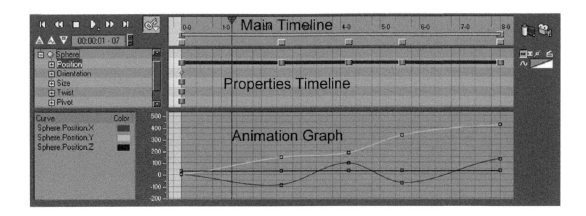

The three biggest components of the Animation Timeline are the Main Timeline, the Properties Timeline, and the Animation Graph. The Main Timeline is the one that looks like a ruler on top. It keeps a measure of the time for all the other graphs here, as well as the position of all keyframes. The Properties Timeline shows the keyframes for each individual property of an object. You'll be able to tell what the line is showing with the Animated Items list just to the left of the Properties Timeline. The Animation Graph is where the splines, the curves representing change in properties, are shown in different colors. To its left is the Graph Legend showing what those colors represent. All of these will be described in more detail as their use is explained.

Underneath these controls is where the Animation Preview can be shown. Vue will render your animation at a much lower frame rate and quality, but do it

quickly enough to give you a good idea of how the animation is turning out. To the right of the Main Timeline is an icon resembling a roll of film. If you left-click on it, Vue will render a preview, which will appear at the bottom of the Animation Timeline. Right-clicking on the Animation Preview icon will pull up some options. There you'll choose what render presets to use, how many frames per second to render for the preview, and size. The set defaults are designed to optimize how quickly the preview is generated and the size. If you increase the render settings or frame rate, be prepared to wait longer. If you used the Animation Wizard, a preview may have already been created for you. The last options will enable you to save the Animation Preview, which is useful when needing to compare or discard the one showing.

In the upper left are three triangles to toggle on and off: the Properties Timeline, the Properties Graph with its splines, and the Animation Preview. To move around in any of these timelines, you can hold the right button of your mouse while hovering it in the field of the graph, making a hand appear. Then you can drag around the body of the graph so you see different parts of it. Since the Main Timeline only deals with time measurement, you can only move it left or right. But the others you may want to move up or down to see different objects or where the curves go. You can also zoom in or out by pressing the Ctrl key (PC) or the Command key (Mac) with the right mouse button and pushing it forward or backward.

Moving Objects Through Time

The Main Timeline can measure the time in three different ways: by seconds, by SMPTE timecode, or simply by frames. To change among these, right-click on the Main Timeline and select to "Show Time As." SMPTE timecode is the industry standard by which each frame is assigned its time value in binary code. You'll see it expressed in the Main Timeline as seconds—frame. To the left of the Timeline, you'll notice a box with the current time, with the SMPTE timecode expressed in the standard hour:minute:seconds—frame. You can type in a value here to navigate through the timeline, and this indicator will also change as you move the Current Time slider in the Timeline. You'll find this triangular slider along the top of the Main Timeline, set, naturally, at the zero mark before you begin any work.

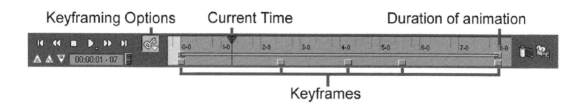

Keyframing Options Current Time Duration of animation

Keyframes

Keyframes

To create a path for your object, making it move from one point to another, you'll begin with a keyframe. This will set the object's properties at a specified time. To create a keyframe, go to the top menu and select Animation > Add Keyframe and choose whether you want it to represent all properties or just one. This is also one of the ways you can start animating without going into the Animation tab or opening up the Timeline. Adding the first keyframe will display the Timeline and open the Animation Wizard if that hasn't been disabled. If you already have the Timeline open you'll see a Key icon just to the left of the Main Timeline. Clicking on it will bring a dropdown menu with your choice of keyframes.

This path corresponds to the Timeline shown in the previous figure.

When you've added a keyframe, you'll see it appear in the Timeline just under where the Current Time slider is. Now, to make your object move, start by moving the time slider to the desired time. Let's say 2 seconds. You can get this exact by paying attention to the Current Time box next to the Timeline. Next, in the OpenGL view (which view you use depends on the direction you're moving your object) you'll drag your object to the desired position. At this point, you'll probably notice that a keyframe was already created for you. This is Auto-Keyframing at work. Auto-Keyframing will add an appropriate keyframe every time you've moved the time slider and then changed a property on your object. If you'd like, you can turn this option off, either through the top menu or through the Key icon by unchecking the Auto-Keyframing option. When you do this, the Key icon will no longer be orange.

When the new keyframe was added, your scene gained length of time. An orange line appeared, representing the duration of the animation as far as rendering it is concerned. You can directly shorten or lengthen this. When

you hover your mouse on either end, you'll be able to push or pull it in either direction. This action will have no effect on where the keyframes are set. This means you could theoretically cut footage in your scene from the render.

Every keyframe is added in the same way. Simply move the time slider, move the object or change the property, and add a keyframe. Keyframes in the OpenGL views appear as waypoints. You can add keyframes for more properties than are listed as well. For instance, if you have selected a light you can change its power, softness, and color, as well as its position and pivot. Nearly every numeric property of any object and many for materials can be animated. If at any time you decide you'd rather have a property or position of your object different from what it is in the keyframe, select that keyframe and make the alterations you need.

To navigate within your animation you can use the Current Time box. Changing its numbers will move the time slider. The other navigation tool is the Stop/Play controls above the Current Time box. You can use this to play or stop your animation in the active window of your OpenGL views. Any movement of your time slider will also have this effect. The Fast Forward and Backward buttons will move your time slider from keyframe to keyframe. This is a useful way to move the slider to a keyframe you want to work on and can prevent the accidental creation of an extra keyframe, which can sometimes cause havoc.

If you've moved your time slider from the zero point before you've added your first keyframe, two keyframes will be created if Auto-Keyframes is on: one at zero and one at the current time, where your slider is positioned. The object will remain in place during the animation until the second keyframe starts a path curve.

The Main Timeline shows all of the keyframes, without differentiating between which objects and properties they belong to. To see a breakdown of all of the keyframes, there is the Properties Timeline. To the left of this is a list of all animated objects and other items such as clouds and postprocessing. Click on the + icon to unfold the list of properties of that object. The rows in the Properties Timeline will correspond exactly with those in the list. If an item or property is animated, a line with all of its keyframes will be present. You'll be able to move these keyframes as necessary.

To the far right of the Properties Timeline, always on the same row as the object, are a set of icons. The first three, from left to right, are the options regarding how an object's path is shown in OpenGL and corresponds to the Path Display options in the Animation Toolbox. These are Persistent Path, Show as Ribbon, and Show Tangents. The Clapperboard icon next to these will open the Animation Toolbox for the object on that row. If you have several animated objects in the list, you'll find as you move down the list that these icons will appear to the right for every object.

Clicking on any property of an object from the list will also make the curves describing how the property changes, called splines, appear in the Animation Graph.

Splines

In the simple animation where you've moved an object from point A to B, you'll not only see the path in the OpenGL views, you'll see splines in the Animation Graph. For a position movement, the X, Y, and Z values must change. It is the change in these values that are represented by the splines.

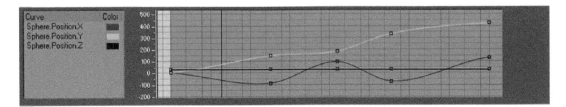

The horizontal values are the movement through time shown in the Main Timeline. Any navigation in any of the timelines will always be in the same place along the time ruler. The vertical values are the units appropriate for whatever property is being changed. As they change over time, the curve moves up or down. For object paths, there are changes in position: the steeper the curve, the more distance that object will be traveling over the time period, which basically means the faster the object will move in the animation. This is also true of other properties. Steep angles are fast changes and flat lines mean no change.

Every keyframe is marked on the splines. You can move this mark on any of the curves, but if you do this, it will create another keyframe associated with where the point you've moved ends up being. A tangent will also appear when selecting a point on the curve. You can use this tangent to change the shape of the curve, which will have the effect of changing both the shape of the path (since it is altering the distance traveled) and the speed of the object.

When you have a tangent visible, you can right-click on the spline curve to open up a menu. This will describe how the spline curve will be generated, and therefore how the object will move and its course and speed. By default, this is always set to Smooth (Weighted). This means that there will be no sharp turns in the course. If you want to change the curve type, you will need to assure the type of curve every time you add a new keyframe.

The types of spline curves are:

- *Smooth (Constant):* This will attempt to ensure there are no sudden changes in speed or position so that the curve remains smooth. If you change a keyframe, however, the tangents will remain the same.

- *Smooth (Weighted):* Like Smooth (Constant) this will keep curves smooth. If you change a keyframe the tangents will be recalculated so that the curve remains smooth. This is the default in Vue.
- *Ease In/Ease Out:* This will cause an acceleration and deceleration as an object starts and stops. This is a natural occurrence for how objects move. Tangents here will be horizontal.
- *Linear:* Lines are straight from keyframe to keyframe. Speed will remain constant. There are no curves here, only angles in both the spline and the object's path.
- *Step:* This curve changes values abruptly at each keyframe. There is no acceleration or gradual change. One frame of the object has one orientation, position, etc., and the next frame is completely different. Between keyframes, the values will remain the same. If you're talking position, this is like instant transport. It can be useful for things like light power, if you want to switch a light on or off.
- *Custom:* This is the kind of curve that will occur when you manually change the tangent.

Also in the menu is the ability to apply these curve types to the curve coming into or going out of the keyframe. This is basically applying it to only one side of the tangent. At the top, you'll be able to edit the tangents numerically when you select Numeric Input, which will open the Keyframe Values Editor. The values in are represented by the tangent on the left, corresponding to the flow of time from left to right. The values out are represented by the tangent on the right.

It can be helpful in fine-tuning your curve to see these three values in their numeric state. Time, obviously enough, shows the time in seconds. Velocity gives you how fast the object is moving in units per second. Tension refers to how much the tangent is "pulling" on the curve; the longer the tangent, the stronger its tension and the more closely the curve sticks to it.

Paths

You can also edit how the object moves by working directly with the path in the OpenGL views. At every keyframe is a waypoint that you can select, move, and alter the tangents (and therefore the bend of the path) on. This is an elegant solution and quite pleasing method of changing how your object moves. You do need to remember, however, that altering the object's path in this way will also change its speed. Make the path longer and the object will need to move faster to get from point A to B in the timeframe. The solution to maintaining speed while keeping course changes is to change the time by moving keyframes within the Main Timeline. However, sometimes time is limited. When you're making movements with the course of your objects, it is important to keep in mind the speed they must move at to get between points.

Tutorial 17: Dragonfly

This will be a simple flight of a dragonfly followed by a camera. The camera will be set to track the dragonfly with an imperfect response.

Step 1

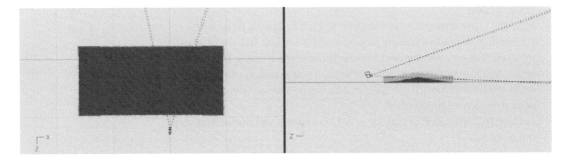

Start a new scene in Vue. Create a standard heightfield terrain. Resize it, using the edges rather than the corners so that you can alter its proportions. Make it a rectangular shape and push down the height as in the screenshot. Once you have your terrain, click on the Load Material icon in the Aspect tab. Go the Landscapes collection and choose "Grass." Now double-click on the material preview to edit the material. In the Material Editor, switch the type to EcoSystem. In the General tab, click Add > Plant and choose "Wild Plant" from Grasses—Plants or something similar. In the Density tab, increase Overall Density to 90%. In the Scaling and Orientation tab, reduce the Scale to about 0.13. Click the Populate button and click "OK."

Step 2

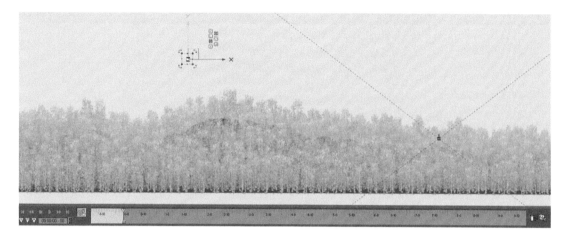

Click Load Object to load the "Dragonfly" from the Animals > Aerial collection. Make sure it appears approximately in the middle over the terrain. Move the camera closer and off center from the rectangle to the right. In the Animation tab of the Object Properties Panel, choose "Look Ahead" from the Motion dropdown menu. Close the Animation Wizard if it comes up. You should see the Main Timeline at the bottom of the Vue interface. Select "Dragonfly." Click on the Keyframing Options button next to the Timeline. Select Add Keyframe to All Properties. This will be the starting keyframe. You'll notice a white circle appear.

Step 3

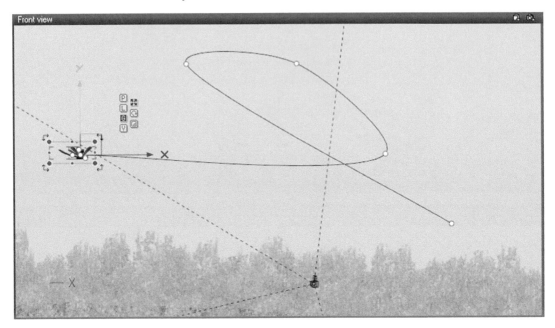

To move your dragonfly, first drag the Current Time slider, the marker triangle at the top of the Main Timeline, to about the 1.0-second mark. Click on the Keyframing icon again to add a keyframe here. As you do this, another white circle will appear. You'll see it attached to the dragonfly as you move it to the right. Now move the Current Time slider farther, to about 1–10 (10 being the number of frames after 1 second). Add a keyframe by clicking on the Keyframing icon again. Move the dragonfly a bit toward the camera. This time go to the front view as well and drag that white circle up a bit so that the dragonfly is flying up and toward the camera. Add two more keyframes, and in the same steps as just described, finish drawing the path so that the dragonfly makes a loop and continues flying off to the right. Be sure to add a bit of height variability using the front and side views.

Step 4

Move the Current Time slide to the beginning of the animation. The fastest and most accurate way to do this is to click on the Start of Animation icon on the far left in the playback controls. Select the camera target. This is the square at the end of the midline in the middle of the camera's field. In the Aspect tab, under the Focus On dropdown menu, choose "Dragonfly." Now select the camera. In the Animation tab, select "Dragonfly" in the Track dropdown menu. Now the camera will track and stay focused on the dragonfly. To make it a bit more realistic, slide the Response setting about a quarter of the way toward loose. In the Aspect tab, change the Focal to 70 millimeters and the Blur to 6%. Don't worry about Focus, as you already set that by linking the camera's target. Click on Render Animation to bring up the Animation Render Options. Select your quality, and in the Frame Rate choose 24 frames per second.

'ho's Going First? *Chipp Walters*

Rendering

With everything set up, now you're ready to render your image or animation for showing others. You probably already have rendered several preview-quality images at either the default settings or the working settings mentioned in Chapter 2. The final rendering options that you set are going to have a huge impact on how good your image looks. However, one common misunderstanding is that quality, and thus render speed, is the result of the render settings only. Hopefully you've seen throughout the chapters the various things that can influence the final outcome.

One of them is the several Quality Boost settings for volumetric lighting effects. Low settings here may result in graininess, but settings that are too high will increase render time without enough quality improvement to be worth it. You'll recall that these should only be changed when you're ready for the final render. Other settings important to the render but outside the main render interface are the scale and resolution of the materials you're using, and the scales of terrains, plants, and other objects.

In order to optimize these various settings for your final render, it is a good idea to take renders of small areas of interest, such as a volumetric cloud, or a branch/stem joint in a plant, with the high-quality render settings you intend to use for the final project. If you find graininess or artifacts of low resolutions, then you can go into

the appropriate options and set them higher to improve the quality of your image. This will usually be more useful than simply increasing the render quality.

In your rendering options, you will have the choices of image size, resolution, quality settings, where and how to render it, and what to render. There are also important animation render considerations such as frame rate, timecode, and things like flicker reduction and pixel aspect. These reflect a balance between render time and quality first, and compatibility of the render with your overall project.

Render Options

As mentioned before, you can access render options by right-clicking on the Camera icon in the top toolbar or selecting Render > Render Options. It is in the middle of this interface that you'll find a large array of settings to control your Render Quality, and there are even more, as some of these can be edited further. Unless you've selected User Settings in the Preset Render Quality box, you'll be unable to change many of them. Many new users of Vue make the mistake of thinking that the presets generate some linear increase in quality. In fact, they each contain certain settings appropriate for different kinds of projects. Presets are useful as a starting point, but often need to be worked with to get the results you're looking for. To know what exactly the presets do and how an image is rendered, it is important to understand all the different Render Quality settings and how they'll affect your image.

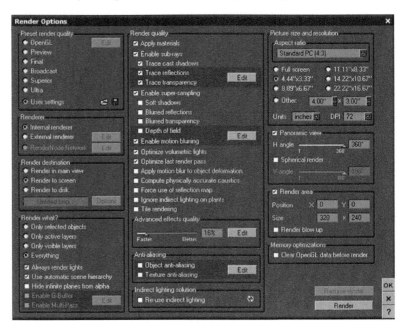

Apply Materials will let you choose to render your scene with no materials. This will not affect the sky, and so it is a possible way to get a very high-quality preview of the sky.

Subrays are all those involved in things like reflections, transparencies, and casting shadows. Once again, this could be helpful with problem solving your shadows and the nonreflective and transparent properties of a material. Here, you can also click on the Edit button to change the number of reflections of a ray that Vue will calculate. Max Trace Level is how many external reflections, such as in a mirror, will be calculated and Max Total Internal Reflection Level will work with transparent materials where light can bounce internally before escaping.

Enable Supersampling involves the actions required for realistic softening or blurring of shadows, reflections, and transparency. This is disabled for the preview preset.

Depth of Field, discussed in Chapter 16, gives a distance range where the focus is sharp. Things not within that range are blurred. If this box is not checked, then you won't have any depth of field in the render, no matter what your camera settings are.

You can also enable Motion Blurring. Both this and Depth of Field share an Edit button that will lead you to the Blur Rendering Options.

Distributed Ray Tracing yields very accurate results, but is very hard on the render time since it requires so many rays to get a render without any noise. Hybrid 2.5D is a method of approximating the blur of either objects in motion or depth of field. There are difficulties using it, however. Any increase in the number of passes will multiply the render time. Motion blur usually only requires one pass, so this is not a big consideration. But depth of field requires more than one pass for good results. Also, a moving object with a great deal of blur will unfortunately and unavoidably cast a totally sharp shadow. However, if the camera is what is in motion, so the whole scene is moving, Hybrid 2.5D is an especially good choice and will give you great results while reducing render times. When rendering using this method, you won't see the effect on the first render pass with the rest of the image, but it will appear on subsequent passes. And finally, because of the differences in how Hybrid 2.5D works with depth of field and motion blur, these two effects are incompatible with each other using that rendering method. If you want to use both together, you will need to switch to Distributed Ray Tracing.

Optimize Volumetric Lights will fake the volumetric lights and thus reduce render times. Take note that this isn't making the volumetric lights optimal, but is optimizing the time spent rendering them and reducing their quality. The result from this reduction is usually not problematic, but sometimes it will cause blurred volumetric lights and in some cases splotchy effects.

Optimize the Last Render Pass will also reduce render times up to three times, but can leave out details and won't let you generate G-Buffer information (more about that later).

The movement of plants in breeze and wind are caused by the objects themselves deforming. Normal motion blur won't apply to this movement, but you can get it by enabling Apply Motion Blur to Object Deformation.

If you have an image with refractive materials that require accurate caustics, enable Compute Physically Accurate Caustics. Of course, this will increase render times.

Choosing Force Use of Reflection Map will cause all reflective objects to use a reflection map. This is useful if you've chosen ray tracing for several different materials but find an increase in render time. Rather than needing to change each material, you can just choose this option. It won't change the ray tracing settings either, so you can just as easily decide not to use it. If a material doesn't have a reflection map assigned to it, the default reflection map will be used, so you'll want to make sure that is right.

Another way to save render time is to select Ignore Indirect Lighting on Plants. Plants have complex geometry that can increase the calculations of indirect lighting by quite a bit. The plant will still do things like cast shadows. A good compromise and the default setting is to select Optimize Indirect Lighting on Plants. This can be found in the Advanced Effects Options interface detailed in the next section. Of course, if plants are central to your image, you may wish to completely render indirect lighting on them.

You can only use Tile Rendering if there is no anti-aliasing for objects.

Advanced Effects Options

The Advanced Effects Quality box lets you control the overall quality of how volumetric lighting is sampled. The better the quality, the more it will be sampled and the less noise will appear in your scene, especially in things like clouds. The Edit button here will get you to the Advanced Effects Options interface. It is in this interface that you will have more direct control over how Vue handles the computation of light rays and, therefore, over the quality. There are two tabs here, General and Photon Maps.

The General tab deals with custom settings for indirect lighting and volumetrics. In addition, at the top of this tab is the Indirect Lighting on Plants option mentioned earlier. The group to control custom settings includes an ability to change how many samples are taken to calculate the indirect lighting. By default, this is set at 256, and usually works quite well.

Under this, you can enable Adaptive Sampling, which will let you massage the way Vue handles the sampling of indirect light. These four settings each deal with how carefully Vue will calculate the samples of light based on certain properties: distance from objects, alignment, orientation, and contrast. The Jittering setting is useful to differentiate how Vue will sample indirect lighting depending on if you're rendering a still or an animation. Reduced Pulsation, the default, will calculate the indirect lighting in such a way as to get rid of low-frequency pulsations that occur if using adaptive light sampling. This is good for animation. Standard will give you a better distribution of light samples, but the artifact of pulsation can appear. Therefore, Standard is better for stills.

Reducing Bucket Size will actually increase the number of samples taken, resulting in a more accurate indirect lighting evaluation. This is because there is at least one ray evaluated per bucket, and the smaller the buckets, the more there are in the render area. It has been known to reduce render times, but it can also increase them. If you're having some issues with the indirect lighting, this is definitely worth a shot.

A great diagnostic tool is the option to Show Samples. This reveals where the indirect lighting samples are being taken from. These are shown by a small dot in the first render pass. You can change the color of this dot so that you can contrast it with the colors in the scene.

The Volumetrics slider under these corresponds exactly with the Advanced Effects Quality slider of the Render Options interface.

The Photon Maps tab lets you choose how many photons will be used to calculate radiosity or caustic effects, and how they behave.

Anti-Aliasing

This is another very useful tool in improving render results, especially when you must use lower resolutions. Set properly, these can also reduce flicker effects in animation. To open this editor, click the Edit button to see the Anti-aliasing Options.

The first choice you have is between Systematic and Optimized anti-aliasing. Systematic is the more accurate of the two, supersampling every pixel to get smooth transitions between colors. Optimized, which is the default, looks for places where there is a big difference between color and supersamples those. This is usually quite accurate enough, but if you find flickering, you may want to switch to Systematic.

There are four different kinds of anti-aliasing and a choice to let Vue choose automatically:

- *Crisp* is the most accurate.
- *Sharp* usually does well enough for stills.
- *Soft* is good for animations, since it just softens out edges.
- *Blurred* gives you even more soft edges.

Another way to increase the accuracy of the anti-aliasing supersampling is to increase the number of minimum and maximum samples it will take. It will

usually send out several samples to see what the color should be. Based on those, it will send out a few more to more accurately calculate the color. The more you sample, the more accurate the color will be. The quality threshold controls how much more likely it will be that more samples are called for. The first samples taken can either be randomly cast per pixel or cast exactly the same, at regular intervals, for each pixel. You'll find a choice between the two by toggling the Regular Subpixel Sampling option.

So far, this has only applied to objects versus their surroundings in the image. You'll also want it to apply to textures or materials, which occur in the next box over. These all work the same, but you have a couple of other settings for textures. Texture Filtering enables you to control how sharp or blurred the texture maps are. Making the textures smoother will let Vue blur them a bit and thus optimize them. This is most useful for animations, as it can start to look blurry in stills. The recommended setting for animations is 33%. Recompute Subrays refers to rays that have been reflected or refracted. This is most useful for special circumstances when you have reflective or refractive materials that are bumpy. Otherwise, it unnecessarily slows down the anti-aliasing computation and thus the rendering time.

Back to the main Render Options, the bottommost option down the center of the interface is the Indirect Lighting Solution. As you've already guessed, choosing render settings is itself an art form and you may find yourself rendering your image several times before you're satisfied with it. You can save the indirect lighting information for use in later renders, instead of having to recalculate it at every render. However, if you change the lighting between renders you may have some undesirable effects, so uncheck it or click on the circling double arrows there to update the indirect lighting.

Presets

Now that you understand what all the settings do, you can see how the presets work and which are best for what.

- *Rendering in OpenGL* mode will pretty much give you the same results as what you see in the main camera view. You may get materials applied, but none of the advanced light effects can be used. This is probably good for extended animation previews, where it is the movement of the objects that you need to see.
- *Preview* mode, as well as having light calculations set very low in quality, neglects any supersampling techniques that can give you things like soft shadows, depth of field, and anti-aliasing.
- *Final* is set higher in quality and includes most of the features you'd want for a good still, but is not an appropriate setting for animation.

- *Broadcast* quality is like Final, but for animation. It has higher anti-aliasing settings and will apply a Hybrid 2.5D pass for motion blur and depth of field. If you're using depth of field in a still, you may want to use broadcast quality. Otherwise that extra setting isn't so helpful.
- *Superior* is another preset enhanced for animation, with a higher Advanced Effects Quality setting as well as using five Hybrid 2.5D passes.
- *Ultra* quality is especially useful for low-resolution images that require high anti-aliasing settings. But it is also the preset quality setting most appropriate for print. Generally, for images used in magazine publications you will require not only a high dpi (dots per inch), usually 600, but also very high settings everywhere in order to achieve good results. Final setting simply does not fare as well under the magnifying glass of a magazine's art editor as the ultra setting does.

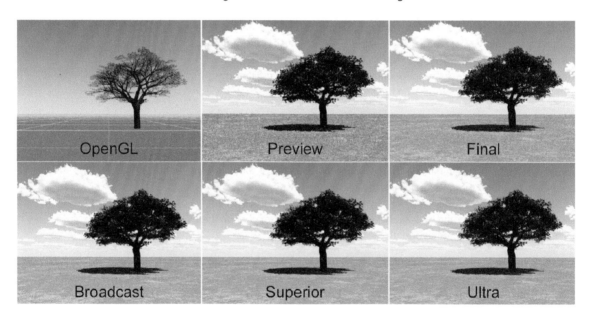

As you can probably see, you may want to make adjustments to settings as your project will have very specific needs to achieve the best results. Do keep in mind though, that there can be a number of things besides rendering that can mess up an image meant for high resolutions. Scale in materials (and elsewhere) is one of them, as are repeating patterns in the material. To evaluate and troubleshoot your image, use the checklist found on the book's web site.

Rendering How, Where, and What?

For preview work, and quite possibly for most of your images depending on your workflow as an artist, you'll want to choose the Internal Renderer. This will render the image within the Vue application itself, and unless you've chosen Render to Disk, you'll be able to watch it appear.

Sometimes finished scenes are rather large and can take a long time to render or even fail. The solution can be to use the External Renderer. When clicking on External Renderer, the Edit button will bring you a couple of options. The local Standalone Renderer is a separate application from Vue. It takes a little longer to start the render, but once begun, the render moves much faster. You can usually get a quicker and more reliable render this way. However, you'll be unable to see the image as it renders. This isn't an appropriate setting for quick work in progress renders. Because it must send all the information to the render application, preview renders will actually be slower here.

There are two networking options. HyperVue™ Network Manager will manage RenderCows™ on other computers to aid in the rendering task. The RenderNode Network also uses multiple computers for rendering. You can find more on these in the "Network Rendering" section.

If you choose any render except the Internal Renderer, the render destination will be forced to Render to Disk. When you do this, make sure it will save it with the right file extension and where you can easily find it. With the Internal Renderer, you'll be able to choose to see your render in the main view or in a new window that opens. When you close that render without saving, Vue will keep it in a temporary directory, allowing you to see the last render using the Show Color Picture option in the top toolbar. You can also save these renders either by clicking on the Disk icon in the screen showing you the render or on the Save Color Picture icon in the top toolbar.

The bottom group gives you useful options on what you'd like to render. This is helpful especially if you have a complicated scene and you want to examine what only one object or layer looks like without distraction. This is also where you can work with G-Buffer and Multipass channels (see the "Multichannel Renders" section).

Size and Resolution Properties

On the right are the Size, Ratio, and Resolution settings that have been discussed before. In general, your image will be measured in pixels and the dropdown list gives you a convenient way to keep it within any necessary

standards for film, television, or print. However, if you're working with print you may find yourself more worried about inches or centimeters. If that is so, then dpi will be a concern. It will allow you to quickly make sure you have enough resolution. For photographic quality images you will want 600 dpi. For less strict printing needs, 300 dpi works very well. The default value of 72 dpi is the standard for images on the Web.

In addition to the option to choose a panoramic view (discussed in Chapter 16) you can select a smaller area of your image to be rendered. This is very useful if you have a specific problem you need to correct. For high render settings at high resolutions it is simply impractical to render a full image. Often just a sample will show you what you need. You can define this area here, or through the top toolbar: next to the Rendering icon is the one for choosing the render area. Click on that, and then use your mouse to make a marquee within the camera view. As soon as you release the mouse button, a render will automatically begin. This marquee will stay in place and any render attempt will only render that area until you disable the render area either in the options interface or at the top toolbar. Clearing OpenGL can sometimes help if you're a bit low on resources.

Rendering Animations

If you're going to render an animation, there are several other important things you need to consider. For animations you have both Animation Render Options and Advanced Animation Options. You can access the first under Animation in the top menu or by clicking on the Camera icon to the far right of the Animation Timeline. In that interface, you'll see the Preset Render Qualities and Frame Resolution, but every other group is unique to animations. In the top, you have the options to limit your animation either by frame or time. Like rendering an area, this is helpful when working with specific problems over time. The frame increment will allow you to skip rendering of some frames. No frames will be skipped in the default value of 1. If you use 2 frames, every other one will be skipped, and setting it at 3 frames will cause two frames to be skipped so that every third frame is rendered, and so forth.

Under that are the channel files you may need:

- *Color channel:* This is the file that will give you your image in full. It shows you the color each pixel should be.
- *Alpha channel:* This shows you which pixel is depicting an object.
- *Depth channel:* This is also called Z-Buffer or Z-Depth. This shows you the distance from the camera of the object shown in that pixel.

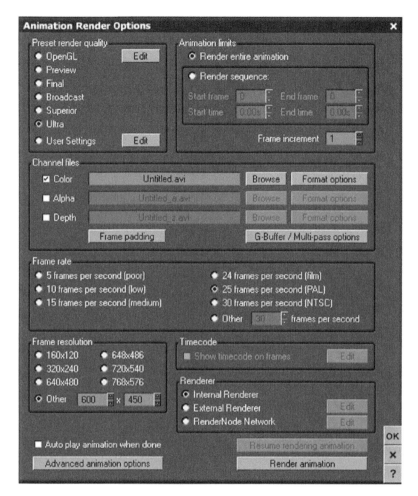

This is information that can be useful for postrendering processing. Next to each of them, with the Browse button to let you choose where to save the animation, are the format options. These let you choose what type of compression you want. If you don't want any compression at all, scroll down to the bottom of this menu and select Full Frames (Uncompressed). There are many other channels you can generate. You can access control of these with the G-Buffer/Multipass Options button (see the "Multichannel Renders" section).

Frame Padding deals with how the individual frames are named. The number value of the Frame Name Options represents how many zeros (the padding) are included in the numbering of the frame found at the end of the name.

Another very important property of animations is their Frame Rate. This is how many frames per second will be generated. There are several choices, along with what standards they meet.

Other options here are the timecode settings, and a choice of how to render. For more information about this, see the section on "Network Rendering".

At the bottom is a button for Advanced Animation Options. There, you'll find yet more anti-aliasing options, this time for use specifically with animations. Deterministic Anti-aliasing uses a random sampling method that almost always gets great results, but occasionally causes a pattern noticeable to the eye. Keep this on unless you see the pattern. Multiframe Anti-aliasing will look between frames to try and detect flickering, then resample any sections where that is occurring. Another option is Distance Blurring, since the distance is the most common place where animation flicker occurs.

As you may know, interlacing is common to television, where the frame rate is 60 per second in many televisions. For use only if you're rendering for television, Field Interlacing will add half of a frame every other frame to fill in the gaps. Obviously, this adds a lot of bulk and render time. It's pointless unless you must have those extra frames.

Pixel Aspect Ratio has been discussed before, with pixels flattened to accommodate certain kinds of filming and television widescreen ratios. This gives you the specific values appropriate for the format you're aiming for.

Automatic Illumination Baking is very useful for still objects in animations. This records a map of the indirect light over the entire surface of those objects so that it doesn't have to be rendered with every frame. Light sources can even be moved, since this works only with indirect lighting. However, sometimes if objects are moved around, then it gets inaccurate.

If you have this selected, choosing Bake Every Time will cause it to be baked at the beginning of rendering animations. Smart Baking will cause a new baking only if the lighting has changed or if more quality in the illumination map is required, though you do have the option to force baking if you want on the next render. The Map Resolution Boost works so that 1 doubles the resolution and −1 halves it. If you've chosen to increase the resolution of your image you can increase your map resolution for the Illumination Baking here.

Multichannel Renders

As well as the color, alpha, and depth channels, there are a number of channels that you may need in the process of postproduction. To see the interface dealing with these, click on the Edit button next to Enable G-Buffer and Enable Multi-Pass at the bottom left of Render Options.

The highest-quality format for these is to generate them in a G-Buffer. This will create a file that stores and structures the information from each channel for use in programs such as Adobe After Effects to tweak your animation. Both RLA and RPF file extensions will save G-Buffer information. If you've enabled G-Buffer to record this extra info, you should save the image file as either RLA or RPF to use the information. You won't be able to save an image with those file extensions if you did not render the G-Buffer channels. You can find a table of what each of these channels does on the book's web site.

Multi-Pass Buffer will generate channels as well, but this time in Adobe Photoshop's PSD format, allowing you to have the information in different layers to work with in Photoshop. For example, if you saved a specular (highlights) channel, when you're working with the image in Photoshop you can alter the highlights without affecting any other part of the image. Without this information saved in channels, darkening highlights could result in other nonhighlighted but lighter areas of the picture to become dark as well. You do have the option to save each channel as a separate file, if you'd rather. Multipass Buffer does not hold quite as much information as the G-Buffer method of saving channels, but is generally more convenient to work with. Not only that, there are several channels available with Multipass Buffer that aren't with G-Buffer, such as shadows, reflections, diffuse lighting, and more.

Network Rendering

All these dire warnings of slowing renders down might have you running scared from doing anything complicated; but there is a solution. This is to get more than one computer in the game. Vue offers two methods of network rendering. Using RenderCows (five licenses of RenderCow are included with each license of Vue 7 Complete, Infinite, and xStream) is appropriate to the small studio or home network. Computers running RenderCow do not have to be devoted only to rendering, since they will run in the background. This means that any computer hooked up to a network at home can be used. All that is required is for each computer to have RenderCow installed in it and running on the right port.

If you start RenderCow on the computer, it won't start up an application, but a process. The port is really the only setting you need to worry about, but to get to it you'll need to look for the icon in the task bar. Right-click, then select Settings > Port number. These numbers are set by default. The discovery port is 5591 and the communications port, where orders and data are received, is 5002. Only change those numbers if those ports are already being used. If you do change the port numbers of your RenderCow, make sure that you also make the same changes in the HyperVue Network Manager. You get to that through the render settings of the Vue application. Select External Renderer, and then click on the Edit button next to that. Select Use HyperVue Network Manager and select the Edit button for that RenderCow to open the configuration mode. Right in the middle of this interface is where you'll find the option to Auto-discover RenderCows with its attendant port number. To the right of that number is the Add button. Clicking on this will let you add a new RenderCow either by name or IP address, and under that is the port number the manager will use to communicate with the RenderCow. Once you've added a RenderCow it will appear on the list.

The way RenderCows (and nodes) work is to render a small section of the picture, called a tile. When all the tiles have been rendered, they'll be stitched together to form the pictures. In general, smaller tile sizes perform better for computers with less RAM and for situations where there might be limited sections requiring lots of computations. You can force smaller tiles in the HyperVue Network Manager interface.

Once you've added some RenderCows to the manager and have your tile size where you want, you're ready to go. When you start to render, the manager will appear again, this time giving you information about what each RenderCow is doing. Make sure that you've properly set the file type and placement in the Render Destination group of Render Options so you'll know where to find it.

RenderNodes work well for large studios with render farms that are multipurpose. RenderNodes are not included, and require e-on software's network license server to be installed as well. They are more powerful and flexible than RenderCows, but are a bit more complicated to get going. These

involve working with the command line and entering paths and perhaps several other instructions. If you're in a large studio, your network administrator should have instructions specific to your setup. The manual is a great resource for this.

Outsource Rendering

But what if you don't have lots of computers, and have a big job? One last way to take care of your rendering needs is to outsource your rendering to a farm. All you'll need to do is save your scene and send it to a service that handles rendering. They'll do the rest (upon payment, of course) and you'll receive your finished image back. One problem is that you won't be able to do much fine-tuning with the image. This makes it important for you to use testing techniques like area rendering, and for animations, rendering low-quality versions that show motion at least and frames or short snippets that show image quality so that you can be sure that you'll be happy with what you paid for.

Tutorial 18: Tree and Field

This tutorial will set up a simple scene with careful render settings to improve the look of the clouds and anti-aliasing.

Step 1

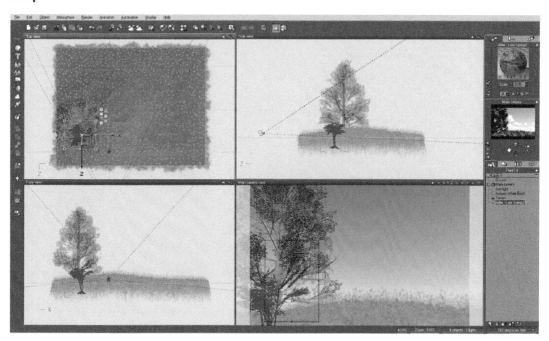

Start a new scene in Vue and create a standard heightfield terrain. Shrink this down quite a bit, rectangular lengthwise, then position it with the camera. The shape will keep the terrain in the camera's field of vision while reducing the number of plants that will be populated on the EcoSystem. And now, load a new material onto the terrain, using "Vegetation" from the Landscapes collection. Click "OK," then right-click on the material preview and select "Edit Material." Change the material type to EcoSystem. In the General tab, click Add > Plant > Grasses—Plants > Dry Weeds. In the Density tab, push Overall Density all the way to 100%. In the Scaling and Orientation tab, make the Overall Scaling 0.7, and click "OK." To the left of the terrain, add a tree. In the example, an "Autumn White Birch" was used. A bit of green was also added with one "Alder—Late Spring" at the base of the birch.

Step 2

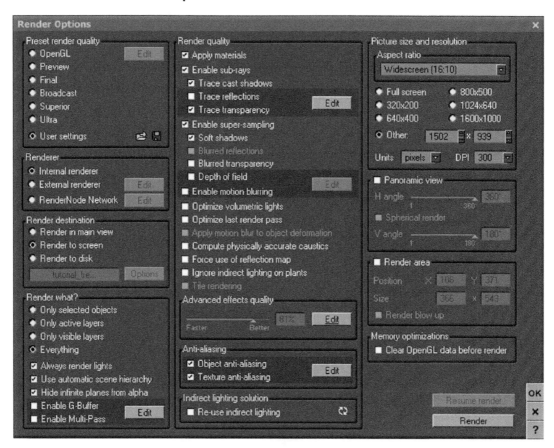

Move your camera close in and put it closer to the ground with about 90 centimeters of height so that the tree is at the far left of the camera's view. Point the camera up so that the terrain occupies the lower quarter. For an atmosphere, load "Daytime" from the Physical collection. Now to get ready for your render, right-click on the Render icon in the top toolbar. To make things just right for this project, you'll want decent anti-aliasing and strong volumetrics for the clouds. There are also several unnecessary settings that can slow down your render. Click on User Settings in the Preset Render Quality group. For now, use an Internal renderer and Render to Screen. In the Render Quality group, disable Trace Reflections. You won't need it, so there is no reason to waste render time. The next thing you want to disable is Optimize Volumetric Lights. This means optimize time, not quality, so disabling it will improve the look of volumetric light effects but increase render time.

Step 3

Click on the Edit button of the Advance Effects Quality group to open the Advanced Effects Options. Enable Custom settings. Go to Bucket Size and decrease it to 8 × 8. This smaller bucket size will help the accuracy of the lighting. There, you'll want to also increase the Volumetrics Quality setting because once you're using custom settings, you can't change it in the Render Options panel. Move it up to what looks like about 80% and click "OK." You should now see that number. Now, in the Anti-aliasing section click on that Edit button. There, make the Object Anti-aliasing Systematic. Change the Anti-aliasing Strategy to Crisp. Increase the Subrays per pixel by using 8 for the minimum and 16 for the maximum. Increase the quality threshold to 100%.

This should give you better anti-aliasing for objects. Now, for the textures on those objects, increase the Texture Filter to 33% and change the minimum Texels per Ray to 8 and the maximum to 10. Push this Quality Threshold to 100% as well. Click "OK."

Step 4

At this point, all you really need to do is set your picture size and resolution. Make the Aspect Ratio Widescreen (16:10). You may need to adjust your camera a little bit after changing this. Choose a resolution that will meet your needs. For a photographic-quality print, you'll want to choose 600 dpi and change your Units to inches to choose the size. This information will not be embedded with the image, but is still helpful for you in setting a size. 300 dpi will be decent for regular printing. If you're just going to keep this in electronic form don't worry about dpi, but usually a resolution of 1024 × 640 pixels is appropriate for things like Web galleries. Once you have all these set, hit the Render button. If you don't want to render now, just click "OK." Vue will remember these settings with the scene if you save it.

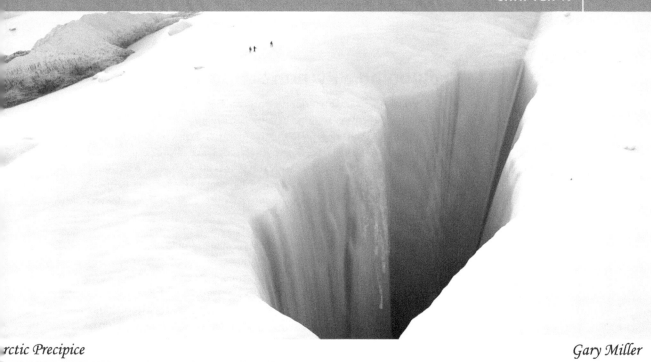

rctic Precipice *Gary Miller*

Python Scripts

As fun as it may sound to have snakes on stage, Python is actually a programming language. Python scripts are basically lists of commands to Vue to create, manipulate, or modify objects and do many other things such as with materials or postprocessing. It is well outside the scope of this book to teach you how to program using Python, although the tutorial following will give you a start on it. There are excellent resources online for that: *http://www.python.org* is a good place to start. If you already know how to program using scripting languages, visit *http://hetland.org/writing/instant-python.html*.

Just because you can't create them doesn't mean you can't run them though. In addition to a handful of scripts available in the Vue 7 files, there are many available for sale on *http://www.cornucopia3d.com* and a few available for free at various Vue user's web sites. Many are very helpful in positioning objects exactly, or getting just the right settings for texture, etc. To learn how they run, this chapter will cover the basic anatomy and behavior of Python scripts.

Running a Python Script

To anyone familiar with scripting languages, you'll be happy to know you won't need to install any kind of compiler, since Vue has its own Python interpreter. To start one, go to the top menu, and click on Automation. This dropdown menu will have "Run python script" in it. If you've already run a script, you'll see the most recently run scripts displayed at the bottom of this menu. Selecting "Run python script" will prompt a file browser to open within the "Scripts" file provided by e-on software. There will be several folders with a few to try out.

However, before clicking on a file, it is usually useful to know what they do. You'll be able to read the text of a Python script by opening it in a simple text editor. The extension for Python scripts is PY. In any well-done script there should be comments telling you what it does and, if necessary, giving instructions. It is this last bit—instructions—that make it a good idea to take a look at your scripts before running them. You may need to do certain things before you can run a script. For instance, in the "FloatingEcoSystem.py" script found in the EcoSystem folder of the Vue-provided scripts, you need to already have an object named "Water" populated with an ecosystem before you can run it, or it will give you an error. If the programmer is thoughtful, the error may be helpful and tell you what is missing, as with this script.

Many Python scripts have immediate results that you can see. Others, such as the "FloatingEcoSystem.py" script, appear to do nothing in any of the OpenGL views or the preview. This is because their work happens at render. "FloatingEcoSystem.py," in particular, requires an animation, since it changes the position of the objects in every frame to correspond to the surface of the "Water." Another fun script that appears in a render is the "PictureFilter_ Cartoon.py." This will create a black outline around every object at the time of render if G-Buffer is enabled, since it calls for the Object ID channel to accomplish this.

One thing you'll notice is that Python scripts (especially those involved in rendering) may run even if you start a new scene. To purge the script, you'll need to restart Vue.

```
#*****************************
#PIXEL FILTER CALLBACK SAMPLE
# - Black & White rendering
#*****************************

#----------------------------
#Define pixel filter callback
#function. Each rendered pixel
#will instantly be turned to
#its grayscale equivalent
#----------------------------
def pyPixelFilterCallback(x, y, r, g, b, Alpha, Dist):
avg = 0.35*r + 0.45*g + 0.2*b
return (avg, avg, avg, Alpha)

#-------------------------------------
#Set pixel filter callback in the scene
#-------------------------------------
Scene().SetPixelFilterCallback(pyPixelFilterCallback)

#*************
#END OF SCRIPT
#*************
```

The red text is the actual script. The comments are shown in black. It is not unusual for comments to outnumber script. In this simple script, there are no special instructions but it clearly explains what it does.

Anatomy of a Python Script

When you open up a Python script in a text editor, you'll see two things going on in it: comments and the script itself. Especially in small scripts, the comments may be much larger than the script itself. Comments are for your sake. They tell you the name of the script, give instructions, and sometimes explain what the script is doing in a certain section. You'll recognize comments by the hash symbol (#) or double quotes ('''') that come before every line to tell the interpreter not to read it.

The script itself will have definitions and functions in it. There can be just about anything here. It can be very heavy with math or just a simple command. Many times a complicated function will be defined so that only one command causes it to start. Then in the next part of the script the command is given with the right parameters. Even if you aren't a programmer, close inspection of the code may reveal how it works.

In the Automation dropdown menu is also the Python Documentation. This is important for every Python programmer. Not only does it have good information about Python as it relates to Vue, it gives access to the list of

all the structures and functions used in Vue. For instance, if you want to create a sphere through the interface using Python you'd need to write `VUEInterface::AddSphere()`. Documentation will give you every function you can use in Vue. To those familiar with scripting languages, you'll be able to make out what it means. To those who've never programmed, these will be an alien language, but one that is not too difficult to pick up.

Vue recognizes Python scripts by their .py extension. Since text editors often save as .txt by default, remember to save it with the correct extension.

With every new release of Vue, there are some commands added or taken away, and others are altered in how they work. What this means is that if you're running a Python script that you've acquired from somewhere else, you need to confirm that its code is compliant with the version of Vue you're using.

You can also use Python scripting language on-the-fly, without needing to save a text file if you're using Vue Infinite or xStream. Run the Python Console by going to the top menu and selecting Automation > Display Console. There, you can see what scripts have been run and you can also enter commands. This would be kind of like running an ad-lib Python script that can't be saved. Although it may seem weird to manipulate your objects in such a roundabout manner, it does give you a great deal of precision in numeric values if you know how to use the language.

Tutorial 19: Jumpstart Python

In this tutorial, appropriate for Vue 7, you'll write your own Python script that will add a terrain, a planet, and delete the sun. Since all the "comments" are in this tutorial you won't be instructed in this tutorial to write them. But still, it is a good idea to practice adding comments into your scripts. Even if you don't intend to pass them on to others, you may forget why you did certain things.

Step 1

Start by opening a simple text editor like Notepad. Or, if you want you can do this all instantly in the Python Console by clicking on Automation > Display Console. To create your terrain and at the same time name it, type the line:

```
mountain=AddTerrain(400,400)
```

Notice the numbers in the parameter. They define certain characteristics attached to whatever object is being created. In this case, this refers to the height and width. (The height here is not the altitude of the terrain, but its X value.) To move this very same terrain, the next line will call the instance, "mountain," and instruct it to move. The instructions occur after the period.

```
terrain.Move(0,100,0)
```

Here, the numbers in the parentheses are defining the X, Y, and Z positions.

Step 2

Now create a planet in the same way.

```
moon=AddPlanet()
```

Move the planet and resize it.

```
planet.Move(0,100,5)
planet.Resize(5)
```

Step 3

When things are created, they remain selected until something else is selected or you deselect things. Because of the next step, you want to make sure nothing you've created so far is selected. In Python, the command for this is:

```
DeselectAll()
```

Now, to make it dark, select the sun and delete it. In this command, the name (as seen) in the World Browser is used to select it. The next line deletes everything that is selected.

```
sun=SelectByName("Sun light")
Delete()
```

To make sure you can see everything in the OpenGL 3D views, type in:

```
Refresh()
```

Step 4

Now that you've written your script, if you've done it in a text editor, make sure that you save it with the Python file extension, .py. Once you have your script saved, go into Vue. In the top menu, select Automation > Run python script. When you click on this, a file browser will appear. Navigate to the Python script you just saved, and select it. At that point, everything will appear as described in this tutorial.

Integration

You may very well have a three-dimensional (3D) application that you love, and would like to use Vue in tangent with it. With Vue 7 xStream you now have an unprecedented ability to harness the strengths of Vue within other applications. These are 3DSMax, Cinema4D, LightWave, Maya, and XSI. Vue 7 xStream is much more advanced than the previous versions in how it integrates. Recent collaborations between the software developers have resulted in smooth and seamless integration. Unlike Vue 6, you only need one license to use it in multiple applications.

Integration will start when you install Vue xStream. During the installation, a menu will appear listing the applications. Vue will detect any that you already have on your machine and will place a check next to the versions you have. Only uncheck them if you don't want Vue integrated with those programs. Otherwise, simply click on the Next button and you'll be good to go.

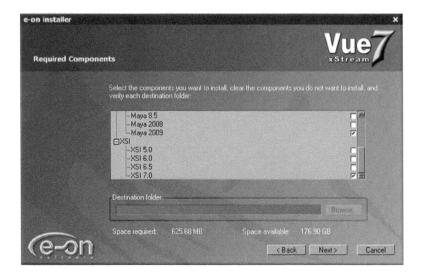

If you're using 3DSMax or Maya, another menu will appear to edit the Mental-Ray Configuration. You'll need it to be edited even if you won't be using the MentalRay renderer with Vue. For any special configuration you have, you'll need to edit the paths to these files to make sure they are correct. Click on each application to see its path, and then use the Browse button if it is not the path you've been using. If it is correct, just click Next.

For 3DSMax, Cinema4D, and XSI, nothing more needs to be done. A menu will automatically appear. Cinema4D does have an extra heading in its dropdown menu, Vue 7 xStream, which is needed for technical reasons but should otherwise be left alone. Although it does let you create an object manually, this should never be done. The xStream Painter will become active when you start painting in LightWave.

For LightWave and Maya there are extra steps.

In LightWave, you'll need to add Vue to the menu. This is done by selecting Edit from the options in the left menu, then selecting Edit Menu Layout from the dropdown menu. This will open up the Menu Editor. The list to the right is the Menus list. Click on Top Group. Now right-click on Top Group and select "Import Branch." In the browser that appears, navigate to the Vue 7 xStream application folder. Go to the folder Environment > xStream > Lightwave 9, where you'll find the file "Vue7xStream_Menus.cfg." Open this file to add a Vue 7 xStream menu entry in the Menus list. You'll be able to drag and drop it anywhere you want on the list. Click on the Done button. Once you've finished this, Vue 7 xStream will always appear in the menu where you placed it.

In Maya, you'll need to go to its top menu and select Window > Settings/Preferences > Plug-in Manager. In that menu, at the bottom you'll find the

"Vue7xStream.mll" file. Check the Loaded box to load it in, and Auto Load to get it to start up whenever you start Maya. Click on Close, and Vue 7 xStream will appear in Maya's top menu bar. Clicking on it will cause all the menu items that are in Vue's top menu bar to appear in a dropdown menu format.

As of this writing, if you install one of the programs after Vue 7 xStream is on your computer, you will need to uninstall Vue and, then reinstall it to access the menu that will integrate Vue into the new application. A plug-in installer is expected soon, however.

Once you've gotten Vue installed, using it within the application is as simple as using a dropdown menu. Everything you've learned in this book can be accessed through the menu. The way Vue meshes with each program is fairly intuitive if you know both Vue and your target application. Some things, like creating an object, will occur right within the program. Other operations, such as adding a material, will start up the Vue application and the appropriate interface will appear. Because of the dropdown menu interface, sometimes things that were simple in Vue will require just a bit more go-around. For instance, if you've created a water plane in Vue, to work in the Water Surface Options interface, you'll need to select the water plane, go to the top menu, and choose Vue 7 xStream > Object > Edit Object.

All of the objects that you create using the Vue 7 xStream menu or that are part of a Vue scene you've opened in the target application are represented by what are called proxies. A proxy is an object in the native application that has the same geometry of the Vue object and basically stands in for it. These proxy objects can be anything: cameras, lights, terrains, plants. Altering the geometry or texture of objects through the native application will have no effect. You'll need to use the xStream menu in order to edit any of this. However, you can move, rotate, or rescale Vue proxy objects in the native application.

Lights and cameras are somewhat different. Vue lights and cameras will be transformed into those from the native application, and it will be those lights that affect the scene and those cameras from which the image will be rendered. Therefore, you can edit the lights and cameras.

Also, you'll be unable to apply any Vue materials to objects created by the target application. In order to do this, you'll need to export that object as an .obj or another type that Vue can handle. Then you'll need to go to Object > Import Object within the Vue 7 xStream dropdown menu.

So, what happens when the scene is rendered? For Vue-specific objects, materials, and atmosphere effects, Vue will communicate with the native renderer, telling it how to handle those. In this way, you can create a scene that combines both Vue objects and objects from the target application. Each application has its strengths and weaknesses regarding how it renders things like Vue's atmospheres and lighting.

Synchronization

If you would rather work within Vue but still want to combine scenes, you can import camera, light, and animation information from each of the applications that Vue can integrate with. This will let you exactly match scenes in development in 3DSMax, Cinema4D, LightWave, Maya, or XSI.

Synchronization is accomplished through the use of plug-ins that work with those applications. Once you have Vue's plug-in installed (for documentation about how to install a plug-in in each application, go to your Vue application CD and open the "Synchro Plug-ins" folder), there will be two different operations you'll need to do. Cameras and lighting are synced with one method, and object animation is another.

To accomplish this, use the plug-in of the other application to generate synchronization data. Once you've done this, when Vue is opened or even if it is running, it will detect the presence of these new data and ask you if you want to use them. For cameras and lights, this will be automatic.

For other objects, you'll need to establish a connection between the objects you want to synchronize. Do this by selecting your object within Vue, going to the Animation tab, and choosing "Synchronized" from the Motion dropdown list. A new dialog will appear with a dropdown list of objects to synchronize with. Choose the name of the object from the other application that you want to synchronize with. You'll also need to adjust the scale factor, which will be the same with every object available for synchronization.

At that point, your cameras, lighting, and desired objects should be animated just like they are in the outside application.

Before doing any synchronization, make sure you save your scene first as all these objects will be automatically changed to match the synchronization data. This will ensure that you don't lose any animation or placement that you developed and want to keep.

This ability lets you work on the scene in both applications separately but at the same time. In addition to being able to use the strengths of your favorite 3D software together, the advantage of synchronization is being able to use Vue's easy-to-work-with interface.

Appendices

Appendix A
Resources

Vue 7: From the Ground Up—*www.vue7fromthegroundup.com*. This book's web site where you can download the tutorial pack as well as some other goodies, find lots of extra references and information, see galleries from featured artists, and link to other readers.

Vue Related

Cornucopia 3D—*www.cornucopia3d.com*. From the developers of Vue, this web site has the biggest store for Vue products such as models, plants, materials, atmospheres, and more. It also includes the largest Vue community that features a gallery.

e-on Software—*www.e-onsoftware.com*. The developers of Vue; this is the official web site where you'll find customer support.

Geekatplay Studio—*www.geekatplay.com*. The authors' tutorial web site with lots of free tutorials, a store, and a community.

LVS Vue courses—*www.lvsassociates.com/register/index.php?manufacturers_id=99*. Three courses by Peggy Walters, the technical editor of this book.

DEMs

Canadian Geobase—*www.geobase.ca*. Provides free DEMs for land within Canada.

USGS Seamless Map Server—*www.seamless.usgs.gov*. Provides terrain data for almost anywhere in the world, although the resolution is best for areas in the United States.

Visualization Software—*www.visualizationsoftware.com/3dem.html*. This is where you can get the software to convert the USGS geotiff format to DEM.

Plants

Plants Database—*plants.usda.gov*. U.S. government database of plants, including 40,000 images, structural descriptions, and where they're most likely to grow.

Clouds

The Cloud Appreciation Society—*www.cloudappreciationsociety.org*. Features thousands of pictures of clouds and the sky

Appendix B
Workflow

To keep your workflow smooth and efficient, remember these few things:

- **Name everything.** When you're working, if you have a lot of objects in your browser or you have a complicated material you're dealing with, it could get very confusing if you have five defaults in your materials layer. Vue helps by numbering objects in the World Browser, but naming things, such as "TreeFrontLeft," can help a lot.

- **Describe the things you save.** This is true especially if you're working with others on a project or are intending to sell the item. When you save, there are Title and Description fields. Fill them in. In one sentence, tell what it is, and give information like how many polygons.

- **Save regularly.** Every time you're about to do something big, save your scene. Try saving every few minutes anyway, and always save if you're going to leave the computer. This can be a hard habit to get into. Even both of us authors have very recently lost scenes because we didn't save.

- **Resources and polygon count.** Always pay attention to these numbers at the bottom right. (You can switch between the two using the button to their right.) These can help you know if you have a scene that is too big to handle polygon-wise, or if your computer is running low on resources. Imported objects can often be a drain on resources. You can change the polygon count that can be handled in OpenGL through File > Options > Display Options in the Limit OpenGL Polygons box setting.

- **Render often at low settings.** This will give you a better idea of how your scene is turning out. In this vein, wait until the end to load atmospheres, especially if they have a lot of clouds. They can slow down preview renders a lot.

- **Area and single-object rendering** is an important way of evaluating how your image will look in your finishing render settings without having to render the entire thing. Areas to look at include clouds (to detect graininess), the edges of objects, shadows, spots of materials, etc. You'll probably already have an idea of possible problem areas or objects through your preview renders.

- **Test.** If you're working on a big project, find simple ways to test what you're doing before trying something very complicated on something else complicated. This can give you experience, indicate if something might not work well, and even inspire. For instance, in animations, it is a quicker render to use a simple sphere or unanimated object to test motions and camera.

- **Exporting and importing.** Know the object file extension capabilities of all the applications you're working with. Use testing as described often here. Remember that Vue can only work with polygons.

Appendix C
Scaling

When creating your scene, one of the important aspects is the scale of everything in the scene: terrain, water, plants, objects, etc. People creating items often work in different scales. This is true even in the case of solid-growth plants, where trees can be as large as a terrain. You may bring something into a scene that is wildly bigger or smaller than the other objects. Sometimes it might not be so obvious. One way to diagnose scale discrepancies is with the shadows that objects cast. For instance, a bird's shadow should not cover most of a background terrain.

To fix these kinds of discrepancies, check the sizes of the objects that aren't matching and bring them all into one scale. It is a good idea to establish what scale you'd like to use early on. Do this by anchoring your scale around a single object such as a terrain or an import you're working with. When choosing a scale, consider both the amount of detail you want and how much rendering time you have.

Vue has a standard default with its terrains, water, and atmosphere (aerial perspective) that all match. If you're working with a terrain, you may very well want to stick with these defaults and scale everything to them. However, you may find yourself wanting to increase their sizes. A good reason for this would be to have more detail. If doing this, make sure you increase the scale of everything else accordingly. For instance, if you make land much bigger, and you intend to pair it with a water plane, which has a default scale of 4.0, make that scale bigger.

The scales with Vue materials vary quite a bit. This can depend on a lot of factors. For instance, if the material is based on an image map, how large is that? Let's say you take two pictures of pebbles at the same height, but you've zoomed in on one of the pictures so that the pebbles are larger. You make each of these pictures into a square, seamless image to use for a texture map. Using a scale of 1.0 for both of these is going to have a different apparent scale on the objects. Therefore, when working with the scale of materials in the Aspect tab, there is no set solution with how they apply with the scale of your objects. You will need to determine the best scale of your material by experimentation. A scale set too small can create repeat patterning (although that isn't the only cause; see Appendix D) or simply be lost, and a scale set too large can make the objects look odd. Pay attention to this detail, as it can often be the downfall of an otherwise good picture.

One other thing to take into consideration when scaling Vue objects is that the materials applied to them don't always scale with the objects. You will need to manually match this.

Appendix D
Quality Checklist

There are three things that often plague Vue artists as far as the quality of their images go: repetitive patterning, atmospheric or lighting graininess, and if it is an animation, flickering.

Repetitive patterning can be the result of several things:

- A material based on a texture map image that is not well suited to the task, such as not enough detail in the image, not being seamless, or badly done seamlessness. Choose images used for materials carefully and use good techniques to make them seamless. One possible cover-up is to go into the Effects tab for materials and use Turbulence in Global transformation.
- A material that is scaled too small for an object can also cause patterning. Here, try increasing the scale and setting of the material so it doesn't use repeat tiling (found in the Color and Alpha tab for mapped picture materials). At large scales, such as vegetation materials in the distance, you may detect repetitiveness that you wouldn't have seen close up. In this case, go to the Effects tab and edit the Cycling.
- Moiré patterning can be the result of using shadow maps on repeated geometries (like slate rooftops), or the way Vue must calculate the material (especially noticeable with bitmapped textures). The solution with shadow maps is to go into the Shadows tab of the Light Editor and disable shadow maps or make your shadow map larger so it is more accurate, or very gently tweak the Bias and Filter Bias (Filter Bias only applies if there is softness greater than zero in the Aspect tab). Enabling Texture Anti-aliasing in the Render Options screen can help reduce moiré patterns on bitmapped textures. Sometimes changing the camera angle slightly will also reduce or eliminate moiré patterns.

Atmospheric or lighting graininess is usually the result of rendering without enough quality in general, but it can also be specific to certain volumetric settings, depending on where you find it. For instance, if you have a light with volumetric lighting enabled and you see noise there, in your final render settings (not in preview!) try increasing the Quality Boost in the Volumetric tab of the Light Editor. This can get rid of the graininess without needing to increase the quality of the render across the board, thus saving render time. Atmospheric graininess can be worked on in the Light tab and the Sky, Fog, and Haze tab. You may also want to try the Light Editor in Sunlight.

Graininess can also be a problem with the material, specifically how the light interacts with displacement mapping (work with this in the Bumps tab) or translucency effects. If you're finding it on materials with these qualities, increase the appropriate Quality Boost settings.

Flickering in an animation can be the result of subtle repetitive patterning not visible until there is movement (especially at large scales) or because of lower anti-aliasing settings. Here, check both into the Anti-aliasing Options (through Render Options, you should be using at least 33% texture filtering) or the Advanced Animation Options. See Chapter 18 for more information.

Appendix E
Postproduction

Vue has many effects that are quite sufficient to create a final product. In fact, some color correction and filtering may be better accomplished through the Advanced Camera Options of Vue, since it can accomplish this without any information loss. However, in consideration of matching footage or achieving artistic effects, you may want to turn to other applications.

This is precisely why you can generate G-Buffer and Multi-Pass Buffer files. For instance, not all effects deal with tweaking the image, but rather with combining motions of objects in different footage. One of the channels includes information about the velocity of objects. But there are lots of other things you can do with multiple channels for your image. These will often include information on objects that were visually occluded from the render, but are still there. Because of this, you can even alter transparencies. For more information about how to generate multiple channels, see Chapter 18. Also, check out the list of channels on this book's web site for more information about how they can be used in postproduction.

Other things you can do include adding blur effects. Sometimes the kind of blur you need isn't dependent on distance or motion. You can modify colors more precisely in many other applications as well. A favorite effect that artists often use is to transform their Vue-rendered images into looking as if they were painted.

You can take this in another direction as well. Rather than adding other things to images generated by Vue, you can use Vue images to enhance real footage. A great example is that of skies. With Vue, filmmakers are no longer limited to the sky that was filmed. One can render exactly the desired sky, and then using masking techniques (such as in Adobe After Effects) to add it in to the footage. You can find a tutorial on this book's web site. Other background elements such as mountains or forests can easily enhance any footage and increase the location possibilities of independent filmmakers and big studios alike.

Index

Printed and bound by CPI Group (UK) Ltd, Croydon, CR0 4YY

22/10/2024

01777530-0008